THE JAPANESE PRINT
A NEW APPROACH

By the same author:

Japanese Masters of the Colour Print
Hokusai
(*both published by The Phaidon Press*)

J. HILLIER

The Japanese Print
A New Approach

CHARLES E. TUTTLE COMPANY
RUTLAND, VERMONT & TOKYO, JAPAN

Representatives

Continental Europe: BOXERBOOKS, INC., *Zurich*
British Isles: PRENTICE-HALL INTERNATIONAL, INC., *London*
Australasia: BOOK WISE (AUSTRALIA) PTY. LTD.
104-108 Sussex Street, Sydney 2000

Published by the Charles E. Tuttle Company, Inc.
of Rutland, Vermont & Tokyo, Japan
with editorial offices at
Suido 1-chome, 2-6, Bunkyo-ku, Tokyo, Japan
by special arrangement with
G. Bell and Sons, Ltd., London

International Standard Book No. 0-8048-1153-9

First edition, 1960 by
G. Bell and Sons, Ltd., London
First Tuttle edition, 1975
Second printing, 1979

0271-000400-4615
PRINTED IN JAPAN

To my wife Mary, my son Bevis and my daughter Mary, who have all shared, willy-nilly, in the production of this book.

To my wife Dorothy and Marilyn and my daughter Lucille and son-in-law Wilson, to the production of this book.

Acknowledgments

IT is a pleasure to record my indebtedness to the following collectors and museum authorities for permission to reproduce prints in their possession:

Huguette Berès, Paris; Sir Chester Beatty, Dublin; Mr. Edwin Grabhorn, San Francisco; Mr. Ralph Harari, London; Mr. Michel Massey, Berkeley, California; Mr. James A. Michener, Pipersville, Penn.; Mr. B. W. Robinson, London; The Trustees of the British Museum, London; the Rijksprentenkabinet, Amsterdam; the Museum of Fine Arts, Boston; the Art Institute of Chicago; the Musée Guimet, Paris; the James Michener Collections in the Honolulu Academy of Arts, Hawaii; the Victoria and Albert Museum, London.

A number of foreign curators and assistants and other experts have been of great assistance in furthering my research, and in particular I would like to thank Miss Margaret Gentles, of the Art Institute of Chicago; Mrs. Fritz Hart of Honolulu Academy of Arts, Hawaii; Mr. R. de Bruijn, of Wassenaar, Voorziller, of the Vereniging voor Japanse Grafiek en Kleinkunst; Mr. Robert T. Paine of the Museum of Fine Arts, Boston; and Mr. Karl Kup of the New York Public Library.

I should like also to record the help and encouragement I have received from such experts in their respective fields as Mr. Kiyoshi Shibui, Mdlle M. Densmore, Mr. B. W. Robinson and Dr. Richard Lane, the last-named specifically for the quotation at the head of Chapter I, and generally, for the light he has shed on the origins of Ukiyo-e through his studies of the literature of the 17th century.

Grateful acknowledgment is made to the Oriental Art Magazine Ltd. for permission to use part of an article of mine on Sugimura Jihei published in 'Oriental Art'; to Mrs. Cicely Binyon

and Messrs. Faber & Faber, Ltd., for permission to quote the passage in Chapter VIII from *Japanese Colour Prints*, by Binyon and Sexton; and to Mrs. L. V. Ledoux for permission to quote the passage in Chapter III from *Japanese Prints in the Ledoux Collection: Vol. 1, The Primitives.*

Contents

List of Illustrations

between pages

between pages

Preface

ONE of the great problems confronting anyone attempting to compress the subject of the Japanese print within the covers of one volume is the large number of artists of first rank, and the even larger number who perhaps only fail to come into the first category because of a limited output or a brief spell of activity. Many of the books that exist are general surveys of the 'Eleazar begat Phinehas, Phinehas begat Abishna' kind, wherein the too-easily-forgotten names follow one another in a bewildering train and issues of interest to the modern reader are lost in a welter of detail.

Although this book deals comprehensively with the Japanese print, tracing its development chronologically, giving due weight to technical as well as aesthetic considerations and assessing its place today in the light of modern tendencies in art, a new and rather oblique approach has been adopted.

It is sometimes possible to penetrate deeper into a subject, whether art or science, by following the career and achievements of a single man, by advancing on a narrow front rather than the wide one represented by a group or school. The biography of an individual is invariably more readable than the account of the movement of which he was part, and often throws light on cognate and side issues missed by the more direct beam of the general history.

And so it is by accounts of the work of a relatively small number of typical artists that I have tried to show something of the scope and achievement of the art of the Ukiyo woodblock print in Japan, by the example of the few rather than the catalogue of the whole.

The artists selected here to demonstrate the art represent a personal choice. The very great have been purposely omitted: they dominate the existing general histories, they are the subject

of numerous separate monographs. That is not to say that this is an anthology of minor artists. A few may qualify for that ambiguous description but the majority are masters of real character who have been overshadowed by more famous contemporaries. Several, too, have made a unique contribution to the art of the print in one way or another, and in bringing their work into prominence it is hoped to emphasise the diversity of the achievements of the Ukiyo-e school of artists.

Many of the illustrations are of prints that have not been reproduced before. That should give an additional interest to collectors and specialists.

Finally, it should perhaps be mentioned that in this book the term 'Japanese print' is used in the limited sense of the product of the Ukiyo-e school of artists. It is fully recognised that there are other forms, in the albums of what has been called the 'Classical School' of artists, in the prints depicting foreigners produced at Nagasaki and Yokohama, and in the broadsheets of the modernists such as Onchi and Munakata, but these groups necessarily form the subjects of separate studies.

Introductory

ART history is not concerned solely with the works of painters, sculptors and other creators: it is bound to be as much a history of taste, of the changing concept of what constitutes art, as it is of the works of art themselves. Each generation has its own sympathies for the art of past eras and rarely responds to the same stimuli as its predecessors. Changes in taste are complex in origin, and the art-historian needs to be versed in sociology and psychology as well as aesthetics to discover the causes beneath the changed bases for our admiration of the arts of certain periods or countries, and behind the reversals and promotions in estimation such as we ourselves have witnessed this century.

As European artists drew further away from the unedited naturalism that prevailed up to the 19th century, there was a seeking out of those forms of art in past ages that seemed to be in harmony with that trend, or to foreshadow it—pre-historic wall-paintings and *graffiti*, Negro sculpture, the textile designs of native tribes from Alaska to the Pelopennesians. Japanese prints were seized on by some of the modernist painters of the latter part of the 19th century—by such artists as Manet, Degas, Monet, van Gogh, Toulouse-Lautrec and Whistler—because they seemed to support these artists' tendencies, thought revolutionary by their academic contemporaries, to move away from the representation-alism that had petrified art during the 19th century. The print relied on arbitrary colour-schemes and a non-naturalistic woodcut outline; it was frankly two-dimensional; it adopted unusual viewpoints, above or below the eye-level; and because of its freedom, it achieved designs in line and colour that were beautiful or significant in themselves, independently of subject.

Nothing had occurred to change the Japanese print, which had been in existence for two hundred years. It obtained recognition

when it did because the new generation of painters and dilettanti found qualities in it that had had no meaning previously. It is true that Japanese prints did not arrive in Europe in any great numbers until well after the opening up of Japan to general foreign trade in the sixties of the last century, but examples *had* been brought back to Europe much earlier. There is, for instance, the evidence of the prints in the collection of Isaac Titsingh, who died in Paris in 1812 after having served as head of the Dutch settlement in Nagasaki. The inventories of his estate mention 'engravings printed in colours . . . in separate sheets, ten inches wide and one foot two inches nine lines in height, representing Japanese ladies in various dresses' which may well have been prints by Koryūsai, Kiyonaga and other artists active during Titsingh's tours of duty in Japan between 1779 and 1785. Thunberg, the Swedish naturalist, is also reported to have brought back examples of Japanese prints after his stay in the country during the year 1775-1776. But, significantly, these early arrivals appear to have made little or no impression on those who saw them: they represented an exotic and alien art no more likely to be understood then in Holland or Sweden than pre-Columbian sculpture would have been understood in Regency England. In the later era that took the art-teachings of Ruskin seriously and when 'truth to nature' was the guiding principle for any aspiring artist, the landscapes of Hokusai, Hiroshige and Eisen encountered by travellers to Japan were misjudged completely. In Captain Osborn's little travel book 'Japanese Fragments', published in 1861, the author wrote patronisingly of the Hiroshige prints he was reproducing (in vilely coloured lithography), 'Even the humble artists of the land become votaries of the beautiful, and in such efforts as the one annexed strive to do justice to the scenery. Their appreciation of the picturesque is far in advance, good souls, of their power of pencil, but our embryo Turner has striven hard to reproduce the combined effects of water, mountain, cloud and spray, touched by the bright beams of a rising sun.' The comparison with Turner shows how complete the misunderstanding was.

Thus it may be said that appreciation of Japanese prints in the West dates from the end of the 19th century not because they were

unknown before, but because it was not until changes had occurred in the western concept of the art of painting that the prints could be accepted as works of art rather than as objects of curiosity.

The acceptance by artists and dilettanti led to the formation of great collections of prints. Japan was ransacked for these once commonplace broadsheets and by about 1914 the source was practically exhausted. The collector is not always actuated by the best of motives, but he is at least responsible for gathering together material in sufficient bulk to enable historians and critics to carry out their work of classification, of demonstrating the trends of an art from period to period, of singling out the artists who were innovators or who typified the different styles. In France and America particularly, as the collections grew and the art of the colour-print could be grasped from the consecutive and logical arrangements imposed by Fenellosa, Hayashi and their successors, the impact of the print on artists and collectors alike grew stronger.

Contrary to the generally expressed view, it was the Nabi and Post-Impressionists, rather than the Impressionists, who were able to profit most from the example of the print. In the early stages, before the formation of collections had given opportunities for appreciating the immense disparities between period and period, and artist and artist, within the Ukiyo-e movement, *any* Japanese print had seemed sensational, even those of the latest 19th-century manufacture that since have been spurned. In Manet's portrait of Zola, the Japanese print on the wall of the artist's studio looks like a late Kunisada of a wrestler. In van Gogh's celebrated portrait of Père Tanguy, one of the first dealers in Japanese prints, a number of colour-prints are shown in the background, and apart from one or two landscapes by Hiroshige, they are garish figure prints of the last stages of the print's decadence. Toulouse-Lautrec was clearly better acquainted with the work of the great Japanese masters—Utamaro above all—and as time went on and the works of the classic period of the print became better known, artists profited more and more from the example of pattern and flat colour of the Japanese. The influence is not always so evident in

the paintings of later artists. It is quite obvious in such a painting as Whistler's 'Battersea Bridge', which echoes one of the 'One Hundred Views of Edo' of Hiroshige, but although such direct inspiration is not so apparent in the works of artists like Matisse, Denis, Vuillard, Bonnard and Rouault, the principles underlying the art of the Japanese print were by their time part of the accepted tradition of modern painting, had been absorbed, as Aztec, Mayan, Negro, prehistoric and Primitive art had been absorbed, in the common reservoir on which 20th-century artists now drew.

It has to be emphasised that it was the prints rather than the paintings of Japan that had this impact on western art. The Japanese themselves find this hard to understand. There, at least among the die-hard purists, the prints are still looked down upon as the product of a vulgar school of artists quite incapable of the lofty conception and the inspired brushwork of the painters acknowledged as classical. A typical 'classicist', Mr. Yukio Yashiro, in his book '2000 Years of Japanese Art', published in 1958, writes of Ukiyo prints: 'These prints have long been considered as trifles in Japan; in much the same way westerners would hardly treasure their picture-postcards.' It is incredible to us that anyone could belittle the masterpieces of Utamaro and Sharaku and a dozen other artists by such a comparison. That the prints of Hokusai and Utamaro should have had greater impact on western art than the paintings of Sesshū and Motonobu is as incomprehensible to such Japanese as it would be to us to learn that the printed caricatures of Gillray and Rowlandson were widely admired in Japan, whereas Turner and Constable were names hardly known at all. But the fact is, the subtleties of calligraphic brushwork and of ink-tone, and the poetic evocativeness of the paintings extolled by Japanese cognoscenti—however much we have come to admire such qualities now—had no influence on the course of European painting in the 19th century because they were out of harmony with the qualities then being sought by the *avant-garde* and because they offered no support to the European painters' aims. There were, it is true, certain Japanese painters whose works might have had—did have, to a

limited extent—as powerful an appeal as the Japanese print artists, but the wilfully patterned paintings of artists like Eitoku, Sōtatsu, Tōhaku and Kōrin, whose major works were in the form of six-fold screens, were practically unknown because inaccessible. The prints, on the other hand, circulated widely and could be seen in the collections of a number of amateurs like de Goncourt and Gonse, or dealers like Bing and Hayashi.

We cannot discount, either, as a factor in their popularity in the 'nineties, the discovery that the prints depicted the low-life of a licentious age, that a great part were pictures of courtesans, or catamite actors of a theatre that was despised by the cultured Japanese of the day. Europe was obsessed at the time with a sort of Cult of Decadence. The Parisian bohemians and their imitative London counterparts courted a *fin-de-siècle* reputation, went out of their way to locate the immoral and perverted where-ever and in whatsoever age it had appeared. There was in general a rather adolescent over-concern with the less savoury activities of mankind. In France, de Goncourt's study of Utamaro shows how much his interest was sustained by the knowledge that the artist found most of his models in the brothels (the '*Maison vertes*'). Given the greatness of Utamaro's prints on purely artistic grounds, the associations with the *demi-monde* of 18th-century Japan gave them a piquancy that clinched their appeal to de Goncourt and his contemporaries.

It is interesting to glance at the fluctuations in the reputation of the print since the days of their first acclaim in the West. To the general public, they have remained the usual, possibly the only, introduction to the pictorial art of the Far East. Both the print, and the literature of the print, are far more accessible than Far-Eastern paintings and *their* literature. Connoisseurs in the West have, however, over the years, tended to move towards the Japanese standpoint, relegating the prints to a subordinate place in the art of the country as compared with the paintings of the 'classical' schools of artists, whilst, paradoxically, many Japanese are now perfervid collectors and students of the prints. Prints which left the country as the worthless products of a school beneath serious consideration have for many years now been

returning home in triumph. This change in their reception in Japan is largely due to the westernisation of the country: slightly behind their European mentors, its artists have passed through the same phases of Impressionism, Post-Impressionism, Cubism, Fauvism and the rest, and in the process, the despised Ukiyo print has acquired new significance for them. As an aside, it may be said that there are other and subtler reasons for this belated granting of status to the Ukiyo print. The Japanese have been quick to realise the propaganda value of the arts, and the Ukiyo print has been fêted as an emigré who has brought honour to his country abroad. Among the Japanese militantly nationalistic so far as the fine arts are concerned, it is still regarded as an upstart, not to be brought into comparison with the aristocrats of the world of painting. It is usually the modern-minded and westward-looking Japanese that accepts the print as a serious work of art.

Where does the print stand in our estimation today? There is a tendency among those dedicated to modernist art at its extremest to dismiss it as a passing influence on western design, important for its effects but, like a catalyst which brings about chemical changes in other substances whilst remaining unaltered itself, of no importance now that its work is done. But although a form of art or a movement ceases in time to have any further influence on the trend of painting, that surely does not mean that it is to be relegated to the scrap-heap like a discarded catalyst. Such a policy would of course mean that the only art of any validity would be that of the latest age, and we would already be referring to Cézanne, Monet, van Gogh and Gauguin as figures in the emancipation of painting whose own paintings are no longer of importance. We ourselves can never know the force of the impact that Impressionism made upon the French people in the 'sixties and 'seventies of the last century, nor can we experience the startling effect of a Japanese print on the Impressionists and others at the same period: but both Impressionist paintings and Japanese prints continue to give us intense enjoyment and interest, and will do so, I imagine, for a very long time.

Indeed, the sudden spate of literature on the Japanese print

indicates that there is a greater general interest than ever before; the higher-than-ever prices in the sale-room testify to the competition that exists among collectors. A great many of the new enthusiasts are to be found among adventurous people (including publishers) who begin to look beyond the frontiers of European art, an area where practically everything is adequately charted, documented and illustrated; and among those who have been led to the print in their study of the evolution of western painting, or the wider study of painting as a human activity. The war caused a hiatus in which few turned their attention to Japanese art, and nothing was published. Now there is this new flood of interest, but it is the interest of a new generation, for whom a great deal of the old literature has lost its validity. The Japanese print is no longer the province of the collector merely: nor can the student and writer remain any longer isolationist, but must be conscious all the time of those countries which, in the arbitrary geography of the arts, impinge upon its boundaries.

CHAPTER I

———— o ————

The Evolution of the Ukiyo-e School
and of the Japanese Print

'living only for the moment, turning our full attention to the pleasures of the moon, the snow, the cherry-blossoms and the maple-leaves, singing songs, drinking wine and diverting ourselves just in floating, floating, caring not a whit for the pauperism staring us in the face, refusing to be disheartened, like a gourd floating along with the river current: this is what we call ukiyo. . . .'[1]

THESE words, the first real testament of *Ukiyo*, 'The Floating World', appeared in a book called 'Tales of the Floating World' written by Asai Ryoi and published in 1661. Already, at this date, a new hedonistic attitude of the Japanese people towards life was sufficiently recognised for it to have crystallised into what almost amounts to a manifesto. Just at this time, too, the first book illustrations that fully qualify for the term *Ukiyo-e* ('Pictures of the Floating World') made their appearance. In Ryoi's definition, the old Buddhistic connotations of the two characters *Uki* (to float) and *yo* (world), are parodied in a way typical of the worldly authors of the *Ukiyo-zoshi* ('Floating World Story Booklets') and the artists of the Ukiyo prints. Originally the word had implied the transience of earthly things, the insecurity of our mortal life, but there is none of this pessimism in Ryoi, Moronobu or their fellows. Just how far the Ukiyo-e style was influenced by the artists' association with the free-thinkers whose books they illustrated is a matter for conjecture.

[1] Translated by Richard Lane: 'The Beginnings of the Modern Japanese Novel: *Kana-zōshi*, 1600-1682', Harvard Journal of Asiatic Studies, Vol. 20, pp. 671-2.

The formation of that style was a long and complex process that began as long ago as the latter part of the 16th century.

It is always difficult to trace the origins of art movements. Even of the beginnings of so recent and distinct a movement as the Pre-Raphaelite, no two accounts coincide. Throughout their long history, the Japanese have had little time for art-history as we conceive it, and have generally preferred legend to fact. To account for the emergence of the Ukiyo-e style of painting they propounded a number of theories, none of them any longer tenable, which in the absence of contrary evidence, became accepted as facts, by Japanese and foreigner alike. The Ukiyo-e style of painting, in these accounts, appears in the 17th century, suddenly and without cause, as if by some mysterious abiogenesis. An artist named Iwasa Matabei was chosen as the founder of the school, though only an extremely small number of paintings are accepted as his work nowadays, and none of these are in the Ukiyo-e style. Another old notion—still repeated by quite serious students even in this present decade—is that a forerunner of the Japanese prints was the *Ōtsu-e*,[1] notwithstanding the fact that these were, in the 17th century at least, popular Buddhistic hand-painted sheets, quite unconnected with Ukiyo, either in spirit or technique.

Today, when an acquaintance with the literature of the early Tokugawa period has become possible, and when a chronological study can be made, from the originals and reproductions, of paintings and book illustrations from the late 16th century until the crucial years of the sixties of the next century, we realise that the Ukiyo style of painting and the cast of its subject matter were the outcome of a gradual evolutionary process, linked with the great social changes that occurred at the time.

Principal among these changes, from the point of view of our subject, was the emergence of a new class of literate commoner. Japan had been for centuries a battle-ground where one great clan strove for supremacy over its rivals, the prize being the dictator-ship of the country under the title of Shōgun or Generalissimo.

[1] So called from the village of Ōtsu, on the main road between Kyōto and Edo, the Tokaidō, where they were sold.

The hereditary Emperor still reigned, on sufferance, but the effective control of the country devolved on the Shōgun. The effect of interminable internecine wars on the economy of the country and the standard of living of the people was disastrous. Early in the 17th century, however, the Tokugawa family emerged triumphant, and despite minor uprisings, was able to impose its will upon the country until the Restoration of the Emperor in 1868. Under the imposed peace, through the development of agriculture, industry and commerce, there was a widespread improvement in the standard of living, an increase in the population and the creation of a class of people—merchants, tradesmen, artisans and the like—that for the first time had the leisure and the opportunities of culture hitherto confined to a small aristocratic or martially powerful minority.

The conversion of an economy based on rice as a means of exchange to one in which money became the medium had a profound effect on the distribution of wealth and resulted ultimately in a levelling of the social distinctions, the townsmen or *chōnin* not merely amassing fortunes whilst the *samurai* class became impoverished, but buying their way into the aristocratic families, an advancement made possible by the system of adoption into such families (at a premium) allowed by the custom of the country.

The fruits of the peace did not come to the people at once, probably a period had to elapse before they could learn to enjoy them. But when the time came, developments had already taken place in the established forms of literature and painting that made the transition to books and pictures for the People, of a calibre that is, that appealed to the plebeian mind, only a further step along a road already partially marked out. Moronobu, the first truly Ukiyo-e artist whose name has been preserved, did not create the Ukiyo-e style of painting, he simply fixed a canon that had been slowly formulating for the best part of a century.

Reduced to the broadest generalisation, the history of Japanese painting resolves itself up to the time of full contact with the West into the fluctuations in a contest for supremacy between, on the one hand, the influence of China, and, on the other, the styles of

indigenous growth. Changes of a far-reaching effect on the
future of Japanese painting as a whole took place in the latter half
of the 16th century. At this time, the line between the two
schools representing the opposing tendencies, the Kanō School,
the Chinese, and the Tosa School, the native, lost its hard defini-
tion. Whereas before an artist brought up in either school
jealously refused to have anything to do with any style other than
that of the school to which he was affiliated, now there was a
tendency for an interplay to be allowed and some of the out-
standing Kanō artists were capable practitioners in the rival
manner. A new generation of warlords in power at the time,
with a taste for building castles and decorating them in a lavish
fashion, assisted by their patronage the production of magnificent
screens and *fusuma* (sliding panels dividing rooms). They were
painted in a broadly decorative style by Eitoku, Sanraku, Yūshō,
Tōhaku and other major artists who although Kanō trained, drew
upon the specifically Japanese elements in the mediaeval Yamato-e
scrolls, enlarged on the purely decorative mannerisms of the early
paintings, and evolved a stylised non-naturalistic form of painting
more impressive to us, possibly, than anything else in the whole
range of Japanese art. The screens are painted in strong colour,
often upon gold grounds, and thick bounding lines give emphasis
to the studied patterning of the designs. They expressed a new
freedom from the restraints formerly implicitly imposed by the
allegiance to the academic school inspired by China. Other
departures followed. Instead of the stock traditional subjects of
legendary sages, incidents from the classics and symbolic animals
and flowers, the contemporary scene began to engage the attention
of artists, and in the then capital of Kyōto, a kind of genre painting
was evolved quite unprecedented in the annals of the country's
art, though the seeds can again be traced back to the old Yamato-e
scrolls.

The earliest of the paintings that are thought of as distinctly
foreshadowing Ukiyo-e is the screen of a Maple viewing party at
Takao, painted by Hideyori about 1565-1570. Another famous
picture is of the Hideyoshi Festival in 1606, depicting a multitude
of people at the shrine of the great leader. Screens known as

Namban, depicting foreigners aboard ship or visiting ports, and others recording sporting events, especially horse-racing, also became popular. Most of these screens must have been painted for the ruling and official classes before the commencement of the Tokugawa régime in 1615. Just before that date, or soon after, screens and scrolls were painted that show a far closer ancestral relationship to Ukiyo-e prints. The most remarkable of these is that known as the Hikone Screen, on which the unknown artist, though purporting to portray the traditional Chinese subject of the Four Accomplishments (Writing, Painting, Music and the game of *Gō*), used the occasion to introduce a party of extravagantly clothed and affectedly attitudinising fops and their consorts, with a sumptuousness of colour and a certain suggestion of *fin-de-siècle* already strongly Ukiyo in feeling. Another pair of screens, known from the family that originally owned them as the Matsuura Screens, comes even closer to the expressly Ukiyo painting of fifty years later. Pictures of the Kabuki or popular theatre, and of dancers, singly or in groups, were not only drawn and painted in a stylistic manner that began to separate itself from all others, but carry overtones of luxuriousness, of display and suspect pleasure-making, that bespeak the tastes of the *nouveaux riches* for whom they were painted.

These varied departures in painting, both in choice of subject and in adaptation of the old indigenous styles, hardly had the cohesion of a concerted movement, but represented the activities of artists of different schools, temperament and social milieu, centred mainly on Kyōto. Yet, in Edo, the newly-founded headquarters of the Tokugawa Shōgunate, soon after the middle of the century, a very definite kind of woodblock print was established with qualities observable in the earlier genre works alluded to above, but now presenting a unified style that earns the title of a School. What were the unifying factors, the forces which finally caused the elements of Ukiyo-e, implicit in the works of numerous disconnected artists, to fuse in this way?

Perhaps we should see them in the enormous demand in Edo from the 'sixties onwards for literature of the Ukiyo kind; in a consciousness among artists of the trend of the public towards the

pleasure-seeking so picturesquely summed up by Ryoi; in the growing practice of illustrating these books with woodblock prints; and in the genius of Moronobu, the most prolific and influential designer of book-illustrations. But in fact it was through the medium of the woodblock print that this Ukiyo art, so long in maturing, came to have its significance for *us*: the very limitations of the medium emphasised the impressive simplicity, the bold decorative patterning, the sinuous linear grace of the Ukiyo-e artist's designs. The availability and bulk of books and prints meant that we were able to see enough to draw our own conclusions—something we were not able to do until comparatively recent years in regard to paintings.

Woodcuts abound in Japanese books before the 1660's, but none make anything like the impact on us made by the Ukiyo-e prints after that date. It is not that the earlier cuts are unskilful. The woodcut was the traditional, indeed, the only, means of reproduction known to the Japanese, and it was used for pictorial work certainly as early as the 10th century, probably a lot earlier: several centuries, at any rate, before any woodcut appeared in Europe. But it never really attained to the status of an art in its own right. At first it was used to multiply crude devotional pictures designed by Buddhist priests. In the 12th century, woodblocks were used to print the outline of designs of a Yamato-e character on fans, the designs being then completed by hand-painting and the printed outline covered over.[1] By the 15th century, the block cutters had attained to a high degree of skill and the woodcuts after Tosa designs made to embellish certain Buddhistic scrolls were an outstanding achievement: but again, the outline was only printed as a basis for complete over-painting. Early in the 17th century, the first book-illustrations of any real artistic pretension appeared in the publications of Koetsu and Soan[2] but these are, at best, only careful translations of designs from the Tosa School which, at that period, was suffering from marked debility, and the prints, though decorative in the books

[1] Two such fans were shown at the Exhibition of Art Treasures from Japan at the Victoria and Albert Museum, 1958.

[2] Called, from their place of publication, *Saga-bon*, Saga books.

they adorn, look thin and meagre when detached from them. After a period of recession in the competency of the engravers subsequent to the *Saga-bon*, there was a sudden vastly increased output of illustrated books of every kind from say 1650 onwards, published to meet the immense demand of the public for books of poetry, legend, history and fiction of every possible kind. By the time the Ukiyo-e style had been perfected and Moronobu and then Sugimura Jihei had reached their full stature, the woodcut technique had been brought to a peak, and albums of the 'seventies and 'eighties represent a new level in the craft of book-production.

Of course, these woodcuts were not conceived primarily as woodcuts. There was, I think it may be conceded, a growing consciousness on the part of such artists as Moronobu and Jihei of the possibilities of the medium as a means of reproducing their drawings, and some regard for the technical considerations of the block-cutters, but it was still to them a means to an end: the woodcut as an artistic medium in its own right did not exist for them any more than it did for Dürer.

The woodcut in Japan, as in Europe until the time of Bewick, was a process of relief engraving, the design of the artist being made or pasted on to the 'plank' of the wood (that is, with the grain, not on the end-grain) and the block-cutter removing with cutting and gouging tools the surface of the wood around and between the lines and other areas of the design to be inked, thus leaving them in relief. Printing ink having been applied to the parts of the block left in relief, paper was laid over the inked surface, pressure applied and an impression taken. The artist never cut the blocks himself: it was a reproductive process in which his part was played when he had furnished the design.

It is only in comparatively recent years that there has been talk of the 'glyptic' qualities of a woodcut, and a move to exploit the especial possibilities of the medium to the full by insisting upon its 'woodiness', its potential for printing in flat ink thick lines and large unworked areas. Now, of course, an artist cuts his own blocks. In a number of prints after Moronobu and Jihei, these artists seem to have occasioned, even by chance, a perfect demonstration of the felicities peculiar to this type of relief woodcut,

in which an interplay of firm line and of shapes of black where the block is largely untouched produces a rich and thrilling arabesque. In paintings, even if they had been accessible, the Ukiyo style would never have impressed us half so powerfully as it does through the medium of the woodcut. The paintings are still firmly linked by their medium to the world of Far-Eastern painting: the woodcut is a medium we recognise as one we ourselves have used, a medium, moreover, that has become of more artistic significance in modern art than ever before.

The first Ukiyo-e prints, then, appeared as illustrations to books and a little later, in album form with a minimum of text, or none at all. The literature that Moronobu and his followers were called on to illustrate was of great variety. There were the old historical romances, based on the great civil wars and centring upon national heroes like Yoshitsune; love stories, especially of the more violent kind; legends and myths; guide and travel books, some of a fictional kind; and anthologies of poetry. Many of the books were written in the simplified script known as *Kana*, whereby the use of the difficult Chinese characters or ideographs was reduced to a minimum, and whence the books became known as *Kana-zoshi*, 'Booklets in *Kana*'. Soon after the middle of the 17th century, the hedonistic tendency noticeable in a proportion of the *kana-zoshi* became more pronounced. Richard Lane, perhaps the greatest western authority on this phase of Japanese literature has summed up the development in a paragraph: 'From the 1660s the *Kana*-booklet writers came increasingly to focus their attention upon that particular feature of Japanese cities, the highly developed demi-monde; and tales and anecdotes of the lives of the great courtesans and bourgeois gallants—who represented the literary ideal of the townsmen— appeared in great number. With this increasing focus of attention upon the actual life of the cities came a new feeling for realism, an increasing depiction of life as it was actually lived. A type of realistic novel or short story came to be known as *Ukiyo-zoshi*, "Booklets of the 'Floating World'".'[1]

[1] 'Saikaku and the Japanese Novel of Realism', *Japan Quarterly*, April-June 1957.

A great deal of this literature, we learn from those who have had the hardihood to translate it, is fustian stuff. It was often frivolous or farcical, sometimes scandalous, and not seldom frankly pornographic. With few exceptions, it is a fair summary to say that, so far at least as we in the West are concerned, the pictures are of immeasurably more artistic importance than the texts.

CHAPTER II

———— o ————

Sugimura Jihei:
The Earliest Broadsheets

IT is typical of the anonymity shrouding so much of the work
of the artists of this period that the very name of Sugimura
Jihei was practically unknown to the early chroniclers of
the Ukiyo-e print. Even so comprehensive a record as that
of Binyon and Sexton[1] omits him altogether. The great name
of the period, almost the only name to early investigators and
collectors (and hence to dealers, even if they knew otherwise), was
Moronobu, and anything produced during the period of his
activity, unless it were unequivocally signed, which was very
seldom, was automatically labelled with the name of Moronobu.
Now, however, a number of quite clear-cut personalities have
emerged from the shadows, of whom Jihei must be accounted of
most consequence.

One may well ask why so much effort is spent in splitting off
the work of minor from that of greater artists: in deciding which
Madonnas are by Leonardo, which by Luini; which etchings are
by Rembrandt, which Lievens; which colour-prints were designed
by Harunobu, which by his followers. Are not the lesser artists'
works just as enjoyable under whatever name we classify them?
Why should we be at pains to establish the identities, or the scope,
of these quite disinterested shades?—neither the masters nor those
confounded with them will benefit now. But until we have
made that segregation we do not know precisely what artistic
force may lie hidden. An artist's significance resides in the sum

[1] 'Japanese Colour Prints', by Laurence Binyon and J. J. O'Brien Sexton,
London, 1923.

total of his works and his final impression on us depends on those works being seen as a whole. In the process of his being detached from a group such as we have witnessed in the case of Jihei, the personality of an artist grows cumulatively, each new-found work setting up a resonance, an amplifying resonance, with others already known, so that the effect upon us of two prints now known to be by Jihei is intenser than that of the same two works when they belonged to the wider range of Moronobu. Isolated, their own unique properties are reinforced and make a deeper impact upon us. It is a matter, so to speak, of a more critical tuning producing a stronger signal. So it may be reasoned that whilst all the research and classification may not be profitable it does on occasion add to our quota of aesthetic pleasure, not merely by discovering new works, but by deepening the impression made upon us by existing works; not by simply resurrecting forgotten artists, but by actually creating artists who had no previous existence so far as we are concerned.

Sugimura Jihei is the perfect example of a lesser light being lost in the glare of a greater artist's reputation, a phenomenon not altogether uncommon in the annals of Ukiyo-e, as we shall discover. Until the appearance in 1926 and 1928 of Kiyoshi Shibui's 'Estampes Erotiques du Japon', two folios of superb reproductions of early Ukiyo-e prints mostly from erotic albums, Sugimura was little more than a name in the meagre Japanese biographies and miscellanies. Practically nothing is known of Jihei as a man. Two short passages purporting to be by him appear in books he illustrated. In a postscript to a book of 1684 'The Mirror of Old Japan in Modern Style'[1] he wrote: 'Although there are many picture-books circulating today, most of them fail to divorce themselves from out-dated styles. Thus, we have composed the present volume, and now publish it for the amusement of the public.' The other passage is even more unenlightening. It appears in the last dated book known to be Jihei's, published in 1697. 'One day,' wrote the artist, 'the publisher called upon me with this book and asked me to illustrate it. I did so as I could hardly refuse, but I am quite ashamed of my poor

[1] *Yamato fūryū e-kagami.*

illustrations.' These scraps are practically all the biographical material that exists, and no more is likely to come to light.

However, Mr. Shibui's research not only confirmed the existence of the artist, but also determined the period of his activity. A picture-book called *Raku asobi*, 'Pleasures of Ease', has the signature Sugimura Jihei and is dated 1681. A few other books are signed between this, the earliest dated, and the latest, mentioned above, dated 1697. Further, a number of album prints and broadsheets have the same name, or parts of it, woven into the dress patterns or some other part of the design; and others again are so stylistically similar that it has been impossible not to associate them with those already authenticated and to detach them from the Moronobu and Moronobu School *œuvre* to which they have been long ascribed. It is a significant fact that a number of the prints detected as Jihei's through the use of the characters of his name in the design were formerly acclaimed among the masterpieces of Moronobu. The works with the hidden signatures are sometimes of a type that he might well have hesitated to sign openly, but there are others that are quite inoffensive. At this period, a book or album artist was not expected to add his signature, as a painter did, to his work, and Jihei was merely claiming his own in a covert way.

Jihei's work for the book-publishers appeared in all the kinds of publication then current, *ehon*, more or less straightforward 'picture-books', *Ukiyo-zoshi*, 'Floating World Booklets', *Jōruri-bon*, a genre not much better than our 'penny-dreadful', and *Shunga* albums, that is albums of 'Spring Drawings', the euphemistic term used for erotic pictures. None of these would constitute literature of an elevating kind and they fully represent the taste of the day.

The majority of the books and albums were produced at a time when Moronobu was in his prime (he died in 1694). It was inevitable that Jihei should have come under his influence, as pervasive in the last decades of the 17th century as Harunobu's in the 'sixties of the next century. In Jihei's prints there is something of the same bold rhythmic grouping of the figures, the lively and sometimes dramatic descriptiveness of the scenes, the unfaltering

line and the telling use of the possibilities of the woodblock for contrasting solid black mass with sinuous line, that one finds in the best of Moronobu's block-printed designs (Plate 1). But Jihei is far more than an imitator. Indeed, the frequency with which his prints have been reproduced as the *chefs-d'œuvre* of Moronobu has led some to conclude that he is, within his own limited field, a greater artist than his better known contemporary. Certainly, the more we know of his designs the more we appreciate his especial genius for spatial decoration. He has the faculty for producing an illusion of rich decorativeness with what is, when analysed, an unusual economy of means; and a disturbing power in conveying the clandestinity of assignations by curious effects of composition. In the *shunga*, the use of a screen, and the figure of an inquisitive servant-girl, are common, but when the straight lines of the screen are used to emphasise the voluptuous curves of the lovers' clothes and to offset with a sort of astringent chord the entwined, cloying themes of the figures, Jihei shows a real originality in what may be thought of as contrapuntal elements in composition. Plate 3 is one of the four sheets that are all that are now known of an erotic album of eleven or twelve sheets. It is a lovely example of the way Sugimura's ample curves and deliberate decoration can convey an impression of tender intimacy. The lovers are caught in an equivocal position—is she assisting him to rise, or is he encouraging her to lie down with him?—but the standing and the reclining figures allow the artist a complex arrangement of full-blown curves, emphasised by the wide, counter-flowing stripes of the girl's *kimono* and the white-on-black band of the man's. The sharp angles of the screen serve both to shelter the couple and to give the group a complete roundness.

One of the main reasons for Jihei's obscurity lies in the fact that a large proportion of his output was of an erotic character. Various attempts have been made to account for the prominence of pictures of this sort in the work of many Ukiyo-e artists, but I do not wish to dwell on this theme here, beyond suggesting that it is wrong to prejudge the issue from our western standpoint: to get the matter properly in perspective, it has to be realised that in

Japan physical love has never been the tabooed subject that it has been in the Christian West, and that Japanese men did not shy from the depiction of the bodily functions as we do. What is also interesting and little discussed is the artistic value of such prints when (or if) they can be disassociated from their subject matter. This is a feat we can perform rather more easily than our forbears, though even now there is a reluctance on the part of some writers to face up to the problem.

The fact is that the handicap of depicting the physical act with, as it were, a magnifying glass over the sexual organs was normally too much for most artists—the element of wilful grotesque overbalanced the designs completely. The erotic prints often suffer from the same drawbacks as our advertisement designs, the constraint upon the artist to sell something, to focus attention upon a particular commodity, leading to trick sensationalism, but rarely to fine art. Occasionally, the dithyrambic swirl of naked bodies achieves a meaning of its own as a composition outside its immediate aphrodisiac intent; in one or two of Jihei's albums there is a Matisse-like stylisation of the forms which are then no more erotic than the Odalisques of the French master, and as capable of being appreciated intellectually as any other abstraction; and even more rarely, as in some of Utamaro's prints in the 'Poem of the Pillow', his greatest erotic work, the tenderness and beauty of the act of love are feelingly expressed. Generally, however, the artist succumbed to the stock lines in lubricity and implausible acrobatics, in pictures that leave us quite cold, whatever their effect may have been upon those who bought them originally.

This is clearly exemplified in the *shunga* albums of Jihei, some prints of which preserve what is, at least for us, uninitiated in the mysteries of Japanese love-play, a normal decorum, or at worst, depict only the sly preliminaries to the scenes which ensue. In these prints, in which the figures are clothed, Jihei is at his greatest. The bold patterning of the dresses of the 'eighties was seized upon as a perfect motif for designs that were to be translated into woodcuts. He used the big conventionalised flowers, the geometrical patterns, circles, spots and bold stripes, and the *mon*

or crests, with all the certainty that Japanese artists habitually display in handling purely decorative motives, and with them balanced the black masses of the hair—noteworthy in any of this artist's prints, the 'coal-scuttle' and the 'helmet' shapes dominating the heads and providing the emphatic axis about which the rest of the design revolves.

In the more plainly erotic prints, we feel the loss of these patterned dresses with their sweeping folds subtly rocking, as with a slow tide, the *mon* and flowers and other dress decoration. The nudes fail comparatively as designs, and even the device of placing abstract decoration around the figures—decoration purporting to be on the rugs and coverlets the bodies lie on, but so arbitrarily placed as to be like a rococo framework to the scene—does not succeed in making up the deficiency. We realise how much of the art of the Ukiyo-e print designers depended upon their use of dress—a theme that will be developed later in this book.

Apart from his contributions to books and albums, Jihei is also responsible for some of the first separately issued prints, the broadsheets known as *Ichimai-e*, 'single-sheet pictures'. In museums and catalogues of exhibitions, these have invariably, until recently, been ascribed confidently to Moronobu. The 'Interior scene with *fusuma* marked with the characters for the Four Seasons' (Plate 4), is one of these, but is proved beyond doubt to be Jihei's by the bold characters on the gown of the girl seen through the opening. These prints have always been accepted as among the earliest examples of *ichimai-e*, and it begins to seem possible that Jihei, rather than anyone else, if not the first to design such prints, established himself as the principal producer of them.

No precise date can be fixed for the first appearance of such broadsheets. Pictures, in our sense of a framed permanent decoration of the walls of a room, are no part of the furniture of a Japanese house. Screens and *fusuma*, which might be said to contradict this view, were movable and in any case had a specific function, the pictures being only incidental decoration. The *kakemono*, the vertical scroll, was the normal form for a painting,

and it was unrolled and hung only when its owner so desired: except at such times, it was kept stored in a wooden box. It is unlikely that the humbler classes, until the Tokugawa era, possessed such a thing as a hanging picture, save perhaps one of the cheap devotional prints distributed by Buddhist priests, but from about 1680 onwards, there is evidence of the production of large prints whose purpose, it seems clear, was to serve as 'poor man's paintings'. Some have survived with their mountings intact, others bear tell-tale fold marks due to their having been rolled for storage. The clientèle for whom they were prepared was the same as that for whom the Ukiyo books were published, a little better off perhaps, but with the same tastes. Many of the prints, like that reproduced in Plate 4, are like enlarged book-illustrations, semi-narrative in style and full of incident. Others represent a new departure: the portraits of the reigning beauties of the *demi-monde*. It is true that books were by then appearing called *Yūjo hyobanki*, 'Courtesan Critiques', which gave catalogues of the prostitutes in the licensed quarters, brief descriptions of their looks, accomplishments and character, but the prints in such books are a world apart from the imposing figures printed on separate sheets from large blocks some 22 inches by 12. The earliest extant print of this size is actually of a young dandy or *wakashu*, and may be as early as 1675,[1] but this is an isolated phenomenon. The next in point of time are several unsigned sheets that on stylistic grounds must be from Jihei's designs, and in fact the print reproduced (Plate 2), has the characters *Sugimura* worked into the collar of the garment. These prints are the first of a type, of stately standing beauties, normally associated in its earliest phases with Kiyonobu and Kiyomasu, and slightly later, with the Kaigetsudō group of artists. Plate 2 is a superb example. Judging by the hair-style and the patterning of the *kimono*, a date not later than 1687 is likely, a decade or more earlier than the *kakemono-e* prints of Kiyonobu and Kiyomasu. Jihei's print is hand-coloured, the colouring having been added at the time of issue and almost entirely obscuring the printed line. The manner in which the colour was applied

[1] In the Museum of Fine Arts, Boston.

varied, and it is unusual to find so early a print entirely over-painted. More often, the colour consisted of arbitrary and decorative touches of strong *tan*, a red lead pigment, from which the prints later become known as *tan-e*, 'red-lead pictures'. As time went on, colouring generally became more elaborate, with the intention, no doubt, of furthering the resemblance to a brush-drawn painting. To the purist, the colouring often comes as a shock, and only seems to detract from the splendid and stark strength of the woodcut line; but the purist looks at them from a viewpoint that has been reached after nearly three hundred years of change in art and with a conception of the woodcut in mind that was unimaginable in the past, either in Japan or elsewhere.

Such prints were not conceived as woodcuts, but as paraphrases, if not reproductions, of the artists' brush-drawings. The block-cutter gave due weight to the idiosyncrasies of the brush-drawn lines, even exaggerated them, emphasising by the very definite-ness of the woodcut line the point of impact of brush to paper, the thickening of the stroke under pressure, the slur where it described a curve, the tapering where the brush left the paper. A woodcut today is conceived in 'glyptic' terms, the artist has in mind the possibilities of the wood as a medium of his art, and avoids at all costs giving the appearance of reproducing brush or pen line. The woodcut must first and foremost proclaim itself as a woodcut, or it fails. Yet the Japanese woodcut of the early phase, for all it may reproduce the brush-drawn design, is nearer our own modern conception of the role of the woodcut than the prints of any succeeding period. By chance, the large *kakemono-e* prints of Jihei, Kiyonobu, Kiyomasu, Kaigetsudō and Okumura Masanobu have certain of the very qualities that are currently acclaimed. The single figure is posed commandingly on the paper, there is little or no background detail to cause distraction, everything depends on the robed figure, the rhythmic disposition of the heavy draperies, the arabesque tightly enclosed in lines that vary in thickness, but which one never finds thin or insignificant. The large patterns of the brocade at this period, too, aided the artist in giving the impression of broadness, of a *nobilemente* mood. Thick bounding lines have become a feature in modern oil

painting. In van Gogh and Rouault, for example, coarse black outlines not only mark the artists' determination to break with naturalism, but also give a tensile strength to their compositions which seem to be held together by the power of the exterior lines. The bold woodcut line in these large prints can be thought of as serving a similar function.

Whatever the cause, there is something singularly impressive to us in all these large early outline cuts of courtesans and Jihei's are marked by the same distinguishing traits that single out his album prints from those of his contemporaries—the cast of feature, the narrow expressive eyes, the almost abstract patterning achieved by dress fold and brocade design: traits, though, that it is as hard to isolate in words as it would be to maintain the beat of a painter's heart outside his body: they only exist as part of the living whole.

I say 'impressive to us', since I can speak only for the appreciation of the last few decades. Nobody knows just what effect these prints had upon the Japanese of the 17th century: no contemporary recorded his impressions of them, and judging by the smallness of the number that have survived, it is unlikely that they were ever published in large editions. And if they had been known to western connoisseurs of even a century ago, one doubts whether they would have had the significance for them that they have for us today. Perhaps it needed an era in which artists like Toulouse-Lautrec, Beardsley, Rouault, and Matisse have flourished to transform what was a popular iconography of the bordello into fine art.

CHAPTER III

─────── ○ ───────

Torii Kiyomasu:
The Kabuki Theatre and the Ukiyo Print

GENROKU is the name of the period extending from 1688 to 1703, and it has come to stand for the culture which expanded and came to ripeness during those years and immediately after. It was marked by the continued rise of the townsmen, *chōnin*, to positions of wealth and power, and the flourishing of the arts enjoying their patronage. Despite successive repressive edicts of the Tokugawa government, the Bakufu, which looked on any change in the social hierarchy as potentially subversive to their régime, the lower orders, that is, the people below the level of the *samurai*, indulged in an unprecedented luxury of living, dress, amusement and vice, and their tastes are reflected in the licence of the literature, the extravagance of dress, and the popularity of the playhouse and brothel. The prints of the period fully illustrate all these tendencies of the age, and are marked by an exuberance and a voluptuousness never quite repeated afterwards.

The activities of Moronobu and Jihei did not extend to the end of the Genroku period (Moronobu died in 1694 and Jihei's last dated work is 1697), but their influence is clearly marked on the next generation of artists, who can be looked on as the children of Genroku. They include such direct descendants or followers of Moronobu as Moroshige and Morofusa, but foremost among them in stature are the first artists to bear the names of Kiyonobu and Kiyomasu.

With these two artists we encounter one of the recurring problems in the study of Ukiyo-e prints: the family tradition, the

27

handing down from father to son (or more often, adopted son), of a style of drawing, a range of subject matter, and a name. The idea that a talent for drawing could be inherited or passed on like an heirloom is against all our notions of an artist's apartness, of his unique, incommunicable gift. In the West, the pupil served his apprenticeship in a master's studio to learn the technique whereby he could express himself through the medium of painting: he was only adjudged artist if he developed in such a way as eventually to produce work immediately distinguishable from that of the master's. Among the Ukiyo-e artists, and Japanese artists generally for that matter, full stature was only achieved by a pupil when he could produce work indistinguishable from the master's.

The truth is, the artists of the Ukiyo-e line, especially in the early days of the print, were accounted by the publishers as little more than craftsmen. The publishers were, from the first, a decisive factor in the world of book and print production, and nobody who has read that masterly study of the relationship between publisher, designer, block-cutter and printer in 'Ukiyo-e Quartet' by Mr. T. Volker, can be in any doubt as to the business-like character of their undertakings. About the Ukiyo-e artists of that time there was little of that aura of divine inspiration with which we in the West have tended to invest the artist: he was one stage in the production line and knew exactly what was required of him. A pupil served a long apprenticeship to acquire the skill to turn out designs with the same facility, and the same appearance, as those of his successful master, just as the apprentice lacquerer or furniture maker was expected to produce work identical to that of *his* master. That the artists were conscious, none the less, of their own individuality, however stereotyped the products they were obliged to design, and that they still tried to project their own personality through them, is borne out by the practice of signing their prints, which, covertly at first in Jihei's case, was openly followed from Kiyonobu's time onwards. But the system of imitation enjoined on the members of a sub-school, such as that of the Torii family to which Kiyonobu and Kiyomasu belonged, meant that mannerisms in drawing the face, the scale

of the figure and the brief touches of landscape were common to a number of contemporary artists, and give their prints at least superficial resemblance. The differences between the work of artist and artist, especially artists so closely connected as Kiyonobu and Kiyomasu, are as much those of temperament as ability and are detected by psychological deductions as much as stylistic.

The problems of identification are complicated, in the absence of any reliable documentation, by the changes that occur in an artist's work over a lengthy period of activity. The classic example is Hokusai (1760-1849) since he had a working life of something like seventy years, and not only was the social world he depicted in his old age utterly changed from that of his youth, but a progressive movement away from the Ukiyo-e style of his earlier period led him eventually to a manner that had little relationship to Ukiyo-e at all. But he is an extreme example. Another who might be instanced is Toyonobu (1711-1785). As a young man, under the name of Shigenobu, he produced hand-coloured prints that are of average merit but which simply do not prepare us for the poetic creations he designed later under the name of Toyonobu. Although, therefore, there is a world of difference in talent, style and technique between prints signed Kiyomasu datable between 1700 and 1715 and those of the years 1725 onwards, this was not of itself a sufficient cause to predicate the existence of two separate artists. However, the tangle of the family records, such as remain, slowly and sometimes not altogether convincingly unravelled by Japanese scholars, has yielded several artists using the names Kiyonobu and Kiyomasu. The great American collector Ledoux summarised the findings up to 1942 in his catalogue of the 'Primitives' of his collection, as follows:

'It is believed that Kiyomasu I was the eldest son of Kiyonobu I, that he was very precocious and died when he was only 22 years of age on July 3, 1716. Shortly after that date someone, probably a younger brother who was born in 1702, began issuing prints under the Kiyomasu name and continued to use this appellation until the retirement in 1727 or the death in 1729 of the first Kiyonobu, at which time the second Kiyomasu ceased to use that

name and became Torii Kiyonobu II. On this theory the prints
signed Kiyomasu which appeared between the end of 1716 and the
dates last mentioned, and those which bore the Kiyonobu name
from 1727 or 1729 until 1752, when the second Kiyonobu died,
are by the one artist.' It is only right to add that there is no
unanimity about the acceptance of this theory and something may
still come to light to disprove it. Indeed, illustrations signed
Torii Kiyomasu are known in a book first published in 1696,[1]
and if it can be proved that the artist illustrated the first edition,
the theories both as to the precocity of the artist and his relation-
ship to Kiyonobu will be at once undermined.

Another theory, far less tenable, is that Kiyonobu I and
Kiyomasu I are one and the same man, and not father and son.
This postulates an artist using two *gomei*, 'art-names', both based
on the same stem, Kiyo, at the same period, a procedure quite at
variance with normal practice, before and afterwards. An artist
was quite capable of using several different names simultaneously,
but he was never known so to use two names derived from the
same root. It is true that, to bedevil matters still further, at least
two prints are known signed Kiyonobu but sealed Kiyomasu, from
a period, too, before the decease of the first Kiyonobu, but I
would prefer to look on this as an example of collaboration
rather than be driven to accept the two signatures as those of a
single artist.

All this is mentioned, not to bewilder the reader, as it must do,
but to give him some idea of the problems that confront the art-
historian in regard to the Japanese print, with the interchange of
names, the near-identity of styles, and the lack of any useful
contemporary documentation. It would be easy to shrug such
considerations aside, but as we have seen in regard to Jihei, the
attempt to distinguish between artist and artist often proves
fruitful beyond the mere satisfaction of the pedant and the
collector.

The artist we are concerned with is the first of those using the
name Kiyomasu. Whatever the date of his birth, or the degree

[1] Torindo Chomaro's *Kōshoku tsuya komosō*. See R. Lane, 'Postwar Japanese
Studies of the Novelist Saikaku', *Harvard Journal of Asiatic Studies*, 1955.

of consanguinity to Kiyonobu I, he bears the same family art-name, Torii, and traces his descent, by birth or adoption, from an actor-artist called Torii Shoshichi Kiyomoto. Kiyomoto seems to have left Osaka for Edo, there to find employment as a painter of theatrical posters for one of the leading theatres. This connection with the theatre, originating in Kiyomoto, became a tradition in the Torii family of artists, was passed down through generation after generation, and had an enormous influence on their art.

The Kabuki theatre was, by Kiyomasu's time, firmly installed as the most popular entertainment of the pleasure-seeking Edo commoners. It is significant that this uniquely Japanese 'People's Theatre' originated at the same time as the genre paintings of the early 17th century, and that it catered for the same clientèle that had commissioned the paintings. The Kabuki theatre, in fact, bore the same sort of relationship to the classical Nō drama as Ukiyo painting did to classical Kanō and Tosa painting. There was an absorption of a great deal of the technique and stylisation of the ancient Nō drama, and of the dance movements on which Nō itself was based, but there was a move towards a greater realism than Nō permitted, an employment of scenes and situations from legend, history and everyday life that had a more immediate appeal to the audience than the poetical ritualism of the Nō.

But the Kabuki moved only so far in the direction of naturalism: it never developed into the representationalism of the western stage but remained a vehicle for spectacle in which the actor's performance was of greater importance than the play, and where the audience looked for the climactic moments, the tableau of a group, or the dramatic poses called *mie* struck by solo actors, with scarcely any interest in the continuity of the play or the working out of its plot. (This accounts for the otherwise, to us, inexplicable inattention of the audience to the performances of plays. People ate, made tea over braziers, carried on animated conversations, whilst the play proceeded, and only gave all eyes and ears to the 'set pieces', the supreme moments.)

It was natural that, from the first, paintings depicting Kabuki

should have been made by artists with leanings towards the new
style and that, as time went on and the Kabuki evolved its own
forms and style, the Ukiyo painting, and later the Ukiyo print,
should become the accredited pictorial record of the stage. It
was almost a case of an association of disreputables. Just as the
expression *Ukiyo* had its opprobrious overtones of meaning, so
Kabuki (though now written with three characters meaning 'song,
dance, skill') originally meant something out of the ordinary and
carried a suggestion of sexual impropriety. The theatre was a
constant source of anxiety to the Bakufu with its megalomania for
suppressing anything that might cause disruption of the existing
order. The plays themselves were rarely considered subversive,
but the players, with their astonishing popularity with the masses,
were. Until 1629, the plays were acted by troupes of women,
but in that year they were banned, ostensibly because of the
immorality of the women, though there were probably other,
political, reasons for the action. They were succeeded by 'long-
haired' young men who made themselves so seductive to the
samurai that in 1652 they too were banned. When the theatres
were permitted to reopen, the actors were obliged to shave off
their forelocks to reduce their physical attractiveness, and until the
use of wigs in the next century, actors impersonating women
were obliged to use a fold of cloth to cover the shaved heads.
From 1629, when women were banned the theatre, all female
roles were played by male actors, called *onna-gata*.

The theatre had an immense following and soon had its own
literature to satisfy the public's craving for information about
the actors, who were fêted in the way that film-stars and 'pop'-
singers are fêted in our own society. 'Actor critiques' (*yarō
hyōbanki*) served the same purpose for the stage as the 'Courtesan
critiques' did for the brothels, and in time, woodcut portraits of
the actors, identifiable by the *mon* or crest all wore on their
person, began to appear both in books and in the form of separate
sheets.

Kiyonobu and Kiyomasu set a style, and a standard, in these
representations of actors which became almost traditional, and
certainly can be detected as an influence right to the end of the

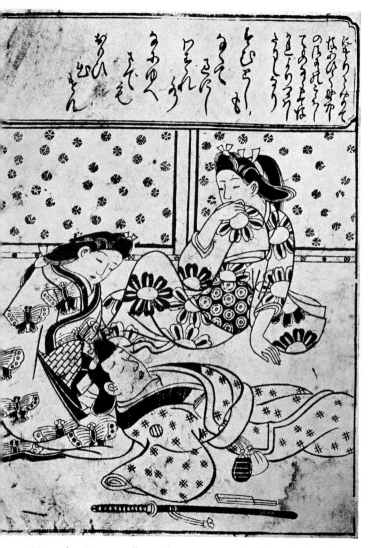

1. Moronobu: A young gallant with two courtesans. An illustration from the book *Ehon koi no minakami*, 1682. 10″ × 6¾″. *Author's collection*

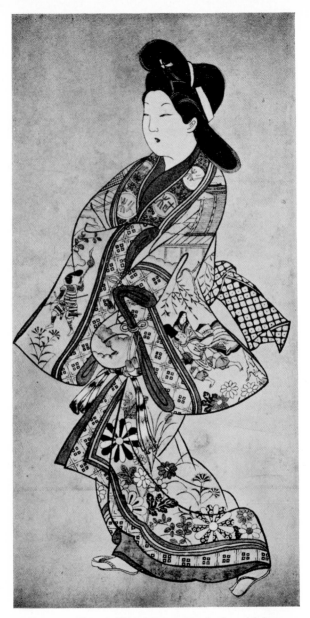

2. Sugimura Jihei: Strolling Woman. Hand-coloured *kakemono-e*
$22\frac{1}{2}'' \times 11\frac{1}{8}''$. *The Art Institute of Chicago*

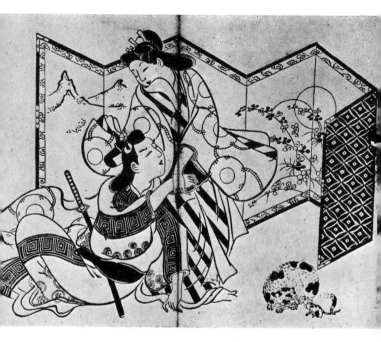

3. Sugimura Jihei: Lovers in front of a screen. From an album
$10\frac{1}{8}'' \times 15\frac{1}{2}''$. *R. Harari Collection*

4. Sugimura Jihei: A young nobleman visiting a lady of rank. *Musée Guimet*

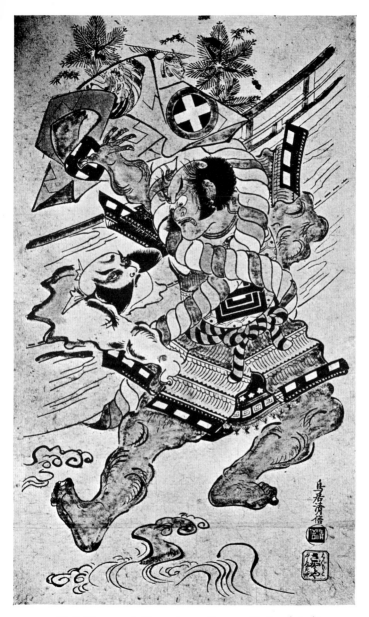

5. Torii Kiyomasu I: Two actors as Soga no Gorō and Asahina
Hand-coloured *kakemono-e*. 20⅞″ × 12½″. *British Museum*

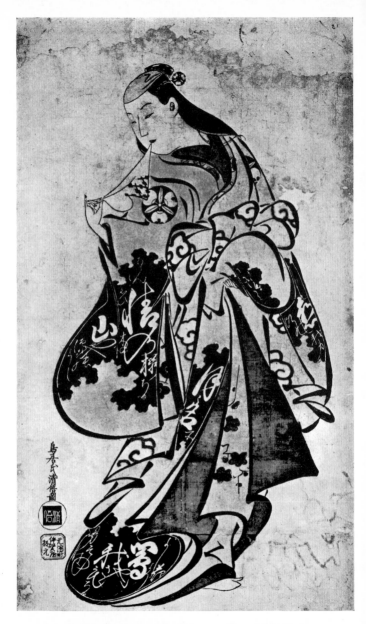

6. Torii Kiyomasu I: The actor Tsutsui Kichijūrō
Hand-coloured *kakemono-e*. 21½″ × 12½″. *The Art Institute of Chicago*

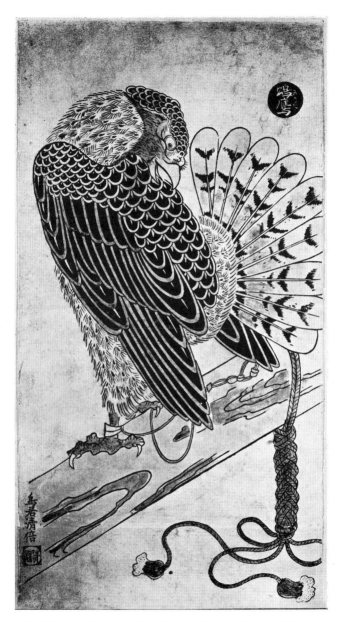

7. Torii Kiyomasu I: Falcon tethered to a perch. Hand-coloured *kakemono-e* 21⅝″ × 11¼″. *The Art Institute of Chicago*

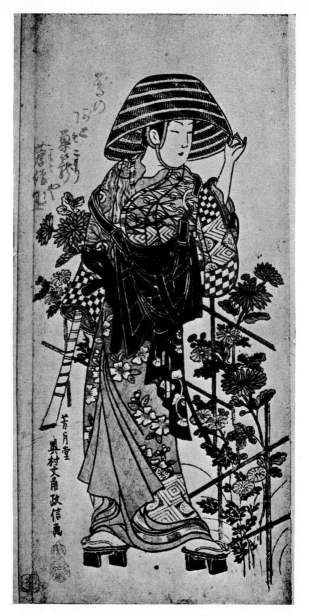

8. Okumura Masanobu: A *komusō* (strolling flute-player who by virtue of the basket-hat travels *incognito*). Centre section of a triptych *Beni-zuri-e.* 11½″ × 6½″. *British Museum*

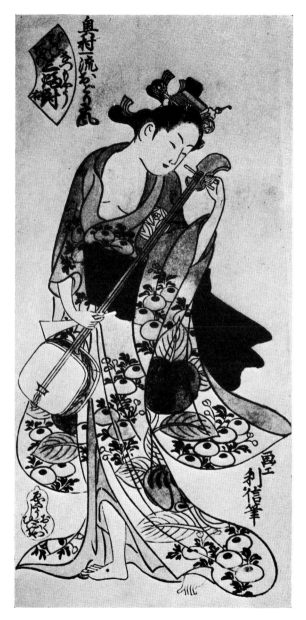

9. Okumura Toshinobu: The First-Class Okumura Danseuse
Hand-coloured lacquer print. 12½″ × 6½″. *Michel Massey Collection*

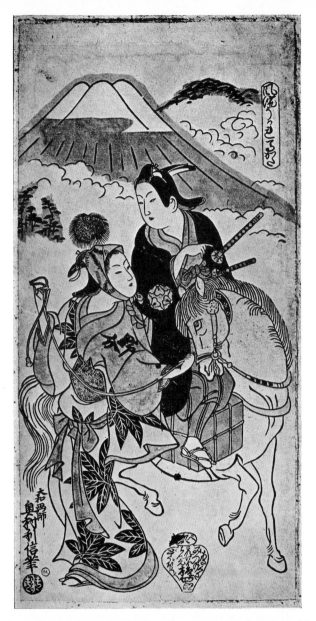

10. Okumura Toshinobu: 'Fashionable captivating pack-horse guide'
Hand-coloured lacquer print. 12¼″ × 6¼″. *Victoria and Albert Museum*

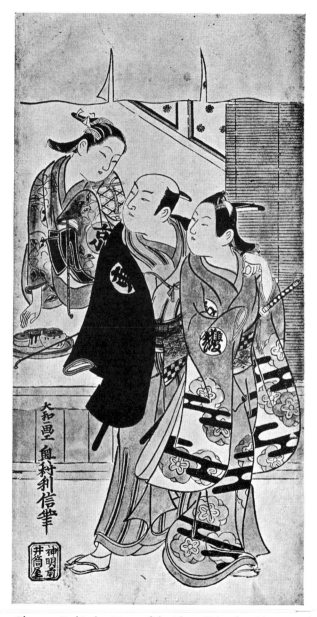

11. Okumura Toshinobu: Types of the Three Cities, the girl representing Kyōto, the man Edo and the boy Ōsaka. Hand-coloured lacquer print $12\frac{1}{4}'' \times 6\frac{1}{4}''$. *British Museum*

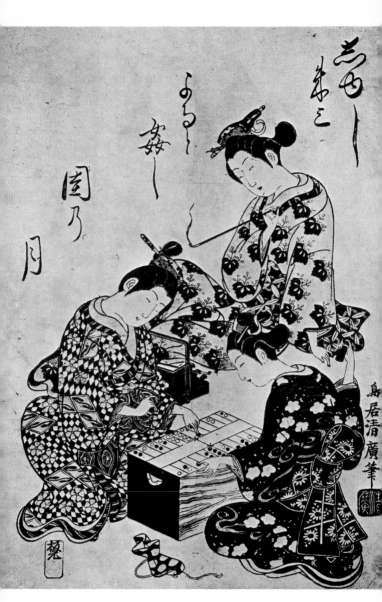

12. Torii Kiyohiro: The Sugeroku Players
Beni-zuri-e. 17″ × 12″. *British Museum*

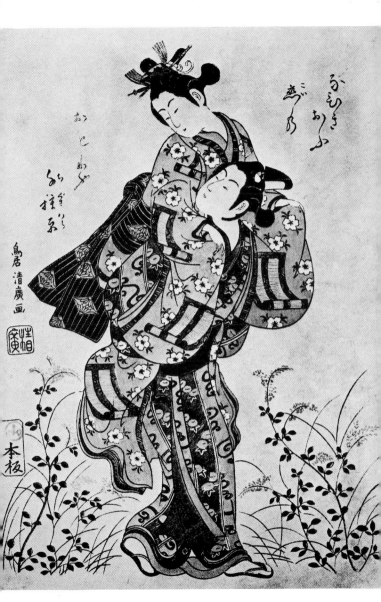

13. Torii Kiyohiro: The Elopement
Beni-zuri-e. 15½″ × 11⅜″. *The Chester Beatty Library*

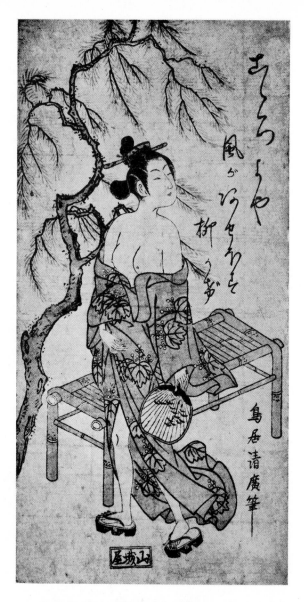

14. Torii Kiyohiro: Girl beneath willow-tree in the wind
Beni-zuri-e. 12″ × 5½″. *Musée Guimet*

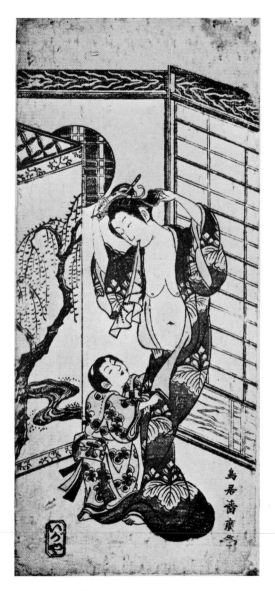

15. Torii Kiyohiro: Child playing with its mother who is in a loose bath-wrap. *Beni-zuri-e*. 12″ × 5½″. *Musée Guimet*

16. Nishikawa Sukenobu: The Frontispiece to Vol. 1 of 'Calligraphic Instruction for Ladies', n.d. 9″×6½″. *Author's collection*

19th century when the Ukiyo print virtually died. Their actor prints have been laid under a charge of non-naturalness, but quite apart from the normal style of a Ukiyo artist, who never so far forsook his oriental tradition to attempt to draw things merely 'as they seem', the artists invariably depicted actors in the contorted and forced attitudes of the *mie*, when a gesture and a grimace were intended to carry a world of meaning to the initiated audience. Kabuki came to have a powerful influence on the trend of print design generally and quite often the artists, even in straightforward genre scenes, seem to be remembering the Kabuki stage with its simple scenery and few props, and focus the whole attention on the pose, the mien, of the figure or group.

Kiyonobu I and Kiyomasu I, it becomes increasingly clear, were practically contemporaries, whatever their blood-relationship, and it is stimulating to compare their different interpretations of actors on the stage. Kiyonobu had a gift for conveying the fiery, impetuous movements, the passages called *aragato*, 'rough stuff', and adopted a mighty, swirling line to bring home the frenzy of such episodes. Kiyomasu, though not incapable (as Plate 5 shows) of handling the 'rough-stuff' convincingly, is at his best in illustrating the more reposeful moments, uses a quieter sweep of the brush, and portrays perfectly the opposite mood to *aragoto*, the *nukegoto*, literally 'tear-business', which we would probably call 'sob-stuff'. The print reproduced (Plate 6) is a lovely example of this. It is in the large format called *kakemono-e* already referred to in Chapter II, and has been hand-coloured in *tan*, buff and lilac. The actor Tsutsui is portraying a courtesan who, by her act of pulling at one end of the strip of cloth called a *tenugui* whilst holding the other end between her teeth, signifies that she is trying to hold back her tears—the action was a stage convention, a mime, for a maiden's restraint in distress. The dress is built up by powerful strokes such as were used on the *kamban*, the hoardings advertising plays, and the woodcutter has lost none of the sweep and swirl of Kiyomasu's line. The decoration of the *kimono*, calligraphy in white reserve on black cloud-forms, was a favourite dress-design at this time (about 1715) and gives a skipping liveliness to the interplay between fold and fold of

D

the heavy garment. The composition relies solely on the figure of the actor: there are no accessories, it stands like a statue isolated from its background, the pose is simple and only meaningful to those familiar with the conventions of Kabuki mime. Yet it is, even to us, a pose of astonishing eloquence. It would hardly add one iota to our enjoyment to know what part the actor was playing or in what play, and yet although the elements of an abstract design are there, it is far more than merely that.

Even more calligraphic in line is a print of a woman carrying a child.[1] She is amusing the child with a 'sparkler'—the Japanese were inordinately fond of fireworks—the occasion being a Festival in Sakai Street. For all the appearance of impetuous bravura, the brush-strokes were drawn with the calculation and sureness that came of a long training, a virtuoso's handling of his instrument. The big pattern of bamboo and plum-blossom is used as a foil to the whirling line and provides an effective contrast of flat pattern to the full-blown contours of the *kimono*.

The details in some of these large prints, if inspected with an eye for naturalism, are often 'incorrect'—the hands are too small, the fingers dislocated; the children, as in the example just referred to, are simply smaller versions of adults. The early masters of the Japanese print are usually referred to as 'Primitives', though nowadays that is considered a misnomer, more appropriate to the woodcut medium than to the artists' designs; but there is a curious parallel, in these out-of-scale children, to paintings of the Italian 'Primitives'. We should not, however, look for accurate naturalistic detail in these prints but allow ourselves to be carried away by the sweep and gusto of the great lines: lines which create their own world of reality, and so dispose of quibbles concerning the creatures that inhabit it.

Apart from his actor and courtesan prints, Kiyomasu is also known for a series of prints, in the *kakemono-e* format, of falcons. No broadsheets of this kind had appeared before and it is one of the distinctions of Kiyomasu, among his contemporaries, that he

[1] An impression is in the Art Institute of Chicago and is reproduced in the catalogue of the 'Primitives' in the Clarence Buckingham collection there, published 1955.

should have been the designer of them. Falconry was a pursuit of the nobility in Japan, and as in Europe, there was a body of literature on catching and training falcons and on the art of fowling with them. The painting of falcons was in the repertoire of a number of Kanō painters attached to the great houses. Was there, among the merchants and artisans who purchased the actor and courtesan prints, a desire to emulate their betters and to have prints of falcons to give an aristocratic air to their rooms? (Plate 7.) Whatever the cause, Kiyomasu supplied the drawings, and copied them from a book called *Nigori kobushi* ('The Clenched Fist'—the gloved hand symbol of the falconer), published in 1687. The artist responsible for the illustrations to this book is not known (it has wrongly been assumed, from the resemblance of Kiyomasu's prints, that he was the artist), but he was no doubt of the Kanō School. The larger scale and the brilliant touches of *tan* and yellow make Kiyomasu's prints something altogether different from the cuts in the 1687 book, and they were the forerunners of many other prints of birds and flowers by Ukiyo-e artists, some of which will be discussed in the chapter on Koryūsai.

CHAPTER IV

○

Okumura Toshinobu:
The Lacquer Print

FOR a long time after the turn of the 17th century there were practically no technical developments in the production of the woodblock print. There was rather more elaborate hand-painting, other colours were added to the *tan* used at first, and the large print gave way to one of much smaller size called a 'narrow-picture', *hoso-e*, at this period usually about 13 inches by $6\frac{1}{2}$, but nothing occurred to change the character of the process.

About 1720, the first lacquer prints appeared. In addition to the normal hand-colouring, areas of the print—the sash, the *kimono*, or some other garment—were printed with a black varnish-like ink that took a high gloss; other parts were coated with glue and dusted over with metallic powder. They are called *urushi-e*, 'lacquer prints'. The prints are suddenly given a texture, a variety in surface depth, and the interplay between woodcut line, water-colour wash, lacquer and brass-dust produces an effect, in the examples that remain in anything like their pristine state, of startling splendour.

It is not known who first introduced this enchanting addition to the repertoire of the print-makers, though the name of Okumura Masanobu (1691-1768) is linked with its introduction, as with most of the technical innovations during this period. This artist is justifiably looked on as the greatest and most influential of the print designers from say 1720 to 1750. So forceful was his personality that, unlike the majority of his fellow designers, he does emerge from the shadows sufficiently at least for Mr.

Michener to be able to describe him as a 'vainglorious, avaricious, mendacious and vastly gifted little man'. He became bookseller and publisher, and claimed, on a number of prints, to be the originator of the two-colour process and of prints of a variety of new kinds, and even allowing for a publisher's self-advertisement, there is little doubt he had much to do with the popularising of prints in the pillar-hanging format (*hashirakake*), lacquer prints, and 'perspective pictures' in which western perspective was used for depicting such subjects as the interior of the Kabuki theatre. Like most artists of immense output, his work is uneven, but his finest prints place him indisputably in the very first rank (Plate 8).

He was precocious even by Japanese standards—he was well acquainted with the world of the Yoshiwara at the age of 13 as a book published in 1704 testifies—and designed prints in the vein of Kaigetsudō, Kiyonobu and Kiyomasu, before creating his own version of the 'beautiful girl picture', *bijin-e*, introducing a new type of beauty to the Edo connoisseurs, with characteristics that were inspired by the Kyōto book-illustrator, Sukenobu. Masanobu illustrated a number of splendid books, made theatrical prints, albums of genre scenes, large *kakemono-e* and narrow pillar-prints, in fact, ran the whole gamut of the Ukiyo-e range, and throughout his career continually widened that range.

Okumura Toshinobu is thought to be Masanobu's son, though the dates of neither his birth nor death are known. Perhaps it would be safer to assume an adoption. He appeared on the scene about 1725, became possibly the most typical designer of lacquer-prints, handling the technique as if he required it to express himself, and retired, or died, soon after the introduction of the two-colour process. He left a body of work of an uncommon sweetness, largely derived from Kabuki, but rarely depicting other than the quieter passages from the plays. The women he drew can genuinely be called charming—for once the adjective, so overworked in describing Japanese works of sort, can properly be used—and it is difficult to realise that as often as not he was portraying only a male impersonator, an *onna-gata*.

The print reproduced (Plate 9) is the essential Toshinobu, and a perfect example of the lacquer-print. The title playfully dubs

the girl a 'First Class Okumura Danseuse' and the fan-shaped cartouche states that the print is one of a triptych giving up-to-date fashions or patterns. As befits one of her profession, the girl is proficient on the *samisen*, which she tunes with a gesture and pose of unusual winsomeness. But the technique adds to our quota of pleasure. As in many other cases, the heavy black 'lacquer' (actually a pigment mixed with glue), is blind-printed, first to indicate the line of folds, secondly, to give the pattern of the cloth. A curiously tactile effect results, like a very shallow bas-relief, and in certain lights the edge of the blind-impressed design is picked out and underlined by the shadow of the impressed line, the pattern thus seeming to be touched in in white on the black. (This effect does not come out in the reproduction.)

The hand-colouring and gold-dusting are more or less regularly applied in this print, but more often such additions are placed quite haphazardly. Strangely enough, this method of 'random patch' colouring presents no obstacle to our appreciation. We more readily accept distortion in regard to colours than we do to form. So long as the outline is recognisable, an artist can falsify the colours of nature and his work will simply be classified as decorative; but if he tampers with the set of an arm or a leg, we suffer a physical revulsion and cry out upon the artist. We have no difficulty in assimilating a green horse or a black tree or a patch of colour that has no rational explanation; but a painting of a woman's face in which eyes and nose have changed places can only be accepted after a great deal of intellectual brainwashing, or, perhaps we should say, eye-washing. In the hand-painted prints of the early Japanese masters, colour was applied in an arbitrary fashion, only roughly conforming to the outline and intended more to catch the eye than to record the actual coloration. In the lacquer-prints this decorative use of colour was carried a stage further. The intensely black and glossy passages, the dabs of bright colour and the glint of surfaces roughened with metal-dust, had only a half-connection with the purely illustrative purpose of the print. The outline still performed its depictive function but the colour, lacquer and metal dust, placed with what always seems an uncanny aptness, adds a quite abstract element of tone and

surface texture. In the process, the woodcut line loses a lot of its force, and although its presence is still felt as the melodic line, one is also very conscious of the accompaniment, as diverting as syncopation. As a consequence, the virility of the brush line gradually diminished, there was not the same insistence on the swelling and tapering as of a full-charged brush. Something more suave, less forceful, resulted, and in Toshinobu one sees the feminising effect of the medium when used by an artist tender, one feels, by nature.

Time and again, throughout the history of the colour-print movement, at periods condemned by the historians for the immorality of the people, the grossness of their appetites, and when a great deal of the literature and pornographic art confirms the historian's findings, artists appeared of a seeming innocence, a gentleness hard to match elsewhere in the world's art. An artist like Toshinobu is no nearer reality than the creators of porcelain pastorals, of shepherds who have lost all their rusticity and retain a crook for decorative effect only. Toshinobu delights in flower-sellers, strolling musicians, tea-house attendants, agreeable vagabonds and virtuous harlots, and succeeds in investing them all with this magic of make-believe, so that even when they are the characters in a Kabuki play, they seem one further removed from reality than the play itself.

Plate 10 is from a perfectly preserved print in the Victoria and Albert Museum, with vivid hand-colouring, lacquer on the man's cloak and brass-dust on the girl's sash. The charming girl, who bears the significant name *Nowaki*, 'Autumn Storm', on her dress, is evidently proposing to lead the young nobleman on the pack-horse astray. He is pointing to the left, but she is turning the horse's head in the other direction, and the title *Fūryū ukare umakata*, 'Fashionable captivating (and perhaps "carrying off") pack-horse guide', completes the idea, which the lovely design suggests, of a man who has lost his way in some enchanted country while still within sight of Fuji.

In the lovely fluid composition of Plate 11, he has typified the Three Cities, Kyōto as a courtesan; Edo as a man turning his back on her and being led away, too affectionately, by a boy as

Ōsaka. There is in this, no doubt, some disreputable innuendo, but it is as difficult to impute vice to these masqueraders as to take the love affairs in the Italian Comedy seriously.

Toshinobu's output was small and confined almost exclusively to lacquer-prints in the *hoso-e* format. He is not of the stature of Okumura Masanobu, but it is justifiable at least to think of him as one of the Japanese print's 'Little Masters'.

CHAPTER V

○

Torii Kiyohiro:
The First Colour-prints

IN the lacquer-print, as in all other types of print up to this
time, the colour was applied by hand. They were painted-
prints, not colour-prints. About 1741, however, the first
Ukiyo prints with block-printed colour appeared, an advance in
technique that completely transformed the art of print-making
and led eventually to the triumphs of full polychrome printing
from about 1762-1764 onwards.

Okumura Masanobu may have had some justification for
claiming to be the originator of the two-colour process, though
a number of capable artists worked in the same medium at or
about the same time—Kiyonobu II, Kiyomasu II and Shigenaga
among them. But it really matters little who introduced it: it
was, after all, probably more the responsibility of the publishers
than the artists and the result of a change of policy on their part,
not the pioneering of a new medium by some inventive genius.
Colour-printing from woodblocks was well known in Japan
before 1741, but until then it had presumably not been a com-
mercial proposition. It was cheaper to employ apprentices and
others to colour prints by hand (it is a fallacy, I think, to assume
that early prints were hand-coloured by the actual designers), than
to go to the expense of additional blocks with all the technical
difficulties that their use entailed.

As to earlier block colour-printing in Japan, two 17th-century
books can be cited, one educational,[1] the other astrological,[2] but
in both the colour is used diagrammatically only. In two other

[1] *Jinko-ki*, 1627.　　[2] *Semmyo Reki*, 1644.

books, however, of the early 18th century,[1] illustrations were printed from colour-blocks, but the experiments were isolated ones and ignored by the broadsheet publishers. Whoever introduced the two-colour process to Ukiyo prints had the good fortune to hit upon two colours delightful in combination—*beni*, a rose-pink made from the safflower, and a green called *ichiban rokusho*, 'first washing of verdigris'. The pink is a fugitive colour and fades to a yellowish tone, but the green is more permanent. As a consequence, only those rare prints that have been preserved in something near their original state possess the balanced beauty of the colour scheme. In the process, each print now had to be impressed on three separate blocks, one for the black outline, the keyblock, and one each for the two colours, *beni* and green, and the necessity for 'register' arose to ensure that the colour blocks exactly tallied, when printed, with the outline. Guide marks called *kento*, in the form of a right-angle at one corner and another line in line with one member of the right-angle, were cut into the key-block and in corresponding positions on each of the other blocks, and the sheet to be printed was lined up with these guide-marks as it was impressed on each block. This type of print was called by a number of names of which *beni-zuri-e*, 'pink-printed-picture', is now most generally used.

The resultant colour-prints are utterly different from anything that had appeared before in Japan or China. The designers, possibly under inspired guidance from the publishers, who alone perhaps could foretell the end-product, produced drawings that could be translated into exciting patterns composed of the subdued outline and the solid black areas of the key-block, aided by a harmony in pellucid tones of pink and green used for dress patterns and tree and landscape accessories. It has been suggested that certain Chinese erotic prints of the 16th and 17th centuries were the inspiration behind the Japanese *beni-zuri-e*. It is true that four or five colour-blocks were employed in the production of these prints, and there is incontrovertible proof that the albums were known in Japan in the 17th century, and were in fact

[1] *Chichi-no-on*, 1730, commemorative of the great actor, Danjuro I; and *Ehon Gion sakura*, 1718-1719, an erotic book by Nishikawa Sukenobu.

pirated and re-published there. But the block technique of the Japanese differed considerably from the Chinese. For one thing, in Japan the black outline key-block remained fundamental, whereas in the Chinese prints the outline varied in colour for different parts of the design: black for faces and exposed limbs, green for drapery, red for dress patterns, and so on. The Chinese too, was a far more linear style, with only rare recourse to solid areas of colour, which, in the Japanese *beni-zuri-e*, contributes largely to the over-all patterning. If it was another case of the Japanese borrowing from China, they transformed the original, as in so many other instances, and made of it something entirely their own.

Before discussing any particular artist's colour-prints, one may pause to ask why the medium delights us as it does. Is it because, unlike an original brush-drawing, it carries a sense of finality? With an ink sketch, so much is a matter of chance—the brush skips the tooth of the paper and leaves a broken trail; or the colour settles in a deep pool with an intensity of tone that sparks off the whole drawing: the artist may use his utmost skill, but providence (even when an artist is so clever that he can actually enlist providence on his side) still plays a part. With the colour-print, there is no element of chance in the knife-cut outline, or in the evenness of the colour, block-applied: they have been calculated, they have been produced by mechanical means, always under the control of a skilful operator. Under the knife, the tentativeness, the uncertainties, even the imperfections, of an original drawing disappear, and in the printing, the variations of tone, the chance surface effects. In the drawing, we enjoy the glorious unpredictableness; in the print, the certainty. It is significant that whereas we accept and take as a matter of course the random application of colour to a print by hand, even finding a pleasure in the careless over-running of the lines, we cannot countenance slipshod printing, and lack of register ruins a print.

Of course, the woodcut suffers in comparison with the original brush-drawing in not having the vivacity, the variety of tone, the viva-voce directness of communication, the infinite possibilities that result from the uncertain factors we call providence: but it

acquires in the process of engraving and printing quite other virtues. The simple act of impressing paper on a block charged with colour and burnishing the back of the paper to take an 'impression' results in flatness of colour-tone and a texture of paper-surface that are the province of the colour-print alone. Each medium has its own singular appeal, not to be paralleled in any other. In etching, it is the suggestive, uninhibited bitten line and the mazy texture obtained by crossed lines and varied biting; in line-engraving, the masculine firmness of the line, the flecks and dots and other quite individual marks of the burin, the feeling of power in the hand engraving tough metal; and in the colour-woodcut, if it is possible to analyse the technical basis of our pleasure, it is first the evenness of the relief printing, which is bound to be more calculable than any intaglio printing (where the intensity of the tone of the line depends on the depth that the line has been bitten by acid or engraved by burin); and second, because of that evenness, a limpidity of tone when large areas are skilfully printed. The block to be printed is painted with pigment—a vegetable dye mixed with a little rice paste to give it consistency—just sufficient to stain the surface of the paper when an impression is taken, and the burnishing, too, brings a certain lustre, or bloom, to the lovely textured Japanese paper. Of course, these qualities are meaningless in themselves, it needs the designer to create reality with them, while still preserving them intact.

Directly the colour-print attempts too much, becomes so complicated that its own inherent qualities are submerged, it fails as a colour-print, whatever else it may become in the process. The truest colour-prints are those in which the printer has not been allowed too much scope, but where he has printed with accurate register, cleanly and evenly, without relying too much on gradation of colour, or 'fading-out'. Of course, this is controversial in the same way that the subject of clean-wiping in the printing of an etching is controversial. Those that feel that the bitten line is the essence of the etching art, object to the printer supplying adventitious effects by allowing the ink to remain on the plate: it has ceased then to be pure etching, and has become a

mixed process of etched line and painted ink surface. It can be argued that the greatest colour-woodcuts are not those that rely most on the virtuoso colour-printer's skill. None of the later polychromatic prints employing upwards of eight or ten blocks, not even the exquisitely printed sheets of Harunobu, Kiyonaga or Utamaro, has quite the limpid certainty, the satisfying completeness, of a *beni-zuri-e* print by Masanobu, Toyonobu or Kiyohiro. It is interesting that this seems to have been acknowledged later by artists we consider the acme of refinement—Eishi, Shunchō and above all, Shunman—who, with an unlimited number of blocks at their disposal, yet on occasion designed prints for an extremely limited palette, sometimes no more than tones of grey with a violet or pink.

Torii Kiyohiro is hardly more than a name that appears on prints published, for the most part, between the years 1750 and 1765. He is known to have been the pupil of Kiyonobu II, and may have been his son. He was, at any rate, a member of the Torii School of artists and, as a consequence, a great deal of his work recorded Kabuki plays. Prints of this kind in the usual *hoso-e* format have the level competency we accept as a matter of course in artists of this family, but rarely the individuality we find expressed in a few prints of larger size, some of which introduce subjects of an intimate domesticity that single this artist out as a personality from the ruck of his fellows. Although he is known, by the illustrations to an unimportant theatre-booklet, to have been at work in 1737, his prints fall almost entirely within the colour-print period after 1741. Even his few hand-painted lacquer-prints probably post-date this year, for the introduction of colour-printing did not immediately put an end to hand-colouring of sheets, and it was nearly a decade before the new process was universally employed.

Kiyohiro's prints exemplify the subduing influence that the new colour-process had on the designers. The reduced significance of the brush outline has already been alluded to in discussing the lacquer-prints of Toshinobu. In the three-block print, the outline had to be still further muted: the declamatory style of the soloist was no longer permissible in a trio. At the

same time, the use of the colour-blocks gave freer rein to that trait always latent in any Japanese, a passion for clothes and a delight in the patterns of fabrics. From the time almost of the first Ukiyo-e illustrated books, the greatest artists were engaged to draw *kimono* patterns, and books often containing a hundred or more designs were issued and were among the most popular of all the publications of the day, so much so that it is rare indeed to find copies complete or without the disfiguring marks of wear. The vogue for separate sheets primarily designed as fashion plates came in rather later, but even in Kiyohiro's time, the publishers were fully alive to the public's intense concern with all matters connected with dress. The subject of any print was always partly the cut of the clothes and the decorative patterns of the fabrics.

The bold limb-leaping patterns of Genroku times had given way to smaller, more intricate floral motifs, interrupted sometimes by areas of neat checks, and the print-makers displayed a real flair for making the most of the opportunities that the pink and green blocks gave. In Kiyohiro's print called 'The Game of Sugaroku' (Plate 12), there is a beautiful play of descending calligraphy, of floral patterns in the girls' dresses (in one case green paulownia leaves on a pink ground, in the other, pink plum-blossom on a green), and the green and white check of the boy's *kimono* with its scattered pink flowers. There is all the intimacy of an imaginary interior, neither the walls nor the floor being marked. The boy is just making his move, and his opponent, all intentness, raises the dice-box, forefinger curled inside to retain the dice, eager to throw. She has the grace that is the mark of so many of Kiyohiro's creations, a frailty of form and a prettiness of movement that anticipates the fragility of Harunobu's *musume*, and is already a long way from the ponderous stateliness in vogue forty years earlier in the large prints of Kiyonobu, Kiyomasu and Kaigetsudō.

The inscribing of poems on paintings was a practice long honoured in the Far East, but the verses the Ukiyo-e artists affected had little in common with the inscriptions of the Chinese and of the Japanese who followed their style. A tenuous connection, no more than a play on words, was all that was

needed for a quotation to be considered apt, and the picture was rarely designed to be illustrative of the text. The verse was often chosen as a test of the nimbleness of wit in those that bought the print, and we are often left wondering at the subtlety of the play between picture and poem, and, even more, at the acuteness of the public that could savour such an intellectual exercise. On the 'Game of Sugaroku', the verse (which, like most of the elliptic verse of the Japanese, is capable of more than one translation), can be read, 'If Shushi and Shusan are together, what a din as the moon shines into the room'. The names of the two players, Shushi and Shusan, are also used to describe one of the positions reached in the game, and our own card game of 'Snap!' gives some idea of the sudden shout that accompanies the move. On another of Kiyohiro's prints, of a girl holding a pet white rabbit (one sheet of a triptych of girls with pets), the verse reads, 'She holds herself erect like a flower in the snow under the moonlight', and this was surely chosen to draw attention to the figure of the slim girl, slightly wilting under the weight of the snow, personified by the white rabbit held to her bosom. The inscriptions have also a purely decorative purpose. Although we may lack connoisseurship in that most oriental of the arts, calligraphy, it is still possible to appreciate the pictorial value of the inscriptions and the artistry with which the *hiragana* is harmonised with the flowing lines of the design.

Other notable prints in the large format by Kiyohiro are of two boys playing with whipping-tops, watched by a passing dandy carrying love-letters, like trophies, dangling from the hilt of his sword; lovers in the snow, the youth bending to scrape the snow from between the supports of the girl's *geta*, or clogs, with the butt end of his fan, she prettily lifting one foot and supporting herself with one hand on the boy's bent back while she holds a snow-capped umbrella with the other; and a slightly risqué subject, sanctioned by its counterpart in classical literature, of a young man carrying a girl pick-a-back through bush clover (Plate 13). The youth and girl are clothed in the most fashionably patterned stuffs and their hair is dressed in the latest styles, but there is little doubt that the intent of this typical Ukiyo-e analogue

of a classical theme (it occurs in the 10th-century romance called the 'Tale of Ise') was perfectly plain to the public that patronised the print-shops, or that the verse, with the dubious double entendre, 'Swaying each other in the heavy burden of love, in the field of a thousand herbs', was much to their taste.

Plates 14, 15 represent another side of Kiyohiro's art, the introduction into everyday scenes of semi-nude figures. These are something quite separate and distinct from erotic prints, and although not common, they occur in the output not only of Kiyohiro but of two or three of his contemporaries, notably Toyonobu and Kiyomitsu. No matter how easily, in time, we accept the conventions and technique of the Japanese print, prints of this period of the partially undraped figure continue to provide delicious surprises. There is usually a naïve lack of draughtsmanship in the drawing of the female form, as if the artist were unfamiliar with its lines rather than incapable of transferring them to paper, and this seeming naïveté is coupled with a perfectly assured rendering of the clothes and their decoration. Draperies drawn and coloured in a flat two-dimensional decorative way are easily assimilated, but we are so familiar with the anatomy of the body, and so used to seeing it painted in the round, that a drawing like Kiyohiro's that gives an unconvincing structure in outline, conflicts with all our established notions—not disagreeably, but in a way that leads us to search for an adjective like wayward or perverse to describe such a print. In a somewhat similar way the nudes of Piero di Cosimo and Lucas Cranach, curiously and painstakingly modelled, contrast with the richly decorated and realistically painted vestments. In the Kiyohiro prints, there is sometimes another conflict, between what we may consider the immature drawing of the nudes, and the extreme sophistication of their actions—the coquettish movements of girls to hold their disarranged dresses around them, the affectation of surprised modesty, hiding only to reveal more, like the wantons in French colour-prints of the same period.

In a print called 'Awabi Fishergirl' in the British Museum, the girl's outer cloak, hanging on a pine-tree, is dark green with red lines through it. She wears the red skirt customary to those of

her calling; her basket has alternate bands of green and red, the waves are green, the outline of the sandy shore is red. The pine-tree bole is red, but the leaves are neither green nor red but a sort of buff colour and clearly printed from a third colour-block. It was about this time, at the end of the 'fifties, that over-printing of colours, and the use of additional blocks, began to be introduced, and the realisation of the full polychrome print was near at hand.

CHAPTER VI

———————o———————

Tsukioka Settei:
Picture Books

ANY extensive treatment here of prints in book form is ruled out from a number of considerations. Apart from anything else, the subject is so enormous, embracing as it does the whole realm of Japanese painting, that one volume would no longer be adequate to deal with both it and the Ukiyo broadsheet as well. On the other hand, for the fullest appreciation of what the Japanese have achieved in woodblock printing, there must be a knowledge of the prints published in books and albums, and I propose a brief general account of the picture-book to bring it into perspective with the broadsheet, using, by way of illustration, the work of a typical mid-18th-century artist, Tsukioka Settei.

The *ehon* (picture-book) is an especially Japanese form of art. Such books really had no counterpart anywhere else in the world. They consisted of a succession of woodcut pictures with little or no text, often without any connecting theme, or perhaps loosely linked by the verses of poets, or by some general concept like 'Bravery of Women'. There is little doubt that this form of a continuous and more or less uninterrupted series of pictures derived from the hand-scroll, the *e-makimono*, a narrow lateral painting extending over many feet, and unrolled slowly to be viewed section by section. As far as the origin goes, the Japanese debt to China is again clear enough, but the *ehon* is a characteristically Japanese departure from a foreign model representing something entirely new and unmatched elsewhere.

From the beginning of the 17th century, at a pace accelerating

as the century grew older, there was a steady publication of books relying as much, or more, on the illustration as the text. The drawings were supplied by artists of the Ukiyo and of other schools. In the middle years of the 18th century, for instance, Okumura Masanobu and Nishikawa Sukenobu were the principal Ukiyo contributors to the vast output of the period (between 1716 and 1751, the year of his death, it is estimated that more than 80 *ehon* were designed by Sukenobu alone, most of them in three or more volumes). In the same years, artists of other schools, Shumboku and Morikuni, for example, were producing books of copies after celebrated Japanese and Chinese paintings, as well as poetry books, illustrated encyclopaedias, topographical works, manuals of etiquette and instruction for women in all the intricate affairs of the household, and collections of disconnected sketches. No year went by without the bookstalls offering numerous new publications ranging from trivial amusement to serious instruction, and many of these books were almost wholly pictorial. That these books were entertaining and vastly popular is evidenced by the well-thumbed pages of copies that remain, and by the frequency with which new editions were called for.

Various reasons have been put forward for the prevalence of this type of picture-book. I think that the idea that it catered for a semi-illiterate reader can be scouted at once. Many of the books presupposed a wide acquaintance on the reader's part with the Japanese, and often the Chinese, classics, and the books of copies after old paintings were surely only a response to a widespread interest in the art of painting. The picture-books of the Yoshi-wara and kindred institutions may have appealed to a depraved taste, but not, certainly, to an illiterate one.

Put simply, pictures meant a great deal to the average Japanese. There was probably a greater general interest in, and appreciation of, pictorial art among the commonalty of Japan than among the comparable classes of any western nation. But that alone would not have accounted for the enormous output of the publishers: the cheapness of book-production and the facility with which illustrations could be provided were both further contributory causes. The illustration of European books always presented the

problem of incorporation of woodcut or line-engraving with the text, the marriage of type-forms with block or plate. With the Japanese printer, these problems did not exist, for picture and text—even when it was no more than a title—were cut on the same woodblock.

The binding was also a simple matter. Sheets of the required size were simply folded in two and fifteen to twenty of such sheets were stitched at their free edges to make a *maki* or volume. This meant that a design covering a whole 'spread' of the book, a 'double-page illustration' as we would term it, was actually cut on two separate blocks. The covers of the book were of a paper rather stouter than the sheets of the book itself, but the binding was only a matter of a needle and thread.

Cheapness and facility cannot, of course, be associated with the magnificent colour-printed *ehon* of the 18th and 19th centuries, but by the time colour-printing had been introduced, the *ehon* was so popular with the masses that it was inevitable that the publishers should find a market for *de luxe* books of the same species. It is generally conceded that these finely-printed *ehon* and albums in colour are among the world's loveliest and most sumptuous books.

Up to 1770, however, there had been very few books printed in colour. All of the books designed by Tsukioka Settei, for instance, whose last dated *ehon* was published in 1771, are in *sumi*, black ink, only. This artist is interesting from a number of points of view. He lived most of his working life in Ōsaka, and his books were directed primarily to an audience different from that in Edo for whom the Ukiyo broadsheets were largely published. After the building and rapid expansion of Edo as the centre of the Shōgunal authority, Kyōto, the old capital and still the seat of the Imperial court, receded quietly into a backwater where poetry and philosophy and painting were practised in a sort of cloistral calm. Nothing seemed likely to disturb the old order. The Emperor and his courtiers, though impoverished, had culture to sustain them, but it was the culture of an imprisoned society denied contact with the energetic movements of the new Eastern Capital. The enervation affecting the court circles was felt

throughout the whole literate population, for without contacts with the outside world there was a lack of fresh material or fresh inspiration for the artists, and all that was left was to refine, and refine again, on the old stock of artistic ideas and techniques. The degeneration of the Tosa School of painters is typical. The virility and lively narrative power of the picture scrolls of the mediaeval originators of this style were slowly but steadily paralysed by a formula of compositional devices and an overloading of minute and meaningless detail. The early works of this pre-eminently native school may have had their faults but they were those of an extravagant exuberance of youth and life; the scrolls of the 18th century depress us like the lugubrious ornamentation of a sepulchre.

Nearby Ōsaka, the other principal town of the Kamigata (as this area was called—the Upper Direction—towards the Imperial seat), was, however, a commercial city, less affected by the sterility that checked new growth in the old capital, and though never entirely carried away by the movements in Edo, did encourage the work of artists who were at least akin in spirit to the Ukiyo men of the new capital. Principal among these is Nishikawa Sukenobu, who was unquestionably one of the greatest artists of the 18th century, and whose books of pictures were as popular in Edo as in Ōsaka. Indeed, they are the source-books on which all subsequent Ukiyo artists drew, and it can fairly be argued that his influence on Ukiyo-e design and subject is probably as powerful as that of Moronobu and Kiyonobu. The example of his gentle, winsome women, the softly rounded curves of his line and the smooth rhythmic swing of his compositions led to a tempering of the sometimes brutal force of the early Edo masters, and the infusion of poetry and allusion that coloured his genre scenes of life in the Kamigata began to tinge the prints of the artists of the eastern capital until, by the time of the introduction of the full colour-print, Harunobu and his circle had completely succumbed to the grace of his example, and the brash vigour had almost been refined away (Plate 16).

Settei, born in 1710, was powerfully influenced by Sukenobu though there is no evidence that he was ever a direct pupil.

Unlike others, however, he maintained a sturdy independence to the end of his days. He had already had a training in the Kanō school before he took to designing *ehon* for the publishers, and though later his style tended to veer away from the academicism of his first tutors, it never became wholly Ukiyo-e, nor was he ever a mere copyist of Sukenobu.

Perhaps it is opportune to mention here that most of the Ukiyo-e artists, and those allied to that school in style, were painters as well as print- and *ehon*-designers, and the relative proportion that paintings assume in their total *œuvre* varies. Some very great Ukiyo masters did not provide any designs for the print and book publishers—Miyagawa Chōshun (1682-1752), a prolific painter, is the first example that comes to mind. The paintings of the Kaigetsudō group of artists far out-number the prints designed by them. Tsunemasa is a name that never appears in books on Ukiyo prints, but he was an excellent painter and in style foreshadowed Harunobu. Settei is another artist whose paintings are of greater importance than his printed works, and to know his paintings is to anticipate exceptional qualities in his *ehon*. In two books at least his promise is fulfilled. There are few things more impressive, even in the enormous range of Sukenobu, than certain of the pages of 'An Array of Brave Women' (1757)[1] and 'A Picture-book of Sprigs of Greatness' (1759).[2] The strength and nobility of his line have evoked the praise of a number of lovers of Japanese books, and their verdicts are interestingly concurrent. Morrison, in 'The Painters of Japan' wrote: 'Traces—in backgrounds very distinct—of Settei's Kanō origin are clear throughout his work. He is best publicly known as a book illustrator—or rather as the artist of many *yehon*, the books of pictures with little text. These books chiefly illustrate the history and legends of Japan, and the exploits of warriors, represented with directness, simplicity and strength. . . .' Mrs. Brown, in her 'Block Printing and Book Illustration in Japan' went so far as to place him above Sukenobu: '. . . the drawings of women being characterised by a robust and noble dignity that Sukenobu, famous as he was for depicting beautiful

[1] *Onna buyū yoso-oi kurabe.* [2] *Ehon kōmyō futaba gusa.*

women, never entirely reached.' And in Toda,[1] we find the same insistence on the force of his drawing: 'Settei may lack refinement, but in the matter of robust physical expression in figure painting, very few Japanese illustrators can equal him.' For once, too, the Japanese view, expressed by Nakada in his 'Study of Picture-books',[2] follows our own very closely.

Not all his *ehon* are of this powerful order, and in fact the thirty or so books ascribed to him present a wide variety. The first appeared in 1753, a book of pictures and poems entitled 'One poem each of Fifty Courtesans', head-notes giving brief lives of the 'pleasure-women', and the poems being of their own composing. In this book the debt to Sukenobu is fairly obvious, and there is even the sort of tameness that comes from a careful plagiarism of another artist's style. In 1762, he compiled the drawings for a guide-book, *Togoku Meisho-ki*, 'Guide to the Famous Places of the Eastern Provinces'. The five volumes are full of cursory topographical drawings to a formula evolved by Moronobu for a folding-book guide to the Tokaidō, the great highway between Edo and Kyoto (and Moronobu himself was only following the style of topographical hand-scrolls current in his day). To us, in Settei's book every village looks alike, pine-woods and mountains are all of a pattern—except Fuji every now and again appearing on the skyline to remind us we are in Japan—and the drawings in light line seem no more than generalised landscape of purely decorative use to balance the factual nature of the text. As if to underline this non-illustrative function of the pictures, occasionally Settei introduces a scene from legend or improbable history to correspond with the text reference to the site, real or imaginary, of the event portrayed.

Ehon Ranjatei (1764), has a title which, literally translated, could mean 'The Flourishing Orchid Entertainment', but in effect the book is a series of anecdotes of ancient poets with their poems, and pictures illustrative of them. The titles of Japanese books are invariably *recherché* and purposely inexplicit. In this book,

[1] Descriptive Catalogue of the Japanese and Chinese Illustrated Books in the Ryerson Library of the Art Institute of Chicago, 1931.

[2] *Ehon no kenkyū*, 1950.

Settei's bold line is again under a curb to bring it into harmony with the small neat calligraphy of the text, but the marriage is a complete success, the pictures again being contrived in the spirit of decoration as much as illustration.

Kingyoku Gafu (1771), the last dated book illustrated by Settei, is a collection of woodcut versions of paintings by Japanese and Chinese artists. It is a compilation of a type not at all uncommon in the 18th century and other outstanding artists besides Settei—Morikuni, Shumboku and Kanyōsai to name only three—were quite proud to subscribe their names to what we might think unoriginal works. But they were not mere copies of paintings but rather interpretations or paraphrases, on the smaller scale of the book-page, in black ink, of paintings that may have been in full colour, or at least, relied on the full range of ink-tone, of a breadth and subtlety far beyond the simple outline of the wood-block. Picture books of this kind became works of art in their own right: Settei's woodcut version of a Sesshū painting is far more than a crude reproduction but, like an inspired translation from one language to another, succeeds in transferring the spirit of the original to an entirely new form.

Settei's masterpieces among the *ehon*, those where he seems to have been able to give free rein to his innate gift for broad sweeping line, are both books of legend, and of history that always seems to be verging on epic poetry. The very theme of 'An Array of Brave Women' seems to have been chosen as a fit medium for his heroic line. If Sukenobu expressed the essential femininity of woman, Settei brought out the courage and sublime devotion of which she is capable, emphasising her frailty by her very strength in overcoming it.

Plate 19, of a double-page from this *ehon*, illustrates a scene from one of the passionate stories that make the country's history books so enthralling. Moritō, an archer of great strength in the service of an Emperor of the 12th century, falls in love with his cousin Kesa Gozen who was married to one of the guards of the palace gates. Seeking to gain the assistance of the girl's mother in his attempt to seduce the girl, Moritō draws his sword and threatens the mother's life, whereupon Kesa intervenes and to

save her mother, seems to agree to Moritō's terms. In the sequel, she sleeps in her husband's bed, and Moritō beheads her, believing her to be the husband. The scene portrayed by Settei provides him with a superb pyramidal composition in which the great purposefulness of every line helps to convey the intensity of the emotions.

The *ehon* of 1759, the 'Sprigs of Greatness', owes its Japanese title to the reputation of certain trees to exhale their perfume from the first two leaves bursting from the buds. The analogy is to the feats of young heroes, and the book is a parade of those youthful prodigies in arms or learning or saintliness, who abound in Japan's history: or at least, in Japan's history-books. It affords Settei an occasion for the 'warrior' type of print that was always popular with the people, the vision of antique heroes doing battle in all the panoply of their intricate armour never failing to stir the hearts of the Edo and Ōsaka townsmen. Men of this class probably shrank from the idea of ever engaging in such violent action themselves, indeed, from what we read, it seems that even the *samurai* at this period had to be exhorted to keep up the manly practice of arms and to avoid the fleshpots of the cities: but pictures of warriors performing doughty deeds appealed as much to the unwarlike merchants as crime-stories do to the most law-abiding citizens of suburbia.

What tremendously vital designs these battles give rise to in Settei's picture-book! Plate 17 reproduces a typical one. The great swirl of the piebald horse's tail becomes the vortex around which all the violent action eddies, and the tangential spear of Nyōmaru's companion, seemingly thrown out to the edge of the design by the centrifugal impetus, is a compositional masterstroke. But Settei could interpret a quieter scene when occasion demanded. Plate 18 is the right-hand of a double-page print and it is reproduced separately simply to give the right scale to the figures which lose so much from diminishment in reproduction. Kojūmaro stands demurely before his stern father (in the other half of the print), and his mother listens behind a slightly opened *shoji*, the sliding panel decorated with a design of flying geese.

The lines in this print are as restful as those in the last described

are agitated, and the device of picturing the woman in a long narrow aperture is wholly successful, first, in conveying the secretiveness of the listener, and second, in adding height to the composition. Settei's robust drawing recalls the early primitives, at a time when the Edo artists were abandoning the forcefulness of the bold woodcut line, and when the introduction of colour-printing was transforming the style of the print-designers. To his contemporaries, Settei may have seemed something of a conservative, mindful to the end of his Kanō upbringing and the importance of the brush-stroke, and never succumbing to the blandishments of the novel, popular colour-print in which the outline played less and less part.

CHAPTER VII

─────── ◦ ───────

Suzuki Harushige:
The Brocade Print

NORMALLY, Ukiyo prints were not dated, though quite often the year of issue can be fixed on internal evidence, with exactness from recorded performances of plays, or approximately from the appearance of new hair styles and fashions in clothes. In 1765, however, a considerable number of pictorial calendars appeared. They were printed from five or more blocks and the designs were supplied by Suzuki Harunobu and other artists working in a style similar to his. Owing to the peculiarities of the Japanese calendric system, which need not be explained here, the number of days in each of the twelve months was varied from year to year, an official pronouncement, made at the beginning of the year, listing the months that would have 29 days ('Short' months) and those that would have 30 ('Long' months). The official calendars, called *Daishō goyomi* (Long-short calendars) were the monopoly of a few designated publishers but 'pirate' editions were sometimes issued in which the information was embodied in a picture. The calendars issued in 1765, for circulation among the members of a few exclusive literary clubs, are notable for the quaint conceits used for camouflaging the calendric numerals, the designers going to great lengths to hide them in the patterns of fabrics, in the framework of houses, in the border of an umbrella, even in the hairs of a sage's face, the expedient leading to a sort of game in which success went to the one that avoided recognition the longest.

This year 1765 has always stood out as a landmark in the histories of the Ukiyo print because some of Harunobu's picture

calendars were printed in full colour. They were the earliest separate sheets produced by this polychrome process to which a date could be given, and so it has been assumed that 1764 (when the calendars for 1765 must for the greater part have been printed), was the year in which full colour-printing was first introduced, and the date of the earliest *nishiki-e* 'Brocade prints', as they shortly became known. Objections can be made to this theory, which in any case implies an inexplicable coincidence—the spate of picture calendars and their being printed in polychrome. There is the significant fact that although the calendars were designed by other artists besides Harunobu, the style of his fellow-designers is so close to his own that we must assume that already, before 1764, he had begun to exert a powerful influence on his contemporaries. Yet, if we exclude the prints in full colour, assuming them all to post-date 1764, there is nothing in his extant *œuvre* to warrant such an assumption. All that would be left would be a number of *beni-zuri-e*, and sheets printed from three or four blocks, mostly of actors, in a far from masterly style, more reminiscent of Kiyomitsu or Kiyohiro than of Shigenaga, his reputed master; and two or three little picture books of 1763, in which the uncoloured designs are pleasant enough, but hardly of a character to take Edo, or the Edo artists, by storm.

The 1765 calendars, issued in what we may call 'private editions' on paper of an unusually thick sumptuous quality called *hōsho*, brought colour-printing to a degree of refinement it had not reached before, but perhaps the process had been used for a few years before that date. Against this possibility is the fact that some of the 1765 calendars were printed from a very restricted number of blocks and were reprinted later with the calendric symbols removed, in a far greater range of colours. Nevertheless, it is difficult to accept Harunobu's emergence as a compelling force at one leap in 1765, and it may well be that other prints, not of a calendrical type but in his own unmistakable style, appeared earlier, so that by 1765 his success with the public had led others to emulate him, or to enrol themselves as his pupils.

Harunobu became one of the select band of artists who dictated the course of Ukiyo art, the others being Moronobu, Kiyonobu,

Okumura Masanobu, Sukenobu, Kiyonaga, Utamaro and Hokusai. All, except perhaps Kiyonobu and Hokusai, dominated their era by creating a new fashion in womanhood, or perhaps it would be more accurate to say, by interpreting most successfully the current trend of the male ideal of womanhood. In a man's world, as Japan was, this was the surest way to success with the Ukiyo public. Once an artist like Harunobu had established a new canon of female attractiveness, the rest of the practising artists had to conform to it, or risk losing their place in the public's esteem. Even a veteran like Toyonobu, who in the 'forties and 'fifties had himself been an arbiter of fashion in feminine beauty, ended his career in the 'sixties by drawing girls little distinguishable from Harunobu's.

In the system of tutelage and the struggle for survival we have two of the major causes of confusion between the works of artist and artist. The unsigned prints of what may be called the Harunobu Period, extending from, say, 1764 to 1770 (the year of his death)—and even beyond as we shall see—have often in the past been uncritically accredited to Harunobu, notwithstanding the fact that he had several acknowledged pupils who each left a body, significantly small, of signed prints; and that he worked alongside a number of accomplished contemporaries who, under his sway at first, went on to develop their own talents and to become stylists in their own right. In the first category, to name the outstanding, we have Harushige, Kōmai Yoshinobu, Harutsugu and Fujinobu; in the second, Koryūsai, Shigemasa, Shunshō and Toyoharu.

Harunobu's supremacy, like Moronobu's, was to a large extent due to his medium. Just as Moronobu found the ideal interpretation of his designs in the stark woodcut line and mass, so Harunobu found his in the full colour print. Indeed, until the polychrome process was perfected he did not reach his full stature. The beguiling O-Sen, Harunobu's favourite model, a tea-house waitress and a paradigm of elegance and immature womanhood, has the grace of Masanobu's *musume*, the winsomeness of Sukenobu's and the waywardness of Shigenaga's, but these virtues are compounded with a touch of fantasy, are worn

with an air of remoteness from mundane things which, more even than the improbable fragility of her wrists and hands, make her as a visitant from a never-never land of the imagination (Plate 20). But more potent even than the lilting line of Harunobu's dream-children—who had, after all, a traceable ancestry—were the new-found colours of the printers in creating the spell that the *nishiki-e* exerted over the Edo connoisseurs. A whole new range of subtle tints came into being, russets, silvery greys, damask pinks, old gold, apple green, and fugitive blues, which in combination provided colour harmonies that enchanted a nation whose taste and refinement in such matters are manifest in everything they made for use or wear or decoration—in fabrics, in pottery, in lacquer, even in metal-work.

Printing in a wide range of colours from woodblocks was nothing new in Japan by the 'sixties. Quite apart from the examples of Chinese polychromatic printing in the publications known as the 'Ten Bamboo Studio' and the 'Mustard Seed Garden' which must have circulated widely in Japan, there had already been published the splendid 1748 Japanese edition of the 'Mustard Seed Garden', and, earlier still, in 1746, a book of designs by the Japanese artist Shumboku, based on Chinese works of the Ming dynasty, (the *Minchō seidō gaen*) both of which books had been printed from multiple blocks. The colours, and even the kind of paper, however, linked these publications as was inevitable almost by their very subject matter, with the Chinese colour-prints: the first Ukiyo prints in full colour employed a range of pigments immediately distinguishable from any used before, and as characteristic of the Ukiyo print as its subject matter and style of drawing. It has been complained, ungraciously, that Harunobu is only Sukenobu with colour added, and that the colour was as much the printer's triumph as Harunobu's: but nothing can disassociate his name from a consummate use of the medium that enlightened patrons, or astute publishers, or his own inventiveness —it hardly matters which—had given him to use.

It is not often that Ukiyo-e artists are mentioned by name in contemporary writings, but in 1767, in an 'Anthology of Prose and Verse', one Neboku Bunshu declared that 'in the manner of

taking impressions of prints everything is changed in the Capital of the East, the sheets coloured with red tints (*beni-e*) no longer find a market. Harunobu depicts all sorts of men and women in the most elegant manner.' He goes on to express astonishment that 'artists of the Torii School did not imitate him'.

But if the Torii artists did not imitate him, a great number of other print designers did and with such success that it is now generally conceded that many of the unsigned prints hitherto attributed to Harunobu were drawn by talented contemporaries, whether pupils or no; and that many of the prints actually bearing the signature 'Harunobu' are either forgeries or fakes, or authentic early unsigned work of other artists to which the signature Harunobu has been falsely added later. Differences in style and technique, slight though they are, would have eventually led connoisseurs to this conclusion in any case, but attention was quite early focussed upon the problem by a 'Confession' written by the subject of this chapter, Harushige, later famous under the name of Shiba Kōkan.

Before giving a translation of this interesting document, it may be as well to sketch in outline the life of this remarkable man and to consider his Ukiyo prints afterwards. A man of uncommon talents in a number of distinct spheres, painting and print-making were probably his main preoccupations, but in his thirties he came in contact with men who were students of western ways and science, and himself became a seeker after the kind of knowledge that in Japan at that time had the allure of forbidden fruit. Since 1640, a two-way 'exclusionist' policy had operated in Japan, no Japanese subject being allowed to leave the country, or having left it, to return; and no foreigners were allowed to enter Japan, with the exception of the handful of Chinese and Dutch who were allowed to trade at Nagasaki. This policy, brought about by the Bakufu fear of interference by foreigners in the affairs of the country and the possible undermining of its rule if not actual invasion of their territory, had the profoundest effect on the future of the nation, denying the people the great advantage that knowledge of the Renaissance in the West might have offered, turning their minds in upon themselves, as Sansom

remarks, and evolving 'nothing but elaborations and refinements of their own culture, a culture withal so remarkable and unique that in itself it almost provides an answer to the common allegation that the Japanese as a people are wanting in inventive genius'.

The Dutch colony at Nagasaki remained a sort of precarious beach-head of European culture and science, albeit not always of a particularly representative character. Although a policy that amounted to non-fraternisation prevailed, strengthened as much as anything by the language difficulty, there is evidence of the Japanese interest in all western matters and occasionally the influence of the West on their style and practice of drawing is quite obvious. The Nagasaki prints proper, which form a separate class, are naturally the plainest examples, but in Ukiyo-e, too, European perspective was employed, from about 1720, in pictures called *Uki-e*, in which the aim of the artist was to give a view of a theatre, a large room or the vista of a street, with 'lines vanishing to a point on the horizon' as the all-too-strict basis of the perspective view, and entirely in opposition to oriental practice.

In his late thirties (he was born in 1738), Shiba Kōkan became acquainted with some of the active *Rangakusha*, that is, scholars of the Dutch language and of things European in general. He is known to have visited Nagasaki in 1788 and recorded his observations in an illustrated record of his journey in the travel-book called *Seiyū ryodan*, 'Account of the Western Journey', 1790. He learned to etch on copper and produced a number of prints in this medium; he studied oil-painting in the western manner and not only became a quite creditable performer but wrote the only book up to that date concerned exclusively with western art, *Seiyo gadan*, published in 1799. He also wrote and illustrated books of astronomical, geographical, scientific and zoological interest, the text often translated from the Dutch and illustrations mostly transcribed from European models. In addition to such varied and suspect activities he also expressed views of a political and philosophic nature that could hardly have had the approval of the Bakufu, and it is somewhat surprising, therefore, that he

should have died of natural causes, at the great age of 81, in 1818.

We return to his activities as a Ukiyo print-designer. It is not known whether he actually received instruction from Suzuki Harunobu, nor whether he was authorised by that master to use the derivative name Suzuki Harushige. (Some have taken the extreme view that there may have been another Harushige, and that Shiba Kōkan may have forged *that* signature, too, but this seems to pre-suppose a quite inexplicable subtlety on Shiba Kōkan's part in confessing to one crime merely to hide another.) Most students take the view that his prints were all produced after Harunobu's death in 1770, and this is confirmed by the forger's own words. Shiba Kōkan, who aped the European even to the extent of indulging in memoirs and 'confessions', wrote in the book called *Kōkan kokai-ki*: 'At this time the master Suzuki Harunobu excelled in depicting the life of women of the day; but soon after 40, an illness carried him off. Then I put myself to design compositions like his and had them engraved and printed, and I imitated him so well that the public took me for Harunobu, so that I felt uneasy in my conscience about the misunderstanding and adopted the name Harushige for my prints. Sometimes I had painted the beautiful girls of my country in the manner of the Chinese painters Kyuyei, Shushu and others, in the sheets depicting the summer months I represented, after the Chinese models, the transparency of gauzes which allowed the naked limbs to be seen; for the winter months, it was a thicket of bamboos and a hint of reeds with a stone lantern in the garden, all covered with snow, and I used thin paper in order to mark the outlines in relief, as the Chinese do. It was the period when women put combs and pins in their hair and adopted a new mode of hair-dressing; I took good care not to overlook that, and the public was greatly taken with my prints. I feared then they would not be able to forget my name, and, soon, and for ever, I renounced these imitations.'

If we can take Kōkan's words at their face value—and there seems no reason, except perhaps a faulty memory or misguided vanity why he should have distorted the facts, writing as he did long after the events recorded—he first counterfeited Harunobu's

F

signature on prints designed in that artist's style, and then went on to design others which he signed Harushige. Presumably, for a short time after Harunobu's death, prints under that signature would have enjoyed the popularity of genuine Harunobu *nishiki-e*, though the demise of so well-known an artist can hardly have been kept from the public long. There will always be controversy concerning which of the prints signed Harunobu are in actual fact from designs by Harushige. Contemporary print-buyers were apparently deceived by them and it is small wonder if we find it hard to distingush them. It cannot just be assumed that those showing girls in transparent dresses, or snow scenes with heavy blind-printing, are by Harushige, since prints of this kind figure among those considered incontestably to have been Harunobu's own designs, but there are prints of these types which have always been rejected from the Harunobu *œuvre* and given to Harushige.

But it is not my purpose here to enter on this controversial subject. A sufficient number of fine prints are extant under Harushige's own signature for us to be able to estimate the quality of his work as a Ukiyo artist, and Plates 21 to 24 must surely convince the unprejudiced that his prints are worthy to be placed alongside Harunobu's: not, perhaps, the greatest of that artist's, which have a rare quality, a spirit of uncontaminated youthfulness lacking in any other artist's work, but the average print whose line and especially whose colour so enchant us.

The print of a girl descending the steps of a Temple (and serving as an analogue, in the curious Ukiyo-e game of parodies, of one of the episodes in the life of the mediaeval poetess Ono no Komachi, the visit to the Kiyomizu Temple in Kyōto), is a pretty thing, and the gentle curves of the girl's figure are contrasted with the even parallel lines of the steps (Plate 21). It does, however, immediately challenge comparison with a famous print of rather similar subject, usually attributed to Harunobu, though it is in fact unsigned. This is a print of a girl performing *Hyakudō*, the ceremony of climbing the steps of a temple one hundred times, each time placing a *koyori*, a paper-string, in a box kept for that purpose. The whole of one side of

the Harunobu print is taken up with the dark needles of a crypto-
meria, and beyond the branches a girl is making her way, with an
indescribable sidling motion, up the steps of the Temple which, as
in the Harushige print, run from top to bottom of the print in
strictly parallel lines. Harushige's treatment of foliage has been
put forward as a sign of western influence, and as a means of
distinguishing the false from the true Harunobu, but his Ukiyo
prints were designed long before he came in contact with the
Rangakusha and before he visited Nagasaki. Besides, the 'Girl
Performing *Hyakudō*' has none of the especial Harushige character-
istics, and must be presumed to date several years before the
'Kiyomizu Komachi'. Pleasant as Harushige's composition may
be, it shows his limitations and an obvious inability to draw a
girl of the exquisite grace, the melting charm, of the Harunobu.

The 'Interrupted Reading' (Plate 23) is a more exciting print
altogether, and the sinuosity of its curves, and the curiously
parallel inclination of the girls' heads, produce a design of unusual
effectiveness. The richness and variety of the colouring
accentuate the flowing movement, and the patterns of the dresses
are coiled about like water-weed in a lazy stream. The new
colours and the opaque tints and white, now introduced, had their
effect upon the designers just as the *beni* and the green had had
earlier. They invited to more elaborate composition. Figures
could be detached from their surroundings by the use of back-
ground colour; and the planes separating figures could be
expressed tonally, whereas before, the limitation of the two-
colour process operated against complicated groupings of figures.
Gauffrage and blind-printing also tended towards a greater
realism. The thick paper used for *nishiki-e* allowed this kind of
embossing to be employed, and the outline of garments gave even
greater prominence than before to dress, a development that was
bound to prove an attraction to the foppish Japanese of the time.
How well the print summons up, like a Restoration play, the
picture of a libertine society in which philandering was the
principal preoccupation of the youths, and the most serious
business of the girls was to make themselves sufficiently attractive
to promote the philandering.

The same air of frivolity pervades the next print (Plate 22), inscribed with a poem entitled the 'Fukagawa Brothel'. The semi-transparency of the *shōji* or sliding panels was used in a number of prints designed by Harunobu, and the Peeping Tom peering through a rent in the paper panels is a favourite motive, especially in erotic prints. But the beauty of this print lies in the contrasting curves of the two figures and the telling use of deep colour in both their dresses. The figure on the right has the gently resigned line—in the realm of music we would say it had a dying fall—that is the mark of Harunobu, and only the slightly awkward set of the head and the hard line of the neck remind us that the print is signed Harushige.

The 'Two girls on a bridge' is altogether enchanting and has a wonderfully rich tonality of colour, the slight oxydisation of the leaden colours of the background tending to enhance the intensity of the lovely tints of the girls' dresses; and just as, in Japanese metal-work, pewter is used as a foil to gold and by some alchemy seems the more precious metal of the two, so the chance patination of the distant sky produces rarer colours even than the rose of the standing girl's *kimono* (Plate 24).

This is a snow-scene, and blind printing (not obvious in the reproduction) has been used extensively, both features claimed by Shiba Kōkan to have characterised his counterfeits. But quite apart from that, the features of the stooping girl and the set of the head on her shoulders (sufficient to distinguish her from a true Harunobu creation) are exactly echoed in the other print, Plate 22, which is signed Harushige. For once, an unsigned print can be with some certainty assigned to an artist other than Harunobu. It seems possible that, in time, a careful study of the signed works of other artists working contemporaneously with Harunobu may lead to many other unsigned prints being returned to their rightful owners. This will hardly touch Harunobu's greatness, but it will greatly enhance the stature and interest of a number of minor artists, like Harushige, much of whose best work has invariably been given to Harunobu in the past.

CHAPTER VIII

———————o———————

Isoda Koryūsai:

Bird-and-flower Prints and 'Stone-prints'

HARUSHIGE, for all his interest to us, is a minor artist. The most gifted of Harunobu's followers was an artist who lived long enough to see the wane of the influence of that master and the slow rise of a new arbiter of Ukiyo-e, Kiyonaga. The artist who spans the period between these two summits is Isoda Koryūsai, in some ways one of the most enigmatic figures in the history of the print movement. In view of the close resemblance of his early work to Harunobu's, extremists have even gone so far as to deny his existence at all, looking on his name as another pseudonym used by Harunobu (who is reported to have used the name Koryūsai as a literary name); others, for reasons never properly explained, wish to deny him greatness as an artist in the same way that certain music critics, with equal bigotry, attempt to deny greatness to Elgar.

The first of these misconceptions has long been disposed of. As a pupil of Harunobu, Koryūsai was given the school-name of Haruhiro, and several prints exist signed Koryūsai Haruhiro. This more or less rules out the possibility of Harunobu ever using Koryūsai as an art-name. There is, moreover, a print, mentioned again later, on which Koryūsai admits to adding the colour to a design made by Harunobu, recently deceased.

It is difficult to think how the second objection ever arose. There is always, especially among collectors, a tendency to make comparison between artist and artist, and with Koryūsai it is perhaps a case of 'We look before and after and pine for what is not'. His early works suffer from a comparison with Harunobu's,

lacking that indefinable innocence which disarms criticism of even the most unoriginal of Harunobu's prints: his later seem clumsy at times beside the superbly assured elegance of Kiyonaga in his prime. But even his strongest critics defer to Koryūsai's pre-eminence in the designing of pillar-prints, and I think he is by far the most original Ukiyo designer of bird-and-flower prints (*kachō*) both in the normal colour-print and also the rarer so-called 'stone-print' (*ishizuri*)—sufficient distinctions in themselves to give Koryūsai a claim to be among the greatest of the 18th-century masters. His activity covers a period of intensely interesting transition in Ukiyo-e, and his output presents a wider range of subject, style and mood than that of any other artist of the period. He is thus the ideal master on whom to base a discussion of the immediately post-Harunobu movements of the 1770's.

He came of a class that supplied very few recruits to the Ukiyo School. Although neither place nor date of his birth is known, the old biographies concur in making him a retainer, of *samurai* rank, of one of the important families. On the death of his liege-lord, Koryūsai became a *rōnin*, a masterless man, a free-lance, and probably indulged in the Ukiyo way of life as well as adopting the painting style that had that soubriquet. We have no means of knowing how long he studied with Harunobu, though I suspect that he did not commence pupil until well after Harunobu had become the most popular artist in Edo, but it was long enough for him to have achieved a manner of design hardly distinguish-able from the master's. The connection between the artists was still close at the time of Harunobu's death in 1770, as witness the pillar-print already alluded to above, and another by Koryūsai, dating about 1769-1770, on which Harunobu inscribed a poem referring to his pupil in most affectionate terms.

Notwithstanding this closeness of style, there is usually little difficulty in distinguishing a Koryūsai print of the period 1767-1770 from a Harunobu. Koryūsai was no slavish copyist, and, unlike Harushige and others, had no intent to deceive. One is tempted to suggest that he was a more worldly person than Harunobu, and certainly his prints lack that ethereal quality that

makes the comparison of Harunobu to Fra Angelico, which some have made, seem plausible: and that despite the fact that Harunobu was much in demand as a designer of erotica. If one judges the prints designed by Koryūsai whilst Harunobu was still alive—and a pronounced change in hair-style shortly after 1770 makes it possible to segregate these early works—perhaps the most obvious distinction is in colour. Even then the distinction is greater in relation to Harunobu's early prints in full colour, produced before Koryūsai joined the ranks of Ukiyo-e. By 1770, the differences between them so far as concerns colour were much less. In the first experimental stages of colour-printing, when the palette suddenly seemed unlimited, rare and unexpected sports of colour resulted that were hardly repeated at all later. The tendency was for the pigments to become stronger and more stable as time went on, and this would be the natural result of a demand for larger editions. A good instance is afforded by a famous set of prints called 'Eight Charming Boudoirs' (*Zashiki Hakkei*) which some have refused to accept as Harunobu's partly on the grounds that in the unsigned first issues, colours and colour-harmonies are employed that are not matched elsewhere in the generality of Harunobu's prints. Two other issues followed the first, and by the third, the rare colours of the first impressions had disappeared and been replaced by others in common use at the time.

The whole problem of responsibility for the colour is intriguing. Did the designer decide how many colour-blocks were to be used, and did he superintend the choosing and mixing of printing-inks? A statement such as Koryūsai's, that he provided the colours for a print designed by Harunobu, might seem at first flush to place the issue beyond doubt, but in point of fact, it is unwise to accept inscriptions at their face value, or to take them literally without corroborative evidence. There is too often a punning ambiguity, a metaphoric intent or downright 'spoof' in such effusions for one to place much reliance on them. The Koryūsai print in question may have been annotated by the artist, or even by the publisher, to bring out the artist's association with the popular idol, now deceased, and to suggest that the mantle of Ukiyo-e artist-in-chief

had fallen to a natural heir. It was, after all, good advertisement
for the publisher of Koryūsai's prints.

At times, publishers collaborated in the issue of a set of prints,
using the same blocks but employing their own printers. For
instance, in 1806 the houses Tsuruya and Izumiya jointly under-
took the publication of a series of Chūshingura prints after designs
by Hokusai and, as Volker says, 'Experts are now pretty well
unanimous in preferring copies issued by Izumiya because their
colour scheme is more beautiful than that of the set by Tsuruya.'
Hokusai may have indicated roughly the colours to be used, but
ultimate colour harmony was the result of the printer's choice of
pigments. This sort of evidence seems to disprove the likelihood,
in many cases, of the ultimate colour effects being attributable to
the designer: there is a stronger probability of the publisher and
his printer making the vital decisions. Hence, obvious distinc-
tions in colour between the prints of Koryūsai and Harunobu may
be traceable to the fact that their prints were issued by different
publishers rather than to any personal colour predilections.
Throughout the *œuvre* of Sharaku we are struck by colour har-
monies, aided by mica grounds, of an intensely personal kind: one
might put that down to a power in that strange artist comparable
to his undoubtedly unique gift for expressive line; but it is also
undeniable that all Sharaku's prints were issued by the one
publisher, Tsutajū, and the choice of bizarre colour to match the
brutal line may have been the publisher's stroke of genius instead
of the artist's.

It is difficult for us to rid ourselves of the normal western bias
in a matter like this and to allow a Japanese artist far more
autonomy than he had in actual fact. The majority of Ukiyo
prints were turned out on a mass-production basis, and this is
hardly surprising when the enormous output is taken into
consideration. Designers did not always bother to complete the
drawings for the block-cutter. Quite often, detail work such as
the pattern of a brocade, the stones of a wall, the foliage of a tree,
would be indicated merely by a sample—a rosette, a single stone,
a cluster of leaves—and the block-cutter would be expected to fill
out the whole. The staggering thing is that, despite this method

of shared responsibility in the preparation of a woodblock print from an artist's first draft, the style and even the personality of the individual artists still come through to us: though the same penetration of the spirit of the original artist is made through the even more intractable materials and laborious processes of other products of Japan usually termed 'craftsmen's work'—lacquer, for example, or metal-work. One cannot help feeling that artist-designer and craftsman-executant were so closely integrated in the production of colour-prints, lacquered boxes and metal sword-furniture—the skilled and sensitive artisan catching the drift of the originator's ideas and moving in complete sympathy with them— that the medium was no impediment to the artist's utterance, but in fact magnified it, as through a series of amplifiers. An outline brush-drawing for the block-cutter by Koryūsai may seem a tame thing: translated by clairvoyant craftsmen, working with colours and papers lovely in themselves, it becomes something far other than it was, a musician's score brought to life by virtuosi, and though we still give all credit to the artist whose name appears on the print, perhaps he should only be thought of in reality as the one who sets off a chain reaction, resulting in an end-product hardly foreseen even by him.

After Harunobu's death in 1770, Koryūsai's style underwent a rapid transformation. In the late 'seventies he designed a vast series of prints under the title of 'Patterns of the latest fashions for young girls' (*Hinagata wakana hatsu no mōyō*). For this series, he, or his publishers, introduced the large *ōban* sheet, 14 inches by 10, which thenceforward became the standard print size. The prints are of an unvarying subject matter: one or more courtesans with attendants, depicted full-length, promenading or engaged in some elegant pastime in a 'house of assignation'. The courtesans are invariably named, but in this series they are merely models displaying with professional *élan* the clothes currently exciting the men and women of Edo. As designs these prints are often un-inspired, and perhaps Koryūsai was not altogether familiar with the requirements of the new format. Some are too crowded, with a confusion of level coiffured heads; others are simply dull, the figures posed, for the sake of displaying their finery, in

uneventful groups; but as repositories of fashion, of lovely patterned silks and brocades, they are unsurpassed.

If I am reproducing only prints of the *kachō* kind, it is not because there is any lack of fine figure prints designed before and after 1770: it is simply that the *kachō* represent a sphere in which Koryūsai is pre-eminent and in respect of which his genius has not been sufficiently acknowledged. There were predecessors even in the Ukiyo-e School. Kiyomasu's falcons have been described, and Okumura Masanobu and Nishimura Shigenaga also designed some examples in the narrow, *hoso-e*, format. There seems no doubt that Harunobu himself gave the most direct lead to Koryūsai in prints of this type as in others, but once again we enter on controversial ground, for many of the *kachō* of the period are unsigned and the signature Harunobu on others is suspect. However, Koryūsai's name appears on so many, and on such beautiful, *kachō* that whatever part Harunobu played in the genesis, Koryūsai may fairly be looked on as the master that exploited the possibilities of compositions of this kind to the utmost.

It is possible that many people who enjoy Koryūsai's *kachō* do not realise how venerable the tradition of animal and flower painting is in the Far East. The source, however distant, can be traced back to the great Chinese painters of a remote past— painters whose original works had mostly been lost through fire and accident and which in Koryūsai's day were known only through copies, and then only to the fortunate élite. Koryūsai and his fellows probably had scant opportunity to see the carefully guarded scrolls bearing the mighty names of Sung and Yüan, and knew no more of the Chinese paintings than could be gathered from the collections of woodcut transcriptions such as *Kingyoku Gafu* mentioned in the chapter on Settei. The painters of the Kanō School, through their aristocratic patrons, may well have been able to study the brush-work of the revered Chinese in the original scrolls and the paraphrases, but most of the Ukiyo artists knew the paintings only at third-hand as woodcuts, already half-way translated into the medium of the colour-print.

But though denied contact with the painting technique of the

ancients, the common man in Japan came, through these humble woodcut versions, to understand the reverent spirit informing animal and flower paintings of China and the classical masters of their own country. Fundamentally, this attitude arose from a philosophy that respected all animate things as different manifestations of the all-pervading life-force and that did not elevate man to a position of domination over brute creation. In consequence, the painter-philosopher—and in ancient China the terms were synonymous—gave a deep and serious meaning to the painting of a bird, or a scroll of flowers and insects, anticipating in their brush-drawings something of the mysticism that Blake or Wordsworth was able to convey in words. In the West, there *was* a tradition of animal and flower painting, but in pre-Renaissance times, realistically as creatures and plants were painted, they were subordinate to the main theme of the painter, which was invariably centred around human or divine beings. If such subjects were painted separately, it was in the nature of an exercise, or a preliminary study for a relatively minor detail in a Nativity or a Crucifixion. During and after the Renaissance, it became increasingly the practice to devote paintings to single animals or to arrangements of flowers, but such paintings were conceived in a way diametrically opposed to that of the oriental masters. Titian's 'Dog' is the portrait of a particular dog; Huysum's flower-arrangements are vehicles for the exhibition of his mimetic skill. Painting was used as a means of reproducing the appearances of things, and the oil-painting technique lent itself to this aim. In the East, where the painters used ink or water-colour and a freely-handled brush, a mere external record of animal or plant was obviously never the intention; and in his unencumbered approach, it was natural that the oriental painter should have tended consciously to *compose* his *kachō*, disposing leaf and flower, or bird on the wing, with the same feeling for spatial arrangement that guided his hand in calligraphy. That might sometimes necessitate the placing of an animal in such a way that the edge of the picture cut it in half, or it might lead to an asymmetry in which, say, a thicket of bamboos would fill one side of the picture space and the remainder be left blank: but the

painter was quite prepared to do violence to natural forms and to normal visual impressions in the same way that, for the sake of effect, he would sacrifice legibility in his calligraphy.

In Japan, even more than in China, there was a flair for pattern so general that it informs the works not only of painters but of lacquerers, ceramists, silk and brocade makers, and metal workers, and was perhaps the one quality above all others that so forcibly impressed the West on its first real contact with Japanese art in the 19th century. Illogically, the very writers who praised Japanese design quite often criticised the artists for their lack of modelling, for the absence of perspective, not realising how inimical these western aids to realism would have been—and did prove later—to the faculty for flat patterning in colour or monochrome. Paintings such as those of Eitoku or Kōrin could never have arisen in a society where naturalistic painting for its own sake prevailed, nor could Koryūsai have designed woodcuts in the way he did if his clientèle had expected botanically or ornithologically detailed plates.

Instead, he employed the flat tints and the other technical resources of the printer to, if anything, still further enhance the non-representational nature of his drawings. In a print of 'Herons in Snow' (Plate 26), stark against a blue sky, the lines of plumage, picked out by *gauffrage*, are decorative first, descriptive afterwards. In another famous print of a heron and a crow, there is a quite deliberate alternation of white and black passages for pictorial pattern. In the 'Chin Dog' (Plate 25), quite apart from the electric spruceness of the little Chin—a pampered boudoir favourite like a poodle today—a striking balance is obtained between the intensity of his black coat against the warm colours of the clothes hanging on the rail and the bowl of toys beside it. In a print of a pair of mandarin ducks among snow-covered bamboos —symbol in the Far East of conjugal steadfastness even in adversity—there is little colour and the effect is given by a simple but sensitive design, the splintery pattern of the bamboos against the full billowing curves of the birds.

Many of these prints, with their exquisite printing and elaborate *gauffrage*, have a distinctly Chinese flavour and particularly

recall certain 17th-century Chinese woodcuts with embossed details. But the Japanese spirit plays over Koryūsai's prints: the Chinese, exemplary as they are technically, have none of the playful verve, the latent dynamism, of Koryūsai's creations. It is, again, one of the secrets of the Japanese gift for design that, however simplified animal, bird and flower may become, they still retain their life, they are not just conventional forms based on living things, but carry a sense of immense vitality that prevents the compositions becoming static, geometrical devices.

In the so-called stone-prints, the unusual technique leads to unique surface and colour effects, but neither promote realism, in fact the process precluded anything approaching naturalism. It was undoubtedly the most curious method of block-printing evolved by the Japanese. It began with simple white-line wood-cuts imitating Chinese stone-rubbings. In China, the outlines of great paintings were sometimes incised in stone and a rubbing gave the outline in white on a black ground. Okumura Masanobu and others of his period had outline designs cut into the woodblock and when printed the effect was similar to a stone-rubbing: the fact that in China such a method was used for perpetuating great works of art added a certain Ukiyo spice to the prints of Japanese low-life or analogues of Japanese classics. Although called *ishi-zuri*, 'stone-printed', they were clearly nothing of the kind. Later, a different and much more involved process was employed. The description in Binyon and Sexton can hardly be bettered: 'After the wood had been incised, so that the design would show white on black if printed, a very thin sheet of paper was damped, laid on the block and pressed into the hollows made by the engraver. But instead of the woodblock receiving the colour, as in the ordinary process, it was the surface of the paper to which the colour or ink was applied, with a pad, not a brush. The design itself did not take the colour, because it was pressed below the surface of the block into the engraved hollows and escaped the application of the pad; it remained white. When the thin paper was taken up, it showed the design standing out in white with a raised and crinkled edge to the white lines where the paper had been pressed into the block. It was then

laid on thicker paper.' It may be added that, strictly speaking, the resultant picture was hardly a print in the true sense of the word; and, moreover, there is evidence in one or two of Koryūsai's *ishi-zuri* (if we accept them as his, for the greater part are unsigned), of a mixed method, parts of the design being produced by straightforward printing methods, others by the forcing of thin paper into deeply incised lines in the manner described in the above passage. The print in such cases was built up from a number of small pieces of paper and reminds one, in technique, of some of the strange effects achieved by the modernist Onchi using *montage*.

Yet the process, so painstaking and unnecessarily complicated, inspired Koryūsai to some of his finest designs and to some of the noblest prints in the whole of the Ukiyo *œuvre*. The 'White Falcon' (Plate 27), is justifiably extolled as a masterpiece: it does genuinely hold its own, both in loftiness of conception and power of design, with the great Chinese paintings with which it challenges comparison.

The 'Falcon and Peonies in Snow' (Plate 28) actually bears the signature Utamaro, but it is so completely identical in technique and style with other prints accepted as Koryūsai's that it is believed the signature (and the publisher's mark and the censor's seal) were overprinted later, perhaps by an unscrupulous dealer with the knowledge that a signed print is always worth more than an unsigned, and while one was about it, why not forge a name like Utamaro, so much more deferred to by collectors than Koryūsai?

These prints, of which few are known, and those in very few impressions, seem to show a change in direction in Koryūsai's art, a tendency to move away from the world of the Yoshiwara, whence he had drawn most of his subjects until then, towards the refined subjects of the Chinese and Kanō Schools. Towards 1780, he was already devoting himself more and more to painting proper and a number of very lovely *kakemono* are ascribed to this time. They are unquestionably Ukiyo-e in technique, but as so often among the print-designers, less frivolous than the broadsheets, and one could easily be persuaded that the artist had sown

his wild oats and was settling down to a respectable old age. He begins to preface his signature with the title *Hokkyō*, a term that at one time had a priestly significance, but which in Tokugawa times became an honorific, usually bestowed on painters of the Kanō School. In a print like the 'Seven Sages in the Bamboo Grove' (an impression of which is in the British Museum), Koryūsai has reverted to a style nearer the aristocratic Kanō than the Ukiyo-e, and one wonders whether, with the new title, he had again achieved respectability in the social sphere and was intent on living down his Ukiyo past.

Apart from a very considerable output for erotic albums and *ehon*, Koryūsai designed very few picture books. One is an undated picture-book of about 1781 entitled 'Poems of the Villas of the North' (an euphemism for the courtesan quarter), a relatively undistinguished collection of designs printed in black, and whose profane subject matter did not apparently preclude the artist's use of his new title of *Hokkyō*. Another is a far more unusual compilation, published in 1781 and confirming the final direction of his style and outlook. *Konzatsu Yamato Sōga*, 'A Medley of Drawings in the Japanese Cursive Style', is a three-volume work containing designs drawn with a racy, impetuous brush in complete contrast to the rhythmic flowing lines of the broadsheets. In Volume 1 there is a procession of courtesans and attendants and the difference between it and any one of the 'Patterns of the latest fashions' is immeasurable: the subject matter is identical; the style, and the feeling, are poles apart. Another, a drawing of a cat and two crows, struck off in a rough, summary way, provides an object lesson, when compared with the studied calculation of the 'Chin Dog' for instance, in the meaning of brush-style in any consideration of Japanese art.

Koryūsai seems to have retired soon after the publication of this splendid book, leaving the Ukiyo-e scene just as Kiyonaga, the next great figure, was attaining to full stature.

CHAPTER IX

---- o ----

Shunchō:

The Triptych and the Pillar-print

AT the time the Japanese print was gaining favour in the West, there was, as I have already mentioned, nothing in Japanese art literature that dealt seriously with Ukiyo-e. As a consequence, there being no native expression of ideals and canons, a body of western critical appreciation came into being in which the Japanese print was assessed in the way European paintings were assessed, with an eye to the naturalism of the draughtsmanship, to the technical accomplishment of the artist in handling his medium, and to composition in the sense in which the word was used in relation to western paintings. Whatever case may be made for the influence of Japanese art on the design of the Impressionists and the Post-Impressionists, it is a curious fact that, with the possible exception of Gonse, the western art-writers who took the Japanese print as their field were either unaware of, or else unsympathetic to, those tendencies in European art that stemmed from Impressionism. Most of them were traditionalists in their approach to western art, and some might even be described as reactionaries. We often find these critics adopting an almost Ruskinian approach to oriental art, using what we now feel to be inappropriate or inept measures of the print-designers' stature, detracting from one because his calligraphic line is more important than his subject, belittling another because details of his drawing are non-naturalistic: deriding them, on this false foreign assessment, for the very characteristics that would have been, in the native view, essential elements of style.

On this basis, it is easy to understand how Kiyonaga came to be

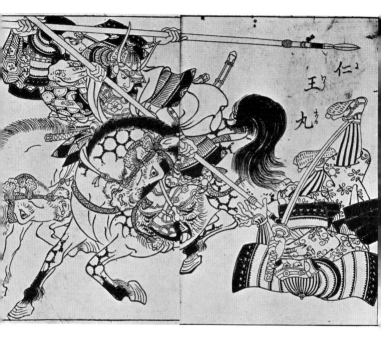

17. Tsukioka Settei: A battle-piece from the 'Picture-book of Sprigs of Greatness', 1759. 9″ × 12″. *Author's collection*

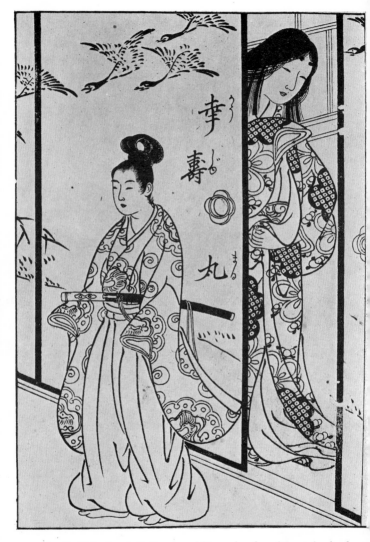

18. Tsukioka Settei: Kojūmaro and his mother from 'Picture-book of Sprigs of Greatness', 1759. 9″×6″. *Author's collection*

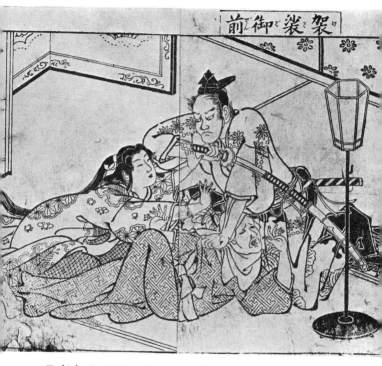

前御袈裟

19. Tsukioka Settei: Keza Gozen interceding for her mother's life; from
'An Array of Brave Women', 1757. 9½″×12″. *Author's collection*

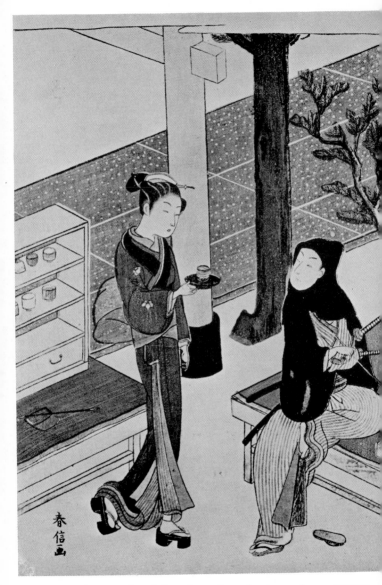

20. Suzuki Harunobu: O-Sen, the tea-house beauty, serving a customer
11″ × 7⅞″. *British Museum*

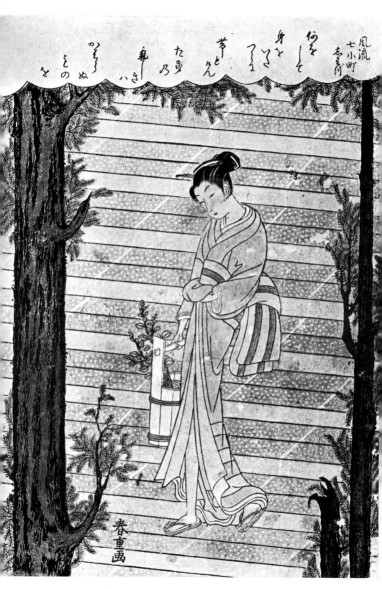

風流
七小町
志三川

何を
身を
芋と
たる
車の
をのぬ
かさ

21. Suzuki Harushige: Girl descending Temple steps
11″ × 7¾″. *British Museum*

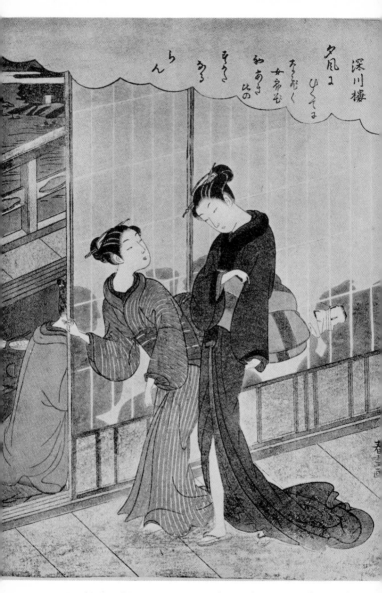

深川楼

夕凪に
ひくそよ
そるねく
女帝玉
和あき
比の

らん

そり
そそ

22. Suzuki Harushige: A courtesan, and a maid opening a *shōji*, inside the Fukugawa House. 11″×8″. *Museum of Fine Arts, Boston*

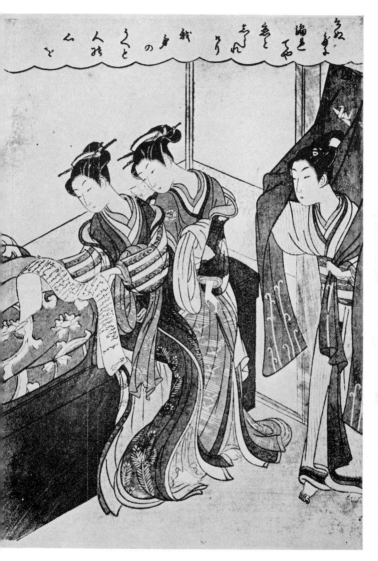

23. Suzuki Harushige: An Interrupted Reading
11″ × 8″. *The Art Institute of Chicago*

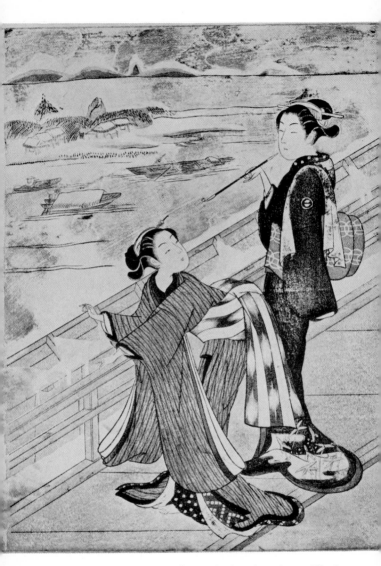

24. Suzuki Harushige: Two girls on a bridge after a heavy fall of snow
$11\frac{1}{2}'' \times 8\frac{1}{2}''$. *Grabhorn Collection*

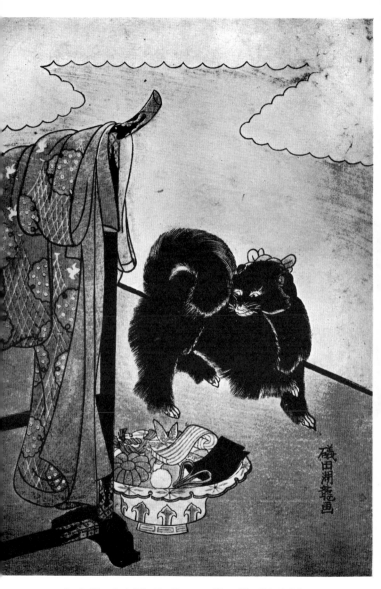

25. Isoda Koryūsai: The Pet Dog. $11\frac{1}{4}'' \times 8\frac{1}{8}''$. *British Museum*

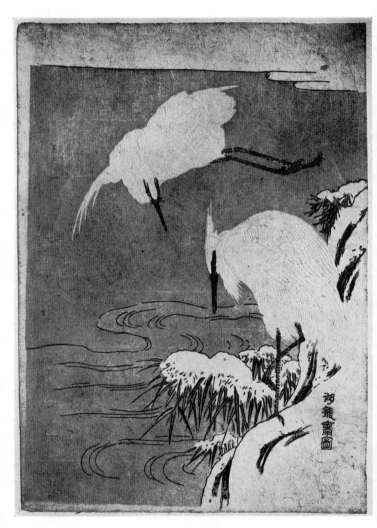

26. Isoda Koryūsai: Herons in the Snow
10¼″ × 7⅝″. *The Art Institute of Chicago*

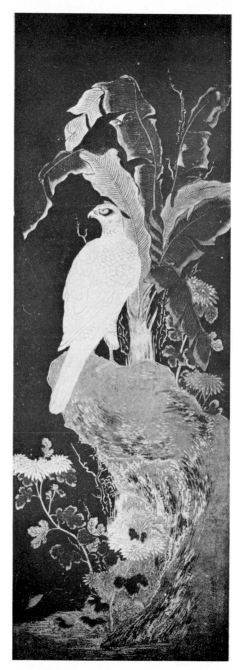

27. Isoda Koryūsai:
The White Falcon
Ishi-zuri-e kakemono-e.
35″×11⅝″ *The Art
Institute of Chicago*

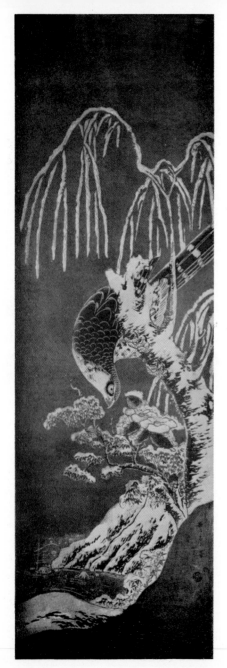

28. Isoda Koryūsai:
Falcon and Peonies in
the snow *Ishi-zuri-e
kakemono-e.* 35″ × 10½″
Huguette Berès

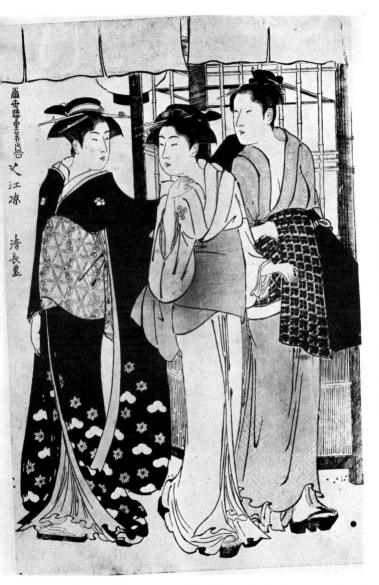

29. Torii Kiyonaga: Three women of the Nakasu district, from the series
'Present-day beauties of the Gay Quarters compared'. 15″ × 10″
Museum of Fine Arts, Boston

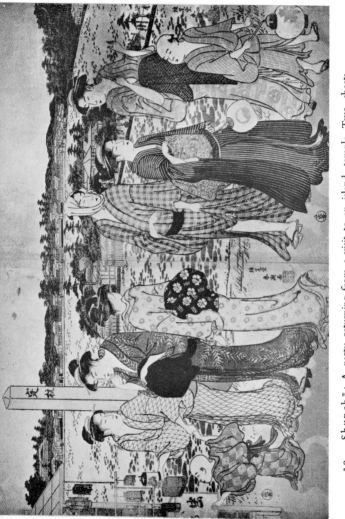

30. Shunchō: A party returning from a visit to an island temple Two sheets of a triptych, each sheet 9½″ × 14″ *The Chester Beatty Library*

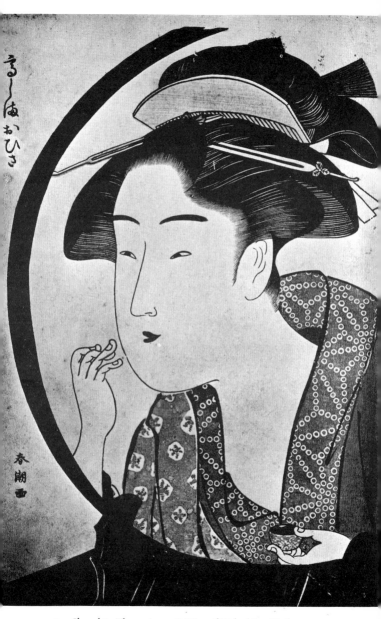

31. Shunchō: The waitress O-Hisa of Takashima Teahouse
reflected in her mirror. 13¼″×9″. *British Museum*

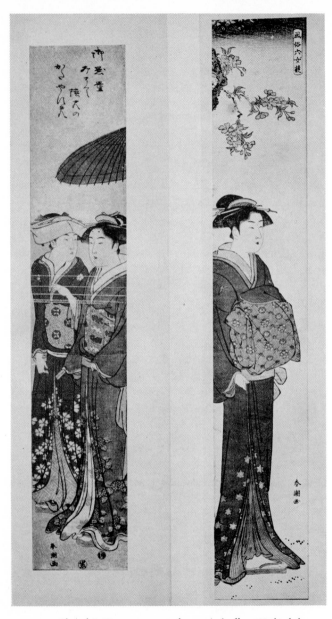

32a. Shunchō: Two women under an umbrella. *Hashirakake*
32b. Shunchō: Woman under a cherry tree. *Hashirakake*
Museum of Fine Arts, Boston

looked upon as the ultimate peak among Ukiyo designers, the summit of a curve commencing low down at the 'naïve incompetence' (as draughtsmen) of the Primitives, soaring up through the greater colour realism of Harunobu, and descending, after Kiyonaga, through the extravagant distortion of Utamaro, Chōki and Sharaku to the banal design and violent non-realistic colouring of the 19th-century artists. The burden of nearly every history of the Japanese print is expressed most succinctly in the chapter headings of A. D. Ficke's 'Chats on Japanese Prints' (1915). First Period: The Primitives; Second Period: Polychrome; Third Period: Kiyonaga; Fourth Period: The Decadence; Fifth Period: The Downfall. It is difficult, of course, to fit Hokusai and Hiroshige properly into this scheme as both happen unconscionably to fall within the period labelled The Downfall, but they are for convenience classified in a separate division representing 'The Revival of Landscape' or some such thing.

To Fenollosa, to Ficke, to Binyon and Sexton, Kiyonaga is the 'culmination'—but the culmination of what? Technically, he inherited a perfected medium and the ideal format. By the time he had reached his prime, soon after 1782, nearly twenty years had passed since the introduction of polychrome printing and among printers a greater range of colours and a completer mastery in applying them existed than ever before. In the previous decade, Koryūsai had introduced the large ōban sheet and Kitao Shigemasa, using this sheet to great advantage, had placed upon it figures of an amplitude and a naturalism that were new to Ukiyo-e and which profoundly affected Kiyonaga's own manner of drawing. The degree of realism, at least in portraying the human figure, had advanced in such a way that in Kiyonaga the men and women are of a naturalism clearly more acceptable to those brought up in the tradition of European art than, say, the figures of arbitrary . anatomy outlined by Kiyonobu's uncompromising brushstroke. The girls are now divinely tall, but their parts are in proportion, their hands and wrists are not, as in Harunobu, ineffectually tiny, and their draperies fall into their folds, over bosom and thigh, naturally and in a way to suggest the body underneath: not, as with Kiyomasu and Kaigetsudō, artificially for the sake of the

G

more sweeping brushstroke. The printers' use of colour, too, with the effects of transparency, for instance, that could be obtained by printing the colours of one garment over another in such a way that the pattern of the covered dress showed through, its colours subtly changed: and finally, the *plein air* settings often introduced, with the effects of space and sunshine and the play of foliage in the light—all served to 'fill out' the prints, to give them, still without the western artifices of perspective and chiaroscuro, a deceptive air of actuality to a degree before unknown. Did Kiyonaga merely then represent the culmination of 'naturalism' in the Japanese print? Was his ability as a draughtsman a natural development along a road already travelled by Koryūsai and Shigemasa, and his success due in part to his being able to avail himself of a medium brought to the pitch of perfection? Perhaps, like Harunobu, Kiyonaga has been over-praised: perhaps, in these days, it is almost a disqualification from greatness to give such constant evidence, as Kiyonaga does throughout his career, of normalcy and temperance.

It is idle to speculate on what might have happened if another artist than Kiyonaga had emerged as the dominating force at this stage in the development of Ukiyo-e. Other equally and perhaps even more greatly gifted artists abounded. Among them, apart from Koryūsai, were Katsukawa Shunshō who had vied with Harunobu in the 'sixties, collaborated with Bunchō and Shigemasa in the 'seventies, and assumed leadership in the realm of actor-print designing; Shigemasa, a faultless draughtsman with as great an artistic range as any other living Ukiyo-e artist; Kitao Masanobu, his pupil, who, at the age of 23, in 1783, produced an album of seven diptych prints that gave proof of an enormous potential talent; Utamaro, only a year younger than Kiyonaga, but in the early 'eighties still experimenting and unsure of himself; even Hokusai, who was in his early twenties and designing prints in keeping with his position as a humble follower of Shunshō. No one sustained a challenge to Kiyonaga. Shunshō made no attempt to rival Kiyonaga's success in the sphere of the courtesan or 'beautiful girl' print and continued his own way, designing actor-prints to the day of his death little different, except in

unessentials, from those of two decades earlier; Shigemasa seemed
to be ruled by a Landorian aloofness: 'I strove with none, For
none was worth my strife', and, in any case, devoted far more of
his energy to book-illustration than to broadsheets; Koryūsai,
invested with his new-found respectability, retired from active
print-designing; Masanobu virtually forsook prints for novel-
writing, earning fame under the name of Santō Kyōden as
one of the great comic writers of his country; and neither
Utamaro nor Hokusai came into his own until Kiyonaga had left
the scene.

What was Kiyonaga's gift, then? Almost, one might conclude
hastily, a lack of originality, or certainly, of the sort of originality
that might have puzzled or alienated the populace of Edo. A
maturer judgment would assess this quality as an essential sanity,
the serenity of a healthy body and mind, the confidence of a hand
that has endured an arduous apprenticeship and performs all it
sets out to do with impeccable expertise. Quite early, he
gauged the taste of the pleasure-seeking people who frequented
the print-stalls. They loved dress and were captivated by the
novel or unusual in the cut of a *kimono* or in the silk or brocade
pattern—one can imagine it being a matter almost of rivalry
among the merchant intelligentsia to be well versed in the current
vogue; they were inordinately fond of pictures of beautiful girls,
and if they were presented under the names of famous courtesans,
and in the latest, exclusive models of *haute-couture*, then the girls
were so much the more desirable; they were, again, like Cockneys,
sentimentally inclined towards certain localities of their home
town, and if the belles in their finery were depicted on the
Ryōgoku Bridge, or in the main street of the Yoshiwara, or in the
lovely cherry-blossom park at Asakusa, such prints were well-nigh
irresistible. The choice of subject may, of course, have been due
to the acumen of the publisher, but Kiyonaga, once he had found
his true metier, drew this sort of print with such superb assurance,
invested his courtesans and their attendants with such abundant
feminine charm, showed such invention in devising fresh motives
for patterning their silks, that his success was assured. There are
the carpers who draw attention to his limitations as a designer and

point to the frequency with which he relied upon the 'process-ional' form of composition in which the tall girls and their foppish consorts form a chain of only slightly varying figures from one side of a three-sheet composition to the other; or who, like Koechlin, suggest that however healthily animal these creatures are, they suffer from a sort of vapidity, and we are not sufficiently intrigued even to enquire what they are doing. Certainly, for us to go steadily through the portfolio of reproductions gathered together by Chie Hirano for her monumental *catalogue raisonnée*[1] is to experience a sense of repetition and monotony: but there are other Japanese artists who, if their works were brought together in sufficiently large numbers, would convey just that impression, and we have to remind ourselves that the prints were issued only at intervals to satisfy a transient demand, without a thought of this later scrutiny of them in bulk. If there is a monotony, it was the outcome of the systematic exploitation by the pub-lishers of an artist who had achieved a complete hold on the public (Plate 29).

During the 'eighties, Kiyonaga's popularity was unrivalled. Most other print designers at work at the time seem to have been obliged to produce prints on the same lines as his or to lose all hope of finding a publisher. Only thus can we explain the extraordinary power he exercised over his contemporaries, including even so highly original an artist as Utamaro. It is unlikely that the artists who followed his style so faithfully ever had any direct association with him, and in fact his most successful copyists—Shunchō, Shunzan, Utamaro, Chōki, Eishi and Eishō—all had their initial training under other masters.

We, at this distance of time, with collected reproductions of each master's works available, are in a better position to distin-guish between artist and artist than their contemporaries were. What was left for the band of highly gifted artists that came to maturity under the all-pervading influence of Kiyonaga, who laboured under the necessity to imitate his manner? Most of them eventually chose their own paths, significantly, in the case of Chōki and Utamaro, in the direction of non-naturalism; or, in

[1] Chie Hirano, 'Kiyonaga: A Study of His Life and Works', 1939.

the case of Shunman, towards a new sphere altogether, the designing of *surimono* and of prints for poetry-albums. Shunchō remained faithful to the Kiyonaga ideal, perhaps through an inherent streak of unambitiousness, or self-effacement, or complacency. As a result, there is a tendency to ignore him as one who merely echoes strains that Kiyonaga gives directly, but to do so is to miss the subtle overtones that belong to the work of a plagiarist sufficiently accomplished to be considered a master in his own right.

Little enough is known of most Ukiyo-e artists: concerning Shunchō there is an almost complete blank. He was a pupil of Shunshō, and in the mid-'eighties designed actor-prints in the *hoso-e* format much in the master's manner. Like other pupils of Shunshō, he quite soon began designing sets of small prints of a type that Kiyonaga, following a tradition almost as old as Ukiyo-e, had made popular. The link between the six or eight or other chosen number of prints was most tenuous and as often as not rested in the title: the real and only subject of each print was the action of the figures portrayed or suggested, and the fashionable garments they were wearing. To give an instance, one of these sets, composed about 1785-1786 when Shunchō had already succumbed to the Kiyonaga influence, is entitled *Edo no gozan*, 'The Five Hills of Edo'. Each of the five small prints is subtitled with the name of one of the 'Five Hills'—Toezan, Matsuchiyama, Asukayama, Atagoyama and Gotenyama—but there is practically nothing of a topographical nature to identify these locations. In the 'Toezan' print, on a quite anonymous patch of turf, beyond a leaning cherry-tree in flower, a youth and two attractively dressed girls have met. He is puffing at one of those long, slender, frustratingly small-bowled pipes the Japanese have always affected, and one of the girls, holding a similar pipe in her hand, is seeming to ask the youth for a light, the other girl peering over her shoulder with the politest interest imaginable. The setting could be any one of a hundred places in the Edo suburbs. Atagoyama is a hill in the purlieus of Edo affording an extensive view over Shinagawa Bay, but the print with this sub-title shows three enchanting *musume* resting in a

tea-house at the summit of a hill, and though it is true that beyond the fence of the tea-house there is a tiny glimpse of a far-off bay, neither tea-house nor bay exists except as background for the girls in their perfectly displayed *kimonos*.

It was with prints of this small size, issued in sets of up to twelve prints, that Kiyonaga had made his name a few years earlier. It was not until he had established himself that he suddenly launched into the series of great prints in the larger format and often of diptych form that have been so universally praised. Shunchō, lagging always some years behind his model, never quite reached the magisterial grandeur of Kiyonaga's finest prints, though he closely approached it in a series of three prints entitled 'Snow, Moon and Flowers of the Floating World' (*Ukiyo Setsu Gekka*). This title, again, is one of the perversions beloved by the Ukiyo artists, who delighted in giving a new, slightly scandalising setting to subjects treated traditionally and with reverence by the classical masters. Originally the 'Snow, Moon, Flower' concept was expressed by the masters of old in landscape, and man, if introduced at all, was dwarfed by his surroundings. In Shunchō's prints, the landscape has receded and the figures fill the picture-space. The key to the 'Flower' part of the trilogy is a very perfunctory spray of cherry-blossom above the heads of a party of picnickers who have fetched up at a stall (probably of a vendor of water, for there are shallow cups on the table), on some green knoll above the rice-fields. The lady of the party wears one of those large flat straw hats which were so picturesque a feature of summer wear in Edo at the time, and languidly plies her fan before her face. The youth accompanying her has his arm inside a closed parasol as if he has just closed it. Preceding them is a servant girl wearing a *kimono* of black-striped linen that, in Kiyonaga's and in Shunchō's hands, becomes a material of a beauty equal to the most expensive flowered silks. There is a statuesque immobility in this group that, more even than the features of the man and girls, justifies a comparison to Kiyonaga at his most monumental. The other two prints are of the same impressive order. 'Snow' is represented by an interior scene in winter time, with men and women by a brazier and two

maids shivering in the background; 'Moon' by a group of three *geisha* on a bridge in moonlight.

But Shunchō could not sustain a flight at this altitude for long: although it was not beyond him to attain such a peak, he cruised and found his truer level some distance below. This is represented, in the Kiyonaga *œuvre* Shunchō followed so closely, by those prints in which the figures are of less exalted proportions, reduced to something nearer the Japanese norm, relatively short by our standards. In the great diptychs of 'Twelve Months in the South', acknowledged the apogee of Kiyonaga's art as a designer, the figures are preternaturally tall, the elongation being fundamental to the conception and success of the compositions as it is, say, to the statuary of Chartres or the paintings of Pontormo. In the triptychs he designed in 1786 and 1787, however, the men and women are of less heroic mould, and the compositions, though effective, have lost that power to storm our aesthetic barricades possessed so abundantly by the earlier prints. It is the suave urbanity of these later triptychs that Shunchō repeats, and indeed, on occasion, enhances, in his own prints in this exacting format.

The triptych was designed as a continuous composition, extending over three of the normal *ōban* sheets, each roughly 15 inches by 10. It could not be cut on one block, since even if a block of the required size could have been cut from a cherry-tree it would have been liable to warp and far less easy to handle by block-cutter and printer than a block of normal size; and again, the size of a print was governed by the paper-manufacturers, who naturally turned out their product in stock sizes. (The *ōban* sheet was, in fact, one-half the medium size in which the paper employed by the printers was made.) We, in the West, may wonder why the triptych, with all its attendant technical problems, was ever introduced. It was, however, yet another harking back, by a circuitous route, to both Chinese classicism and to the early Yamato-e, or native forms, of Japanese painting. Among the Kanō painters, it was an established practice to paint three separate *kakemono* linked by a common theme—to take a simple example, Longevity would be depicted by a centre piece of

Fukurokujū, the God of Long Life, and by wings of a Pine Tree and Cranes, symbols of 'One thousand years of happiness'. The *makimono*, the continuous lateral painting, was the favourite vehicle for the Yamato-e painters. The triptych was neither of these things: the design was continuous, unlike the three separate paintings of the Kanō artists, yet it was of limited width and viewed at a glance, in which it differed from the Yamato-e scroll: yet there was a half-hint of both scroll and 'set of three', and in fact, the Primitive print-designers did actually design 'sets of three'—actors in a play, or girls representing the Three Capitals or some other subject that leant itself to trilogic treatment. Although the 'continuous' triptych of *ōban* size may not have been an innovation of Kiyonaga's (Shunshō designed at least one triptych that may be earlier than any of his), he undoubtedly developed it and became the greatest exponent of the form, his long processional compositions, linked by the level lines of a landscape far more realised than had been customary until then, spreading naturally over the wide surface presented by the three joined sheets. A margin was left by the printers to enable purchasers to join the sheets together, but it seems almost to have been expected by the designers that the sheets would rarely remain together, for each, so far as was possible with the needs of the over-all composition in mind, was designed to be complete when isolated. It is due to the astonishing feats of the artists in designing three separate sheets, each perfectly balanced as a composition in itself, and yet, brought together, making another and richer harmony as a triptych, that we owe the difficulty of deciding, in many instances, whether a single sheet originally formed part of a triptych or not.

Shunchō is known to have designed some thirty or forty triptychs, but possibly his output was considerably more. There is no doubt that this kind of print offered him the most congenial vehicle for his particular talent. Nobody was ever more adept at disposing graceful groups of figures in a *plein-air* setting. He had a natural refinement that made him avoid over-complexity and a restraint that prevented the multitude of diversely-patterned and coloured dresses becoming an uncontrolled riot of colour—a

pitfall that even so sensitive an artist as Shunman did not altogether avoid in certain of his triptychs. His use of a landscape setting, however much owing to Kiyonaga's example, was often decidedly original and in one called 'The Picnic' and another 'Maple Viewing', the background is broken up by hillocks of a yellow that floods the prints with sunshine. Sunniness, in fact, is a characteristic both of the atmosphere and the idyllic mood of the great majority of Shunchō's triptychs. He is another, one feels, who had that sweet temperament I have remarked on in Toshinobu.

Plate 30 is from a lovely print by Shunchō in which the colours are quiet tones of modulated greys and pale lilac and pink. It is a diptych, though there was almost certainly a third sheet, at right, now lost. It does, however, amply convey the sweet drawing of this master, the infinite variety of exquisite dresses. The Party is returning from a pilgrimage to the island temple seen behind them and whence others are approaching the bank across the connecting causeway. The cast shadows—unusual, but not unknown in Ukiyo-e—seem to suggest a dying sun, and the lanterns carried by two of the group also fix the hour as late on a summer evening. The gesticulating hands are evidence of lively chatter, and the girls at the left are trying to make up their minds which of the caged singing insects they should buy for the small boy with them. The figure of the girl with her back to us, her foot just lifted from the ground as she walks, is as enchanting as can be found in any print of the period.

This print is typical of many that bear Shunchō's signature. There is a quality of idyllic carefreeness pervading them; nothing occurs to disturb the round of elegant pleasure-making and unemotional philandering. There are the petty excitements— still dear to the Japanese today—of outings to admire the cherry-blossom or the autumnal colour of the maples, of pilgrimages that were the reverse of solemn to popular shrines in the Edo environs; there is the flurry caused by a sudden summer shower, with the consequent throwing together of strangers as they shelter under a tree. Afar off, we occasionally glimpse peasants labouring in the rice-fields, but if they are brought nearer to the foreground, they

lose all real contact with the soil and become the prettily-dressed rustics of a pastoral. It is difficult to believe that this was the art of a people at a time when a large percentage of the population suffered under grinding poverty and when widespread famines occurred with distressing regularity. We look in vain for the slightest commentary on the evils that had arisen through mal-administration, the oppression of the peasantry, the stern police-state measures that governed the populace, the profligacy of the ruling classes. This very decade, from 1780-1790, that saw the publication of both Kiyonaga's and Shunchō's prints, prints to all appearances full of an undisturbed geniality, was one of the most disastrous in the history of Japan. But the prints were in no sense social documents, unless, perhaps, we should look on them as evidence of the desire of the people to turn their eyes from the sordidness of reality to a dream-world where everyone passed the time in an endless round of aimless amusement.

Before going on to Shunchō's pillar-prints, mention should be made of a few un-typical prints that have always excited interest and comment. These belong to the last years of his career, from 1790-1792, and reveal the impact of other influences than Kiyonaga, who had virtually withdrawn from the scene by that time. Two of these prints each show the head and shoulders of a famous wrestler and an equally well-known tea-house waitress, recognised beauties of the day and depicted by practically every Ukiyo-e artist of note. One shows the wrestler Onogawa and the Takashima Tea-house girl O'Hisa; the other, Tanakaze and O'Kita of Naniwa Tea-house. Popular sporting heroes and renowned beauties represent a combination familiar to us today in the press, but of this material Shunchō has contrived two magnificent designs at once outstanding in a pictorial sense and for the sidelight they throw on the objects of popular acclaim in the Edo of his time. Stylistically, these prints seem to owe a debt, if to anybody, to Shunei, whose double portraits in a rather similar style are discussed in Chapter XII. Another print falling outside the general classifications is that of O'Hisa, whose head and shoulders only are reflected in a black-lacquer-framed mirror as she makes up her face with cosmetic (Plate 31). Here a debt to

another artist seems even clearer, in this instance Utamaro. It is just possible that Shunchō's print preceded a somewhat similar one by Utamaro, but one is so wedded to the idea of Shunchō as a 'follower' that it is difficult to think of him pioneering any new type of print.

There is the same dilemma concerning the first use of an extremely restricted palette in printing. Here I would feel inclined to name Shunchō as the instigator, if it were not for the feeling that it was more likely due to the prompting, at least, of a publisher. The fact remains, however, that Shunchō's seem to be the first in which colour was confined to shades of black and grey, with the addition, in very limited areas, of lilac or pink or other muted colours. The effect is a quiet subdued harmony that is quite entrancing but so subtle that even if colour reproduction were at my disposal, only a very inadequate version would be possible. Perhaps the best known of all the prints of this type is the six-sheet composition of the 'Six Jewel Rivers' by Shunman (see Chapter XI), but this seems to post-date the earliest examples by Shunchō. Although later in life Shunchō enlisted as a pupil of Shunman's, it was for the purpose of learning verse-writing, and as a print-designer, Shunchō can be looked on as Shunman's senior, if not his master.

Mention has already been made of the pillar-hanging print, the *hashirakake*, in discussing Koryūsai's outstanding gift for design in this format. Koryūsai is unquestionably the most versatile of all the Ukiyo-e masters in handling this type of print, but he has always had his admirers in that regard, and instead of adding another panegyric to the many that have already appeared, it seems better to devote space and illustrations to the pillar-prints of two other great designers, Shunchō, and, in Chapter XIII, Toyohiro.

The long narrow panel of the pillar-print (some 26 inches by 5) was unique to the Ukiyo colour-print. It was expressly introduced to hang, when mounted, on the *hashira*, or pillars, of a Japanese house, and one must assume that the need for such decoration had not arisen before the introduction of print-making, or, put in another way, the parvenu class that patronised the

Ukiyo school of artists employed a form of pictorial decoration of their houses that their betters would never have considered desirable. It is not merely a format peculiar to the Japanese print: it is without parallel in the rest of the world's art and only artists with an innate flair for pattern, for the application to a given space of decoration at once arresting and satisfying—and this gift seems to have been the birthright of almost any Japanese— could have made a success of it. It would have been easier to understand their success if the designs had been floral or of the *kachō* type, with the sort of conventionalising of plant and animal forms that we are familiar with in western illumination or other books calling for narrow decorative panels: but in fact, the vast majority of *hashirakake* are figure-prints, and it is the treatment of the human form within the imposed limits that is so astounding an achievement.

The earliest designers of this type of print—Okumura Masanobu, Shigenaga and Toyonobu in the first half of the 18th century—from the first showed no compunction in handling the human figure as they would any other element of their composi- tion. Quite often, this meant that a figure would be cut in half vertically by one side or other of the print with a resultant asymmetry that is a marked trait of Japanese pattern. Harunobu, and Koryūsai, and Kiyonaga and Shunchō after them, used the single figure either in this manner, or by boldly filling the panel in a way that gives a singular majesty to the form; and gave them- selves scope for even greater virtuosity by grappling with the problems posed by fitting two or more figures into the exiguous space at their disposal. To give height to the design, a single figure in flowing robes would be set against a background in which vertical lines reached up to the top edge of the print, and foreground objects to the base. Occasionally in Shunchō, two figures stand side by side, their height varied by their position relative to each other, and the sides of the print dissecting each figure; more often, some action is introduced which provides for one figure standing erect whilst the other bends or kneels in the foreground. There is nothing like the variety in Shunchō's compositional devices that there is in Koryūsai's, but there is

hardly a single print of his in this format that is not superbly designed. There is, too, a greater departure in these prints from the models of his mentor Kiyonaga, and it is perhaps true to say that Shunchō shows greater originality in the pillar-print than in any other format (Plates 32a and 32b).

CHAPTER X

———o———

Chōki: What is a Minor Artist?
The Effect of 'In-breeding'

QUITE often the term 'minor artist' is applied to some individualist who does not match up to the current measure for 'greatness' but who may, nevertheless, offer something unique, a flavour that still has power to titillate palates grown jaded with the strong wine of mighty names. The term 'minor artist' is equivocal at best, and often does not distinguish between a paucity of output and a poverty of talent. It has, too, the suggestion of allowing an artist a position on sufferance, with the support of a coterie of enthusiasts only. If an artist's rank can be assessed by comparison with acknowledged major artists, then in the hierarchy of great names of the Japanese print—Hokusai, Utamaro, Harunobu, Kiyonaga and so on— Chōki occupies only a subordinate position, and justly so simply from the limitations of his *œuvre*, both in number and scope. Yet ever since Japanese prints were collected, connoisseurs have placed among the outstanding masterpieces a certain small proportion of his colour-prints because of their intensely singular design and strange mood: qualities which give them not merely an especial place among the colour-prints of Japan, but among the depictions of the feminine form the world over. If the claim for the description of a minor artist is made for Chōki that is not a plea for mediocrity.

Chōki resembles a number of other artists in relying for his reputation on only a relatively small proportion of his total output. Just as Cotman's unique position among water-colourists derives from the Greta paintings, the work of an extremely short

but inspired period of his career, so Chōki is reckoned among the most significant of the Japanese print-designers by virtue of a handful of prints bearing that certain impress we recognise as his own. The rest of his prints range from rather undistinguished *bijin-e* and triptychs in the manner of Kiyonaga, Eishi or Utamaro, to remarkably inept imitations of Sharaku.

We first hear of him in the 'eighties as a pupil of Toriyama Sekien, a notable compiler of picture-books of a *diablerie* and macabre humour much to the taste of the Japanese. In this atelier, if we can use such a term with anything like accuracy in describing the studio of a Japanese master, Chōki may have met Utamaro, who also received instruction from Sekien, but neither Chōki nor Utamaro adopted Sekien's style, which was not *Ukiyo-e* but rather a version of his own based on the Kanō, in which he had had his own initial training. On the other hand, Chōki must have profited by the contact with an artist of Utamaro's abounding originality, and his own prints of real significance came after Utamaro had finally cemented his position as acknowledged leader of *Ukiyo-e* with some sets of prints with mica backgrounds, in which girls were portrayed half-length in a novel and even sensational manner.

By the early nineties of the 18th century, the courtesan print had a phenomenal degree of popularity. The function of the Yoshiwara and kindred establishments in Edo and Osaka has always been an object of curiosity to the West and the volume of literature on the subject both in and outside books on the Japanese print, is probably out of all proportion to the relative sociological importance of the licensed brothels. At the same time, no student of the Japanese print can ignore the fact that every *Ukiyo-e* artist seemed irresistibly attracted by the *demi-monde* and its queens, and that many of the masterpieces of the figure print have as their subject the hired women of the 'Green-houses'.

The prints simply reflected the plebeian demand, of which the publishers had to take cognisance. The courtesan of the prints, the *Tayu* or *Oiran*, was beyond the price of all but the wealthiest townsmen: she existed for the officials serving their term at the Shōgun's court and for the ever-increasing number of wealthy

merchants, and was idolised at a distance by the remainder of the populace, attracted by her beauty and accomplishments, the exalted company she kept, and the nature of her occupation. She was, moreover, the model on which the leading dress-designers tried out their most fabulous creations, and that, if nothing else, would have established her as a favourite among the Edo populace. Only a little below the great courtesans in popularity came certain well-known *geisha* and tea-house waitresses, whose notoriety, seemingly out of all keeping with their humble occupations, may have been due to other activities not so openly acknowledged.

Above all, the public demanded and the publishers enforced, novelty. Even Kiyonaga, assured of his hold upon the print-buyers, had varied his type from time to time, but as he withdrew from the scene and his influence waned, a struggle for supremacy among the practising artists showed itself in a greater variety in the treatment of the *bijin-e*. It was not merely a matter of each generation having its own standard of feminine beauty to which the artist had to conform: it was also a question of capturing the public interest by frequent changes in the presentation of the currently accepted type. In the 'nineties, a number of superb designers were at work. In this decade Utamaro, Eishi, Eisho, Eiri, Chōki, Shunchō, Shunman, Shunei, Toyokuni, Toyohiro and Kunimasa as well as a dozen lesser artists, designed *bijin-e*, or prints that, whatever the avowed subjects, were basically the same thing. It was inevitable that the competition should be fierce, and that the different publishers should exploit the artists in their employ to the full, driving them to novelties and experiments and aiding them by the innovations they enjoined from the printers. Outstanding among Utamaro's successes were the half-length portraits of girls on a mica background, the surface shining a bright silver in the light and throwing up the girl's form in strong relief against it. As time went on, another expedient was introduced, this time Eishi vying with Utamaro, the girls being depicted full-length and their forms drawn out to an extreme height and slenderness, with wonderfully enhanced opportunities for the elegant display of the lovely gowns.

The effect of this constant intensive forcing of new versions of

the stock theme led eventually to the sort of enervation and morbidity we associate with hot-house culture, or even in-breeding among human beings. A feverish lassitude or a lisping affectation replaced the healthy animalism of earlier masters, reaching a climax in Chōki that leads us to think of him as an invalid Kiyonaga or a devitalised Utamaro. Yet the very creation of the disturbingly strained beauty of the women of his prints evoked designs of an intensity and poignancy rare in Ukiyo-e. Occasionally, he reminds us of Modigliani: there is a comparable, though not similar, perversion of human proportions in compositions at once compelling and unsettling. In some prints, too, there is a dreamlike unreality, we enter their world with a complete suspension of belief, brought under a spell as opiate as Chagall's.

His prints exploit every technical refinement of the colour-print. In his greatest triumphs he relied on mica backgrounds, not the solid mirror-like surface Utamaro used, but a surface broken into cloud form, or darkened for a night sky against which fireflies glow with a moist luminosity. The faces and limbs of the strange women he portrays seem to be preternaturally pale, a pallor due to the printers' use of the lovely papers at their disposal. Onchi, one of the most prominent of modern Japanese print-makers, is reported to have said, 'I give half the credit for the world-wide fame of Ukiyo-e colour-prints to the wonderful *hosho* and *masagami* papers on which they were made. For example, it's the paper which is responsible for the sensuous beauty of the women's complexions.'[1]

There are three types of print in which his own peculiar gifts are evinced: those showing single courtesans full-length; those that are of single half-length figures, or busts only; and those in which two figures are portrayed. (A case may be made that in the few triptychs and the single pentatych designed by him the girls are unmistakably of the Chōki family, but whilst this is true, the prints lack both the disquietening mood and the powerful design that are his especial attributes. They do no more than hold their own in company with prints of this type by Kiyonaga, Shunchō, Eishi and Utamaro.)

[1] Quoted by Mr. Oliver Statler in 'Modern Japanese Prints', 1957.

H

Plate 33 is a lovely example of the first of the three categories. It was common enough for courtesans to be depicted with their elegantly long pipes, but we are struck at once by the extravagant exaggeration of the pose, and particularly the extreme affectation of her gesture in placing the comb in her hair: this is the hall-mark of a Chōki. The verse, beautifully translated in the British Museum catalogue, reads, 'I put my pipe to my lips, but my throat is choked with sorrow and cannot draw in the smoke; there is not a night I have not passed in weeping. O miserable to be a woman and exposed to all men's eyes!' and the title of the print is 'Confessions of Takaō' (a courtesan who in a celebrated drama *Sendai Hagi* chose death rather than submit to the will of the Lord Date).

But his feminine type and the eccentricity of his design are emphasised even more in the print of a waitress and a geisha. The girls are of that narrow-shouldered, simpering order that only appears in his most characteristic prints, and both their physiognomy and their pose lend the design a quite indefinable distinction (Plate 35). To attempt to analyse the subtle personal quality is tantamount to bringing a kaleidoscope to a standstill: the separate shapes can then be described in detail, but the pattern they make in motion bears little relation to them. A print such as this brings out our ability to appreciate purely pictorial qualities, the qualities of balance, design, composition, line and colour. We cannot possibly have any interest in this meeting in far-off Ōsaka of a waitress with a geisha to exchange confidences: it was an everyday incident in Japan in the last decade of the 18th century, and although the girls' names meant something to Ōsaka dwellers at the time, they mean nothing to us. And yet, it is their attitudinising, their manneristic gestures, that supply a sense of tension, create an atmosphere inseparable from the total effect. Purely arbitrary shapes without a vestige of association with the human form, could never quite achieve the disturbance a design like Chōki's brings to our feelings. There is a compromise here between on the one hand the abstract elements of composition and on the other the creation of actuality, carried to an ultimate balancing point, and the sensing of this delicate equilibrium is a

major factor of our enjoyment: pushed beyond that point into the realm of purely abstract art, an entirely different, more cerebral, less emotive, pleasure would result.

There are three or four prints on mica-ground that move us as much by mood as by purely pictorial virtues, but, again, the mood is only conjured up by the slight abnormality of the girls' forms and by the heightening of certain landscape effects. One of them is the 'Firefly' print to which allusion has already been made. A girl carrying a fan and a cage for insects is out at night with a young boy along the bank of an iris-fringed stream. Fireflies are careering about their heads, and the boy is trying to swat one of the insects with his fan. In that description it sounds a typical Ukiyo-e genre scene, but Chōki creates poetry of this everyday happening. There is perhaps the most telling use of the mica background in any Japanese print, the nimbus of silver surrounding the insects against the leaden background providing a touch of fantasy to a landscape already unreal with enormous iris flowers. The figure of the girl is instinct with the affected grace that we have spoken of as Chōki's own contribution to the repertoire of Ukiyo beauties: she holds the insect case in one hand and a fan in the other with a mincing, fastidious curling of the little fingers of each hand.

Another of these mica-ground prints is a moonlight scene. One girl is seated on a bench, head tilted back and a rapt expression on her face that may mean she is drinking in the poetry of the moonlit scene, or perhaps simply savouring the smoke she has drawn in from her tobacco pipe held negligently in her hand. Another girl behind her bends over to light her pipe at the little charcoal brazier these dedicated smokers invariably carried with them. It is summertime, and the girls are wearing light gauzy dresses, the nearer in one so transparent that in the moonlight her arm shines palely through the material. Utamaro was perhaps the most resourceful of all his fellows in making a play of the lines of one figure against the contrary or complementary line of another, but here Chōki has given a new turn to this problem and has balanced the involved line of the two girls with the bold silver circle of moon shining above them against dark clouds of mica.

But the print known as 'Sunrise at the New Year' (Plate 34) is more charged with atmosphere than any of the foregoing. The *fukujusō* plant in a pot on the water trough is the only augury for a propitious New Year.[1] That apart, the print seems heavy with foreboding, and one can easily believe the girl's gesture of pulling up the collar of her *kimono* to be a shrug of despair.

The originality of this completely unbalanced design can easily be overlooked today, for the device of asymmetrical loading of one side of the picture space is now a commonplace: but few prints are so suggestive of a brooding unquiet, so communicative of an inexpressible poetry. It is hardly a disillusionment to accept the likelihood that we may be completely misinterpreting Chōki's intentions, which may have been perfectly plain to his countrymen, or to believe that the poetry is of our own infusing. We bring to his prints eyes and minds which have been conditioned by a vastly different way of life, and by a century and a half, since he worked, of violent change in the western conception and practise of the art of painting. Chōki's courtesans, like Sugimura Jihei's, cast their spell over us as they did over his countrymen, but for different reasons: and between Sugimura's time and Chōki's— roughly a century—the Japanese taste itself had changed considerably. Malraux's new definition of style might easily have been written with Chōki in mind, 'for us, a style no longer means a set of characteristics common to the works of a given school or period, an outcome or adornment of the artist's vision of the world; rather, we see it as the supreme object of the artist's activity, of which living forms are but the raw material. And so, to the question, "What is art?" we answer, "That whereby forms are transmuted into style."' And yet there is nothing permanent in this definition either, for what, after all, is style? It, too, means different things to different people, in different centuries. We have no idea what the Japanese of 1795 thought of Chōki as a stylist and it is unlikely that the world a century hence will be moved by his prints in the same way that we are today. Certainly, people of that future period will never understand what

[1] *Fukujusō* (Adonis amurensis) is a symbol of wealth in Japan, and its golden flowers come out early in the New Year.

we experience. The language of taste and art-appreciation changes as art itself does, and what we experience now is incommunicable to aftercomers because the words we use today to describe our sensations will by their time have come to have other shades of meaning, fresh nuances, different associations.

CHAPTER XI

○

Kubota Shunman:
The Art of *Surimono*

UBOTA SHUNMAN has already been mentioned as one
of those artists who came to maturity at the time when the
influence of Kiyonaga was strongest. Although originally
a pupil of Shigemasa, his figure prints from the first betray a debt
to Kiyonaga, and if eventually in his two greatest prints he
achieved an unmistakable individuality, even in them he has not
moved so far from his source of inspiration that it can be forgotten.

All those who have collected or studied Japanese prints are
unanimous, however, in discovering in all he did a hyper-refine-
ment and a degree of subtle originality that place him in a
category rather apart from his fellows. These personal
characteristics are marked not only in his *nishiki-e* but in his
numerous *surimono*[1] and prints for poetry albums, and as these
latter constitute genera of Ukiyo-e art of some importance, this
chapter is devoted primarily to them in general, with examples of
Shunman's work by way of illustration.

Shunman was born in Edo in 1757. His earliest training seems
to have been in what was called *Shikunshi*, 'The Orchid, Bamboo,
Plum and Chrysanthemum', which had its roots in classical
Chinese painting. Although, as stated, he studied Ukiyo-e under
Shigemasa and became a quite adept practitioner, his interests and
cultural activities were wide, and it is to this catholicity of taste
and intellectual breadth that we can attribute the fastidiousness of

[1] *Surimono* literally means 'printed thing', but came to have the special
significance of an unusually careful production for presentation, a greetings or
announcement print.

his work compared with the generality of Ukiyo artists. Apart from his work as a print designer, he was the author of numerous light novels and a master of the form of comic verse called *kyōka*. The fiction often appeared in the cheaply produced 'yellow-backs' (*kibyōshi*), with illustrations of his own or other Ukiyo artists, and amounted to little better than hackwork for both author and artist. *Kyōka*-writing was an activity of the more literate section of the community. It was a form of verse so expressive of the temper of the age and so intimately linked with certain aspects of Ukiyo art that attention must be given to it later in this chapter. More is documented concerning Shunman's activities in this sphere than of his work as a print-designer. In the preface to a book of *kyōka* published in 1810, 'The Waterfall of Words in *Kyōka*', it is stated that Shunman became successor to the *kyoka*-master Tsumari no Hikaru, presumably on or shortly before that master's death in 1796. As a leader of one of the main branches into which the practitioners of *kyōka* writing were divided, it is clear that Shunman was highly esteemed for his verse composition. Literary prowess was not uncommon among Ukiyo artists. Kitao Masanobu (Santō Kyōden) has already been mentioned earlier in this book; Jippensha Ikku was the writer of a classic of comic literature; and quite a number of others were recognised as *kyōka*-writers, though it might be said that they were of a vast company of amateur versifiers. Shunman was obviously more of a professional, and his verses appear in various anthologies of the period. His ability in this field has a bearing on his success as a creator of *surimono*.

His first colour-prints appeared early in the 'eighties, but it was not until towards the end of the decade that he produced the broadsheets on which his fame principally rests. Probably no artist except Chōki has achieved so high a reputation on such a small number of prints. Two above all others have earned universal praise: one a 6-sheet print, the other a triptych. The 6-sheet print is Shunman's version of the 'Six Jewel Rivers', *Mu Tamagawa*, a subject which most Ukiyo-e artists turned to repeatedly. Six famous rivers, each associated with a flower, a bird, a fulling-block, (*kinuta*) or some other object, are personified

by beautiful girls in their loveliest attire. The river itself may appear in the picture but even that is sometimes considered unnecessary, the clue to the print's subject being in the title, and in the object associated with the name of the river. Shunman's version is a loosely-linked composition in which one river and its tributaries are made to do service for the six, the foreground of each of the six prints being occupied by a group of the most elegant women and by their male escorts who vie with the girls in the exquisiteness of their attire. The landscape is not insistent, but is deftly touched in even though the seasons pass and the weather changes from one sheet to the next. Although designed as a hexatych, this is a print that is perhaps appreciated better as single sheets and, this, in fact, is how it is generally seen, for complete prints are excessively rare. The drawing throughout is of the utmost delicacy, the colouring restricted to black and tones of grey, except for slight touches of pale green, pink and warm yellow. It is easy to understand why even the Japanese have excluded Shunman's works from their general condemnation of Ukiyo-e on the grounds of vulgarity, tasteless colour and inexpressive line.

The triptych is remarkable for the unexpected and capricious use of colour. In Japanese prints, night time had always been indicated by token—a black sky or a carried lantern—the colours not being darkened in any way, and as bright as in prints portraying daylight scenes. Shunman's triptych represents people going home from a poetry-reading gathering. Three groups are shown, one on each sheet, outside the wooden fence of the garden to a villa or perhaps a tea-house. It is a spring night, and the air is heavy with the scent of the blossom of the cherry trees leaning over the fence. At a side gate, a lady is just departing with a maid carrying a lantern, and they meet a servant-girl with a basket of fish. Two geisha are leaning by the centre gate, attended by a manservant with a lantern in his hand and their instruments in a box on his back. Behind them is a man in a fashionable *kimono* followed by his wife and child. Just within the orbit of each of the lantern's glow, there is vivid colour, on the dresses of the departing guests, and on the cherry blossom above,

but Shunman had no intention of creating a *trompe l'œil* of artificial light, as Honthorst or Wright of Derby might have done, the colour effect is quite capricious and succeeds in giving a touch of fantasy to the scene rather than an air of reality.

Beyond the fence, in an upper room of the house, we are given a glimpse, by the light of a candle on a stand, of an elderly poetry-master with shaven head seated with two young pupils, a man and a girl, while another acolyte reads from a poetry-book. Shunman himself must often have made one at just such a pleasant gathering as this—might even, in fact, have been the model for the *sōshō*, or poetry-master, seated with his little band of followers in the candle-lit room. It is a detail which leads us naturally to the prints which are closely linked with poetry, the *surimono*, and the designs for poetry albums.

One might almost ascribe the genesis of the *surimono* to two features of the Japanese way of life: the importance attached to New Year's Day, and the propensity for forming clubs for cultural or at least quasi-cultural pursuits. Through the ages, the Japanese have been a people addicted to festivals, they seem to have found as many occasions as possible for making holiday, and none was honoured more elaborately than the first day of the New Year. We ourselves can best understand their mood if we imagine our own Christmas Day shorn, as it nearly is after all, of any religious significance. It was a day for the renewal of hope, for a superstitious trust in symbols of good-luck, for a forgetting of past disappointments and cancellation of all regrets. How early the practice grew up of sending greetings on this most auspicious day we cannot tell with certainty, but by the second half of the 18th century, privately-printed inscriptions on small sheets of special paper, with or without pictorial design, were commonly exchanged among friends. Known as *saitan* or *ganjitsu* ('First day') *surimono*, their whole drift was to mark the day, for the recipient, as a propitious one and apart from the message of the verses, however oblique, the artist might clearly invoke the intervention of providence by depicting one or more of the Seven Gods of Good Luck, or the Pine, Crane and Tortoise (symbols of longevity), or of Fuji, a Falcon and an Egg-plant (the

Three Lucky Things), or certain heroes whose names had an underlying suggestion of good fortune.

Possibly the tea-ceremony, originally a patrician function bringing aesthetes together for elevating conversation and the practice of connoisseurship, gave the lead to plebeian people to band themselves into clubs for the pursuit of flower-arrangement, poetry-writing and music recitals. These clubs form a pleasant feature of the cultural life of the times and, naturally attracting the choicer spirits of those engaged in the arts, are behind a number of the most lasting legacies of the age. The association of artists, calligraphers and poets was directly responsible for the production of some of the world's loveliest albums and books, and Shunman himself was, as both artist and poet, associated in a major capacity in the compilation of a number.

It is to the members of these clubs that the growth of the *surimono* as an art form can be ascribed. The pictorial calendars of 1765 have already been mentioned. They illustrate a tendency which grew with time to employ the *surimono* type of print for circulating information among the members of clubs, or coteries or among friends not perhaps tied by allegiance to any organisation: among, that is, strictly limited numbers of people. The pictorial calendars of 1765 were one of the means whereby members of certain literary clubs celebrated the 900th anniversary of the death of Sugawara no Michizane, looked upon by all good amateurs as the great Patron of the Arts. They were not the first and by no means the last of the *surimono* that combined New Year's Day wishes with the usefulness of a calendar, however cryptic. Meetings of poetry clubs and other organisations were announced by the issue of beautifully designed prints. Advertisement of forthcoming music or poetry recitals; announcement by artist, poet, singer or actor of a forthcoming change of name—a frequent and confusing happening; felicitation to people on attaining a certain age, or giving some singularly praiseworthy performance in the arts; were all achieved by the same means.

By the very nature and object of these prints, the issues were small and in what we would call 'private editions', the paper used being of the finest quality and the printing of the most refined.

Usually, the prints were small in size, but for longer announcements, or where numerous poems of a congratulatory nature were incorporated, a long *surimono* came into being. This latter was a sheet some 20 to 22 inches long by 8 or so inches high, and when folded in half longitudinally the design would occupy one half, the inscriptions the other.

So much for the prevalence and scope of their use. What is of more interest to us is the intimate fusion of poem or announcement with the pictorial decoration. It called for the sort of artistry in which Japan is supreme.

The collocation of inscription and pictorial design was quite normal in the Far East. Fine calligraphy only enhanced a good brush painting, and a picture was treasured as much for the written word as for the drawing of flower or figure or landscape. Many composers of the short poems called *haiku*, made a practice of embodying the idea or the spirit of their verse in a drawing equally elliptic and suggestive, expressing a sudden poetic thought simultaneously in word and picture. Although the pictorial design of a *surimono* assumed rather more importance than the drawing in a *haiga*,[1] it was still intended as an enhancement of the poetry, or a reinforcement of the inscription, and it is one of the *surimono* master's gifts—one often lost on us for lack of deep enough knowledge of the language and literature of Japan—to give over-tones to the verse rather than merely to illustrate it, to set up vibrations in the mind of a recipient, attuned to receive them. Among men and women in Shunman's circle, or of his cultural level, a wealth of literature, legend, custom and lore was part of their consciousness and the slightest symbol, the faintest associative reference brought numerous disparate ideas immediately to the surface, like lurking fish to a dropped crumb. In the *haiku* and *kyōka*, the writers often combined a concreteness of image with a vagueness of allusion, creating a field of suggestiveness in which the mind of the reader could roam at will. The designer of *surimono* and of *kyōka*-album pictures achieved something of the same sort. Part of the pleasure to the recipient of a *surimono* would reside in appreciating the subtlety of the allusions,

[1] The drawing accompanying a *haiku*.

and it was a compliment to his intelligence if they were of the most recondite kind. One of the best-loved *haiku*, the archetype almost of the verse form, is the one by Bashō:

> 'An ancient pond!
> With the sound from the water
> As a frog plunges in. . . .'

In a legend known to everyone, a tree-frog played the same sort of part in rallying the spirits of the great mediaeval calligraphist Ono no Tofu as the spider did in giving heart to Wallace. If an artist introduced a frog into the picture, whatever his decorative object might be, its presence could automatically bring to mind these and other nebulously associated ideas. This is a very simple illustration of the evocative power of word and symbol among those of sufficient culture and sensitivity; usually the chain of allusion would be far longer and less definite.

From all this, it might be assumed that the art of *surimono* was nearer literature and calligraphy than to drawing and design, but that would be to misjudge it entirely. Its literary associations are indeed part of its *raison d'être* but we can, fortunately, enjoy the prints as works of graphic art. Some notion of their purport has to be known to explain the slightness, often, of the design, the enigmatic (to us) subject matter. The brevity of the drawing, akin to vignetting, is often suggestive like the pregnant dots . . . of the writer.

Earlier, I said that the *surimono* called for the sort of artistry in which Japan is supreme. The absolute supremacy, to my mind, is in the field of applying design to articles of superb craftsmanship. In lacquer and metal, for example, the Japanese have produced small objects for everyday use in which the exploitation of different materials and the patterning of small surfaces with apt decoration is carried to a pitch as nearly perfect as anything from the hand of man can be. The same sort of gifts are shown in the best *surimono*, which call for greater exercise of sheer craftsmanship than any other form of print. There are those who, with that curious propensity which persists to deny every-thing original to Japan and to hand it as tribute to China,

consider that *surimono* derived from the 17th-century Chinese ornamental letter-writing papers, and especially the collection of them published about 1644 known as 'The Collection of Ornamental Letter-papers of the Ten Bamboo Hall'. Tschichold even states categorically that 'Undoubtedly prints of this kind, or perhaps the very pictures of these sections (the first seven of the book) were the prototypes of those most exquisitely printed Japanese New Year greeting-cards, the *surimonos*, which similarly defy all reproduction.'[1] These Chinese prints have only recently been reproduced in facsimile in a quite remarkable new Chinese edition.[2] They are miraculous miniatures exquisitely engraved and printed, but rarely rising individually, as designs, above a sort of ornamental prettiness—which was indeed their function. One can understand the temptation to see in them the germ of the Ukiyo-e *surimono* art, but in Japanese hands the flower-and-bird motifs were infused with life, and the still-lifes were arranged with wit, subtlety and suggestiveness: there is a world of difference between the simple, if exquisite designs of the Chinese papers, and those of the *surimono* of Shunman, Hokusai, Shinsai and Hokkei. It may be possible to prove a direct influence of the Chinese papers on the *technique* of the engraving and colour-printing of the Japanese craftsmen, though even in this respect it has to be remembered that the *surimono* only reached its zenith from the latter part of the 18th century onwards—nearly 150 years after the first publication of the 'Collection of Ornamental Letter Papers'. It seems more probable that the highly-developed craftsmen of Japan evolved their own *surimono* technique, which was after all no more than a hyper-refinement of the process already used for producing the ordinary broadsheets. In producing *surimono*, all the resources of the printer are brought into play: deep *gauffrage*, heavy overlays of mica, silver, brass and bronze, backgrounds of gold, even, in rare examples, inlays of shell. The result, from the printing point of view, is a preciousness, a bejewelled aspect in which the overlays and *gauffrage* have the same plastic or tactile

[1] Jan Tschichold: Hu-Chêng-yen, a Chinese Wood-Engraver and Picture-Printer, 1943.
[2] *Shi-chu-chai Chien-P'u*, Peking, 1952.

effect as *impasto* in a Monticelli. Some of the artifices employed recall *netsuke*: a chestnut by Gambun, for example, invaded by snail and ants, with the wood encrusted with metals made to seem more precious by the contrast of the rough-grained wood, is a sculptured *surimono* subject. There are hints, too, of the flower-arrangers' and of the driftwood-composers' arts. Many *surimono* are still-lifes, but of a kind quite different from those we are familiar with: the Dutch conglomeration of fruit, flesh, flowers and eating utensils, or the Cézanne compositions of apples and white napkins. The Japanese delight in bringing out the shape and texture of different things and especially by arrangements not to be found in nature. The rough coruscation of a piece of natural rock or the twisted grain of polished wisteria root are appraised for their own beauty, but if azalea buds are placed over the stone and a tea cup of rough pottery beside the polished root, something even more aesthetically satisfactory results, something particularly sophisticated and refined.

It is not surprising that such prints are the most difficult to reproduce adequately. There are gradations of tone, metallic glints, variations in the surface of the paper given by *gauffrage*, that can never be reproduced: only the original printer with wood-blocks and soft paper and an incredible skill could produce such finesse. This must be borne in mind if Plates 37 to 39 do not seem to live up to the high praise I have lavished on *surimono*.

Plate 37 is one of a series designed by Shunman for the club known as the *Chō* Club. In the fan-shaped cartouche is the name of the club and the title of the set of prints—*Somoku awase*—'A collection of flowers and trees'. About six of the series are known and all are lovely. In the one reproduced we look into the throat of one tiger lily, velvety in texture, brown-purple in colour, and at another from the side, much paler; an astringent yellow of the cudweed is a foil to the warm rich colour of the lilies. The *gauffrage* is heavier than usual, the design being almost wholly in relief, like the form of lacquer known as *taka-makie*.

Only the pictorial half of the long *surimono* is shown. On the other fold is a long list of *kyōka* clubs and their members, one of

them being the Shunman Club. Presumably this was a directory of verse clubs, a who's-who of *Kyōka* writers (Plate 38).

The third is perhaps the subtlest of the three, but suffers more than the others from the lack of colour in the reproduction. The tints are printed quite flat. To the right the upper fish is red, the lower blue, the flat fish being yellow at the head and brown at fin and tail; the tea-cup and kettle are cream with a green glaze covering the upper part; the knife blade is silver and the outline of tea utensils, fish and the stand they are on is given by a very sharp blind-printed line barely visible in the reproduction. There is something extremely modern in this designing in flat tints, and the diverse shapes give an effect wittier than a Paul Klee (Plate 39).

Kyōka were (and are) looked down upon by the literary purists as a vulgar, plebeian form of verse, bearing the same sort of relation to the classical short poems as Ukiyo-painting does to Kanō. But even Aston in his 'History of Japanese Literature' had grudgingly to admit that *share* reigns supreme in these verses, and explains that *share* may be translated as 'wit' but that 'in order to express its full meaning a spice of what is comprehended under the terms gaiety, esprit, playful fancy, stylishness, must be added'. These are the very terms we would apply to Ukiyo-e: and the verses were in keeping with the temper of the people and the age, just as Ukiyo-e art was. Meetings for *kyōka* reciting and composition were occasions for conviviality in much the same way as the meetings of catch-clubs in England in the 17th and 18th centuries. The *sake*-cup circulated freely and the verses became the wilder and bawdier as the session proceeded. Seen in this light, *kyōka* are no better than the light occasional effusions of amateur scribblers in a section of the community that was incurably frivolous, quite without desire or strength to sound philosophic depths. The verses were full of double-entendres and innuendoes not seldom of an indelicate kind and it is difficult for us to square them with the unusually refined illustrations which accompanied them. Utamaro, for instance, produced many of his most exquisite designs for albums of *kyōka*: his 'Insect', 'Shell' and 'Bird' albums being justly acclaimed as among the finest achievements of Japanese book-production.

Shunman's contributions to anthologies of *kyōka* were to albums in the illustration of which a number of artists collaborated, and he is most often found in the company of artists like Tōrin and Rinshō. Tōrin was an independent artist much influenced by Chinese models, and sometimes in his album-prints Shunman all but abandons the Ukiyo-e style and shows signs of being persuaded by Tōrin into quite other paths. In others, he adopts a bejewelled *surimono* style, the prints having the appearance, almost, of being 'supplements', not part of the original make-up of the album. In the best-known of the albums, however, his style is his own refined brand of Ukiyo-e, but transformed for the purpose of the album by unusual traits both in the design and in the printing. Typical of these albums are 'The Colours of Spring' (*Haru no Iro*), published in 1795, and 'One Hundred Twitterings' (*Momo saezuri*), published in the following year. Both appeared under the aegis of a *kyōka* club which had as its sign the *mitsu tomo-e*, the three commas in a circle that appears under the fan title-cartouche of the *surimono* in Plate 37. Shunman's prints in these two albums are typical of his grace and refinement. The figures are small in relation to the page compared with those in the normal broadsheet; dress and accoutrement are worked out with intricate detail, and the colour-printing enriched with gradations of colour, scrumblings that remind us of pastel on a rough paper, and a general fineness of line that puts the album-prints in a class apart. The minuteness of scale in figure and detail prevents any from having the nobility of design that the broader treatment of the *nishiki-e* made possible, but they are works of such prettiness that it would be to break the butterfly on the wheel to criticise them for want of grandeur.

CHAPTER XII

———o———

Katsukawa Shunei: The Theatrical Print in the Late 18th Century. The Origin of the 'Large Head' Print

THE only print-designer contemporary with Kiyonaga who completely maintained his independence from that artists' influence was Katsukawa Shunshō (1726-1792). Shunshō was the product of a sub-school whose founder members were primarily painters, and Shunshō himself, despite his prolific output of prints, devoted more attention to brush-painting than most Ukiyo artists, his work including a large number of distinguished *kakemono*. This upbringing, outside the main print-designing ateliers, gave him more freedom than a designer brought up, say, in the Torii school. His earliest drawings for the print-publishers were produced whilst Harunobu still held sway in Edo, and his prints of 1765-1770 show that he had made little effort to avoid the 'sweet thraldom' to the master who so dominated that period. But profiting from contact and collaboration with Ippitsusai Bunchō and Shigemasa, he took the theatre as his special field from about 1768 onwards, and at a time when the Torii masters seemed to have nothing new to say in the narrow *hoso-e* print, infused into this type of print entirely new characteristics. During the next twenty years he created dozens of masterpieces based on current Kabuki productions. By the time that Kiyonaga began to exert his power in the early 'eighties, Shunshō was established as the master of the theatrical print and alone needed to make no concessions to the style most other artists were constrained to adopt.

As the leading designer of actor-prints, Shunshō was much in demand as a teacher, and a very large number of pupils are recorded, mostly identified by the character *Shun* with which their names begin. Designing theatrical prints was a highly competitive occupation and numbers of the pupils never seem to have made any great mark; others, like Shunchō and Shunzan, as we have seen, went over to the side of Kiyonaga and gave up the theatre altogether. Two pupils, however, with no more than occasional glances in the direction of the rival school, remained faithful to Shunshō and his style: Shunei and Shunkō (1743-1812). Both were men of great talent and both were prolific designers of actor-prints, but whereas Shunkō so closely followed Shunshō that it is matter of the nicest judgment to separate their prints if signature is lacking, Shunei had a more venturesome spirit and, departing from his master's well-tried models, produced some original works of varied character. His chief claims to attention in any history of the print are, firstly, his pioneer work in regard to what has become known, rather clumsily, as the 'Large Head' print; and secondly, his influence on the great actor-print designers of the 'nineties, Sharaku and Toyokuni. But as is so often the case, he has been viewed with a sidelong glance by eyes focussed on the masters he influenced, has been judged as the remote cause of an effect rather than as an effect himself, and the very real artistic merit of his own prints has been played down. Binyon and Sexton, with eyes fixed firmly on the peaks, are sometimes a little damning about the lesser ranges. Of Shunei they say '. . . he had not sufficient originality to become a real leader' and '. . . Shunei, even at his strongest, is always just a little empty'. As to originality, it was surely of some consequence to have introduced a type of print that led to what are acknowledged to be among the greatest masterpieces of Ukiyo-e—the 'Large Heads' of Sharaku, Kunimasa and Utamaro; and whilst it is true that many of Shunei's run-of-the-mill actor-prints might qualify for the term 'empty', I feel that that is the last criticism one would level at Shunei at his 'strongest'.

He was born in 1762 and was already making his mark early in the 'eighties. At a quite early period in his career, about

1782-1783, a book of ghost stories was published in which he was named as the artist and Shunshō as his supporter or mentor. (*Kaidan Hyakki Zue*, 'Illustrated Stories of One Hundred Ghosts'). Just how much Shunei owed to his master in the drawings for this book is hard to say, for oddly enough the style seems to proceed not from Shunshō but Sekien, who has already been mentioned as the master of Chōki and Utamaro and as an artist with a flair for portraying ghosts and goblins, of which the literature of Japan is as full as a witches' sabbath. The drawings are uncannily effective and, in one or two instances, quite powerful and imaginative essays in the macabre. For a young man in his early twenties, even allowing a certain amount of assistance from Shunshō, the book represented a considerable achievement and betokened a talent out of the ordinary.

But Shunei's main purpose in life, as a pupil of Shunshō, was to record the theatre, to follow each short-lived play by a series of prints portraying the principal characters in selected scenes. Almost invariably, following the Shunshō pattern, the prints were in the *hoso-e* format, in triptych or diptych form, with one player pictured on each sheet. At his most inspired, the master Shunshō was able to create striking and memorable works of art within these very proscribed limits, conveying the intensity of an actor's characterisation sometimes by the violence and whirling limbs of the player but, oftener, and with greater effect, by a rendering of his vehement immobility, of the iron restraint imposed by an emotion that would have rent him apart if expressed in movement. The colour print was used quite simply, without trick effects and with reliance on a fairly narrow range of limpid colours, of which a warm yellow, used in foregrounds as a rule, is so commonly found as to qualify almost for the name 'Shunshō yellow'. It was inevitable, however, that under the press of the obligation to produce such prints to order, in large numbers and at short notice, only a small proportion of Shunshō's prints should be of this high order. Though never incompetent, he was frequently dull. Exactly the same may be said of Shunei, many of whose *hoso-e* prints seem quite perfunctory and leave us cold. Among the hundreds of prints turned out almost by rote

there are, however, the few that cause us to catch our breath: where he has captured a gesture, a movement, a baleful glance as the head is turned, rendering the whole figure dynamic, potentially violent in the momentary immobility. Plate 40 shows the actor Ichikawa Komazō standing by a river bank in that position of making ready for an affray, hand on hilt, so often strikingly portrayed. Behind him, on the bank, lies his hat; on the far bank, the green of the bamboos is stark against the night sky. The actor's black outer cloak, set off by the brick red of the sash and sword hilt, is the most telling feature of the design, its shape forcing itself upon our attention and dramatically modelling the man's form. Shunei's greatest successes are in prints where he has used the solid black of the woodcut, as in this print, with commanding effect. Players are given a saturnine grimness and a scene invested with foreboding by the telling use of black passages, usually in conjunction with other colours in a low key.

More than other theatrical print designers, Shunei continually reminds us that the dance was in great measure responsible for the origin of Kabuki, and delights in recording the movements from the choreographic interludes which break up the performances of plays. Many of the dances were far more gymnastic than the smooth movements of the ballet to which we are accustomed: rhythmic whirling of limbs, noisy stamping of feet, a display of gorgeously coloured clothes rather than a gliding gracefulness that disguises physical effort. Like Kabuki itself, the dance was spectacular, and Shunei interprets it for us in a number of outstanding prints. Typical is a set of the *oban* size with the not easily explained title of *Oshie-gata*, 'Patterns for cut-cloth pictures'. *Oshie* were pictures made from cloth cut to shapes, sometimes, it appears, over a cardboard former, but the term may have been applied to another form of picture made by attaching coloured silks and brocades to a colour-print, the stuffs being cut to cover the dresses and sashes of the men and women depicted in the print. It is possible that Shunei's prints were expressly designed for this purpose, but so far as I know none have been found treated in this way. Shunei's set is of single figures of women engaged in well-known dance movements—'Lion Dance', a figure with long red

hair dancing with a branch of peony in each hand; 'Man Dance', a girl disguised by wearing a sword and nobleman's hat; 'Fox-woman's Dance', the dancer, in a dress decorated with bird-scaring devices, holding a black hat on the top of a staff; 'Insect-seller's Dance', a quiet movement, the girl carrying an insect cage in each hand; and 'The Bleacher's Dance' (Plate 41), in which great play is made by the dancer of the long strips of linen, thrashed vigorously to accompany her steps.

But Shunei's most individual contribution to the actor-print was unquestionably the 'Large Head' print. Controversy will probably continue as to whether he or Shunkō was the first to introduce this kind of print, but it is a fact that his print of Ichikawa Yaozō III as Sukeroku in a play produced in the early part of 1787 is the earliest dateable example, and as his works in this form are more numerous, it seems reasonable to attribute the introduction to him. Of course, we cannot experience the novelty that this startling innovation must have had for the Japanese. Our own style of portraiture, especially engraved portraiture, however different from the Japanese, at least prepared us for the isolation of the head and shoulders, but there were no precedents at all in Japanese art. The focussing of the artist on the head of a well-known actor, and his bringing it forward with all the terrifying nearness of the motion-picture's 'close-up', must have produced a sensation when the prints first appeared on the publisher's stalls and in the foyers of the theatres.

It is conceivable that Shunei and the other first designers of 'Large Heads' drew their original inspiration from western engraved portraits, some of which were no doubt brought into the country by the Dutchmen at Nagasaki. If so, little trace of the European origin can be detected. The 'close-up' did not actually mean greater realism in portraiture: it meant a new orientation for the design, fresh possibilities for spatial arrangement. True, the features were perforce given on a larger scale but still only in outline, so that, in a sense, the non-realism was magnified rather than diminished.

Shunei composed several superb designs of this type. One of the most dramatic is that of Ichikawa Komazō II enacting the part

of Sadakuro in a play produced in 1790.[1] The head looms ominously forward, centrally placed and vertical, and against it there is a play of angles, the shoulders sloping diagonally away in one direction, the handle of the umbrella he is carrying in the other, the ribs of the umbrella being used in a highly original way to close the pattern. Another famous print is of the actor Bandō Hikasaburō as a nobleman (reproduced in the Ledoux catalogue), where a most forceful arrangement, largely in unrelieved black, is achieved, the edges of the print being allowed to lop off the top of the curiously-shaped *kuge's* hat and the tip of the fan held outwards at an angle—cuts which have the effect of concentrating the design and projecting interest to the centre of the print, and the white grimacing face of the nobleman. The print reproduced, one of the gems of Mr. Michener's collection, is less well known, but is a superb example of the concentrated malevolence of expression and of the overpoweringly forceful design of which Shunei was capable in this type of print (Plate 42).

Certain of Shunei's 'Large Heads' were printed with mica backgrounds, but these were a few years later than the earliest on grey grounds, and it is doubtful if they preceded Sharaku's mica-grounds—certainly they were later than Utamaro's use of mica for his half-length figures of beautiful girls. The glittering mica was an eye-catching device, probably introduced by the publisher Tsutaya, for not only Utamaro, but Sharaku and Chōki, who worked almost exclusively for him, produced mica-ground prints. Shunei's mica-ground prints lack the force of the earlier 'Large Heads'. The heads seem to have been reduced in size to make way for large areas of mica and have lost the dramatic intensity of his earlier portraits.

Another type of print, the double-portrait, may or may not have been introduced by Shunei, but again, he is singularly successful in handling the problems posed by two heads *en buste*. As the print reproduced in Plate 43 shows, it was not just a question of design, though the placing of the heads across the diagonal of the sheet is most effective: there was also the interplay between the characters, so eloquently expressed here by the

[1] An impression is in the British Museum, reproduced in Binyon and Sexton.

upturned eyes of the man as he glances over his shoulder and by the responsive half-smile of the player behind. Shunei contrived to convey perfectly the mime of two experienced actors and to produce a memorable design in doing so.

Shunei's connection with the theatre was a strong one and he seems to have been recognised as an expert in all matters connected with the stage. When, in 1804, the celebrated author Shikitei Samba produced an encyclopaedia of the stage, *Shibai kimmo zui*, Shunei was chosen as the principal illustrator and in fact drew the pictures for seven of the eight volumes, Toyokuni providing a series of drawings of the leading actors in one volume (the 7th of the set). Although the novelist Samba treated the subject in a light-hearted, even facetious, manner, the illustrations at least provide us with a reliable picture of the stage in its heyday. There are maps of Theatre-land in Edo; pictures of the exterior and interior of theatres, of the foyers, the green-room, with actors dressing for their parts; diagrams of the mechanism for raising and rotating stage sets; drawings of typical stage sets, including a castle, a shrine, a belfry, a brothel, a beggar's hovel, a water-gate, a bridge and many others; a volume devoted to stage plants and animals; and exhaustive charts of various forms of make-up, of wigs, mouths and eyebrows. The drawings are hardly works of art, but the book is a valuable guide to Kabuki stage-craft in all its aspects.

One other passionate interest of Shunei has to be mentioned—*sumō* or wrestling. This artist always gives the impression of being a man's painter and, at his best, a painter of men. In a number of prints designed by Shunei in collaboration with such artists as Shunchō and Utamaro, it is noticeable that the male figures in the compositions always fell to Shunei, the female to his collaborators. In his actor prints, he is most successful in portraying actors in sinister or saturnine male roles. Few equalled him when it came to conveying the heavy masculinity of gross wrestlers, the performers in a sport followed then, and now, with remarkable fervour by the *afficionados*. Kabuki was recognised as an entertainment equally for women as for men: indeed, women often predominated in the playhouse. *Sumō*, on the

other hand, was exclusively a man's sport. Shunei has left us a triptych of a great gathering at the *sumō* arena of the Ekoin Temple in Edo, showing the parade of wrestlers that preceded the great contest of January or May. There is a sea of heads in the enclosure and long lines of figures crowding the double tier of boxes: but there is no woman to be seen, it was an all-male audience.

By his own nature, Shunei was most likely to be successful in portraying the idols of the followers of *sumō*. In a print, for example, of the wrestler Onogawa and his pupil Kusonoki (in the British Museum), the figures swell to the edge of the print so that one feels their solid weight, the bloated arrogance of the champion, and the obsequious aping of the pupil. Other artists designed some splendid prints of these favourites who challenged the supremacy of the actors in the public's favour, but none I think succeeded so well as Shunei in impressing us not only with the sheer brute strength and the heavy lumbering gait of the wrestlers, but also the insolent boorishness of demeanour that came from their being fêted by the rabid followers of the sport (Plate 44).

Shunei lived on until 1819, but did little for the publishers after about 1805.

CHAPTER XIII

———————— ◦ ————————

Utagawa Toyohiro:
The Development of the Landscape-print:
and a Digression on Ukiyo Brush-painting

TOYOHIRO appears in most histories of Ukiyo-e more for his relationship to other artists than for the virtues of his own work: first, as the brother of the successful Toyokuni, next, as the master of Hiroshige. He is not a controversial figure, he made no startling innovations to claim western attention, but perhaps by reason of that very quality of reticence which causes us to overlook him, he is one of the two artists that many Japanese print-lovers admire for outstanding refinement (the other being Shunman). The theatrical print designer had to have a streak of the pushful showman in him, much as a newspaper journalist today. To be successful, as Toyohiro's brother Toyokuni was, the artist had to mix with the players, to be familiar with the night-life of theatreland, to frequent the haunts in tea-house and Yoshiwara where good copy could be found. It was a sign of unusual fastidiousness in an Ukiyo-e artist if he eschewed the stage: several publicly disassociated themselves from any connection with it (Harunobu and Utamaro, for example, with a pride that came with success late in their careers and both forgetting the prints they had made of stage celebrities before they had made their names). Toyohiro was one of those who would have nothing to do with the theatre, and in one print went to extravagant lengths to show his aversion. This is a pentatych showing visitors to the Myōhō temple. Among a great concourse of people from all walks of life there is a group of three actors;

whilst all the remaining sheets are signed by Toyohiro, he enlisted his brother to draw the actors and to sign his name, Toyokuni, beneath them. In this and other ways he is the interesting antithesis to his extrovert brother. Ficke, one of the few to deal sympathetically with his work, suggests that his brother's popularity was due to an ability to 'shift and veer with every change in public taste, while Toyohiro was unable or unwilling to move with these fluctuating winds'. The unwillingness is sometimes implicit in Toyohiro's subject matter and in his conservatism generally. He impresses one as the reluctant Ukiyo-e artist, condemned by birth to an association he found distasteful, and escaping by incursions into fields laying rather outside the normal limits of his school. From our point of view, his development of the landscape print is probably the most significant result of his search for subjects outside the theatre and the brothel, but the Japanese themselves, perhaps more discerning in such matters than ourselves, find evidence of his quiet refinement in figure prints as well.

Both Toyohiro and Toyokuni were pupils of Toyoharu, the founder of what became, in the 19th century, the predominant sub-school of Ukiyo-e: the Utagawa. Toyoharu's name is linked so closely with the development of *Uki-e* or 'perspective pictures', that his accomplishments in other directions are apt to be overlooked. He was a young man when Harunobu's influence was paramount and a few prints of the early 'seventies show that he, like that other independent artist, Shunshō, began by making quite creditable designs in the Harunobu manner. He collaborated with Shunshō and Shigemasa in the production of a set of prints of the Twelve Months in which all three seemed to bury their differences of style in the interests of uniformity—an unexpected outcome of collaboration not by any means confined to this set. (Shunshō and Shigemasa, for instance, designed the prints for a sumptuous *ehon* of courtesans 'A Mirror of Fair Women of the Green-Houses' (1776), in which it is difficult to determine the artist of any individual print though normally each artist was recognisable by his style.) Later, however, Toyoharu abandoned the more regular kinds of Ukiyo-e print and

specialised in topographical sheets, often betraying western influence, and on occasion even copying western prints of European towns and architecture, with the most curious hybrid results. He was, moreover, an outstanding painter in the true Ukiyo-e style. That Toyohiro was clearly more the pupil of his master than Toyokuni is borne out by his greater interest in landscape and by his success as a painter.

Born in 1773, Toyohiro was active between 1795 and 1824. Actor-prints apart, there was nothing in the range of the normal Ukiyo-e artist that he did not attempt, always, however, taking a line a little off centre, avoiding the too well-worn paths and presenting stock subjects with a freshness that is almost originality. His triptychs are often Ukiyo versions of the pastimes of the nobility: a young prince on a wooden hobby-horse surrounded by court ladies and children; a Daimyō's kite-flying party; a drawing competition in a nobleman's house; a school of archery, with onlookers watching mounted archers competing. A number of Edo street-scenes bring in the great drapery establishments— drawn, for the most part with a tedious attention to perspective that bespeaks a familiarity with his master's *Uki-e* technique—and other prints, of people visiting notable temples and shrines, offered further opportunities for elaborate architectural backgrounds. His designing of the figure in these intricate compositions is not always to our eyes particularly elegant, though in the best-known triptych, of girls enjoying an 'Evening Cooling', a scene of summer indulgence that Ukiyo-e artists found especially attractive, his composition of groups of lissom forms vies with those of the greatest artist practising at the time—Utamaro. His later triptychs and figure-prints generally take us for the first time into the 19th century, and in his prints, as in so many other artists', one senses a change, experienced like the chill air of a new house when the threshold is passed. This is hardly a trick of the imagination: one has only to look at the sudden deterioration in Utamaro's work after 1800, and, even more marked, in that of Toyokuni. In Toyohiro there is a certain loss of sweetness in the women, their faces become hard and angular, and they are recognisably related, though immeasurably more refined than their descendants,

to the repellent Utagawa brood of squint-eyed, lantern-jawed creatures that Toyokuni and his followers fathered. By the turn of the century, Ukiyo-e seemed on the point of exhaustion, the works of even the most prominent artists became jejune and stale, and the colour-print needed some fresh impetus, a new stimulant, to revive its vigour.

One source of fresh inspiration was found in landscape. Landscape, it need hardly be said, occupied Ukiyo-e artists before this time, but apart from the *Uki-e* type of print, which was a genre apart, had rarely been drawn for its own sake. Landscape was the supreme form of art in the estimation of the classical schools of painters, but the mark of Ukiyo-e from the first had been its concern with mundane human affairs, the everyday life of people in the towns and suburbs, to which landscape was no more than an incidental background. The masterpiece of the Kanō and Chinese-inspired artist might well be a painting of a mountain cataract, or an ancient pine-tree, or a wide vista of the plains, with the human beings made insignificant beside the immensity of the scene. Generally, such subjects were unthinkable to a Ukiyo artist: his interests centred on the events of the town, the passing show, the people, the topical, not the eternal. None the less, Ukiyo-e artists quite often had leanings towards other higher forms of art, and just as Koryūsai and Harunobu ventured successfully into the classical domain of the bird-and-flower painting, giving their own slant, in the colour-print, to a type of painting hallowed by its association with some of the greatest Chinese and Japanese names of antiquity, so Utamaro and Toyohiro, and later Hokusai and Hiroshige, Eisen and Kuniyoshi, designed 'pure' landscape, but landscape that, because of the colour-print medium and the inescapable idiosyncrasies of the Ukiyo-e style, seems to belong to another world than that of the classicists.

The later development of the landscape print is discussed in the chapters on Eisen and Kuniyoshi but here it is necessary to touch on Toyohiro's position as a designer of landscape prints, and his influence on the trend of this type of print in the 19th century. It cannot be claimed that there are any masterpieces among his

prints. The best known—the 'Eight Views of Edo'—have received high praise, but although adequately expressing breadth and distance and relying on topographical features to the virtual exclusion of figures, there is something flat and tepid about the prints, which lack both bold brushwork and a strong colour-print technique. These 'Eight Views' also suffer from the rather meaningless use of lateral conventional cloud bands for separating the planes of the picture, a survival from the technique of the early Yamato-e scrolls and a further reminder of the constant recourse of Ukiyo-e artists to the fount of traditional native painting. Much more successful is the singularly poetic series of the 'Six Jewel Rivers' where a happy relationship is achieved between figures and landscape, here treated simply and boldly and in a manner far more suited to the colour-print than the detailed topography of the 'Eight Views' (Plate 45).

Toyohiro's influence on the development of the landscape print was not due to any overwhelming success of individual prints, though the discerning probably saw the possibilities of the broad wash technique of the 'Six Jewel Rivers' set. The significance of his prints lies in the fact that they gave a lead to other artists, notably Hokusai and Hiroshige, to remove the landscape subjects from the picture-books where they had languished hitherto, into the realm of the broadsheet. In that respect, the 'Eight Views', appearing as they did about the turn of the century, have an importance not otherwise justified on their artistic merits. Hokusai's early Tokaidō series, issued in the first decade of the 19th century, must have followed closely on the publication of Toyohiro's prints, and the way was open for the development of the landscape print, leading eventually to the masterpieces of the '36 Views of Fuji' and the 'Waterfalls'.

I have already mentioned, in the chapter on Shunchō, Toyohiro's achievement as a designer of pillar-prints. There are some half-dozen of his in which he adopts a device very much his own: a single figure, positioned beyond a narrow aperture, being glimpsed rather than seen whole, but as though with an intensity of gaze that fixes on the parts of the form visible through the opening. The resultant compositions are some of the most daring

and striking in the whole range of the Japanese print. The action of a girl holding an insect cage, or of a youth arranging irises in a vase, or a girl making up at a mirror, is not fully described, for the movements, like the limbs, are curtailed by the narrow framework of the print: but the drawing, like the best kind of Japanese poetry, in describing the part leads the mind on to complete the rest. The figures, or the parts of figures, fill the panel, and yet one is fully conscious of the space surrounding them, just as we are conscious of the sky in a landscape by van Gogh where the horizon is higher than the upper frame of the painting and the solid earth fills the canvas. There is, in each of these pillar-prints, a sense of extraordinary compression, as if Toyohiro, not satisfied with the already difficult task of designing within such narrow limits, had set out to achieve a *tour-de-force* by conveying the idea of life-size figures. In what is perhaps the most exceptional, a girl pauses to read the letter she has just written, leaning her head upon the hand holding the brush. The head is placed slantingly across the narrow panel, the edges of which cut through the centre of her hair at one side and across her chin at the other; the only part of her body silhouetted is part of her right shoulder, the whole lower area of the print being filled with the unwound letter-scroll and the flowered *kimono* seen behind it. Most other designers accepted the exigencies of the format to the extent of sacrificing part of the outline of the figures, but none were prepared to go to quite the length of discarding it almost entirely as Toyohiro did (Plates 46*a* and 46*b*).

As might be expected from his obviously cultured and refined approach to the stock of Ukiyo-e subjects, Toyohiro was a *surimono* designer of the highest order, and though not so prolific in this field as Shunman and Hokusai, can be linked with them for the wit, sophistication and originality of his compositions in this form. He is known, too, for certain small prints, usually monochrome printed, from brush-drawings made in a semi-Kanō style and devoted to subjects associated with that school. Drawings of various types of flower-arrangement are among these, and such amusing little sketches as the 'Long Armed Monkey and Crab' reproduced by Mr. Michener in 'The Floating World'.

Such things are exceptional in any Ukiyo-e artist's *œuvre*, but it has to be borne in mind that prints like it, and just as good, were common in the *ehon* and albums designed by artists of the Kanō and Independent Schools: Shumboku, or Morikuni, or Kanyōsai, for example, to name only three. Toyohiro's own book-illustrations are of great variety and interest, both as illustrations to novels and for topographical works, but for reasons given already, cannot be dealt with here.

Toyohiro's ability as a brush-painter has already been alluded to. Whilst this book is intended to deal with certain aspects of the Japanese print and a further one would be required to deal adequately with the paintings of the colour-print designers, it seems worthwhile to touch on the subject of this other activity of the artists, and especially to consider the relation between the paintings and the designs for prints.

Plate 47 is a reproduction of a typical Toyohiro, and for that matter a typical Ukiyo-e painting. Face and limbs are dead, opaque white. The clothes are in a body-colour that admits of intricate floral motifs of the stuffs being superimposed in fine detail on the ground colour. The landscape details, the foreground bank, the bole of the tree, the moored junks and the distant shore, are painted in transparent washes that remind us at once of our own water-colour technique. It is a curious and imperfectly integrated amalgam of methods: of the opaque, finely-detailed Tosa, delighting in the superficial ornament of dress as much as in the episodes of courtly life depicted; and of the broad wash technique of the Kanō or Shijō Schools, revealing always the passage of the brush and depending for much of its effect on the transparency of the colour washes. By the Japanese themselves, who judge painting on the brushwork and on the expressiveness of the work through its brushwork, Ukiyo-e paintings have invariably been slightingly referred to. Few Ukiyo-e painters, except in their off-guard, non-professional effusions, satisfy that first requirement of the oriental connoisseur for expressive brushwork. *Descriptive* brushwork, as Toyohiro's largely is, they look on as menial, inartistic naturalism. When we add to this condemnation of the Ukiyo-e style their aversion to the 'Floating

World' kind of subject-matter, it is easy to understand why the collector of what we might call 'paintings in the Japanese taste' ignores Ukiyo-e.

Even with an imperfect understanding of the qualities extolled by the native connoisseurs, we are able to sense that the technique of the Ukiyo-e painting is a laborious one inhibiting or obscuring the brush-stroke, the calligraphic line; there is too, we feel, a confusion of scale, the ornate drapery being painted with an observance of fine detail as though a miniaturist had been set to paint life-size figures; and an antipathy between the background details, the glimpse of landscape and the so-often-introduced overhanging bough, touched in with light transparent washes, and the worked-up body-colour of the remainder of the painting.

But the Japanese have always lagged behind the West in appreciation of the prints, and their disparagement of the print-makers' paintings need not necessarily be any criterion of our own attitude to them. In point of fact, the paintings have never made anything like the impression on us that the prints have. It is not merely that they are much fewer in number, though the comparative ignorance of the print-collector concerning Ukiyo-e painting arises to a certain extent from that scarcity. The paint-ing technique, though anathema to Japanese purists, is still sufficiently oriental to interpose a barrier: the woodblock print medium has acted almost as an interpreter between us and the foreignness of Japanese art. The prints, again, are in formats (with a few exceptions) akin to those of our own prints, easily assimilated at a glance: the paintings, on the other hand, are in the tall upright *kakemono* form, or the long lateral *makimono*, both requiring a certain adjustment in our normal approach to a painting. But though these are possibly contributory causes, the real reason for the lack of impact of the paintings is their tameness compared with the prints. A painting by Kaigetsudō can be a wonderfully decorative work, with bold black outline and gor-geous colour for robes and sash: but it lacks the majesty of an uncoloured impression of a woodcut by the same artist though the subject can be identical. The painting, in the comparison, seems cluttered with colour and lacks the serene simplicity that the

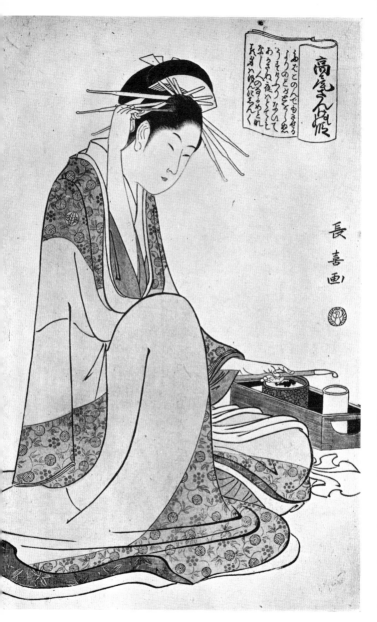

あだこのんてもきよせる
うりのどみきてく色
うそゆりつなへて
あてそれ夜へとそして
なしくのすゆめとれ
きまたんにさんく

高気うん帳

長
喜
画

33. Chōki: The 'Confessions of Takao'. 15″ × 9⅞″. *British Museum*

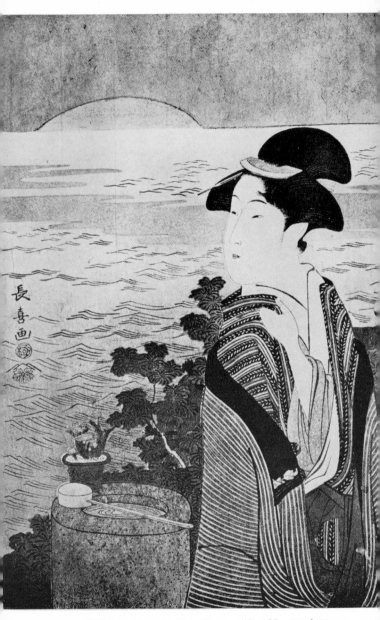

34. Chōki: Sunrise at the New Year. $13\frac{1}{4}'' \times 9\frac{5}{8}''$. *British Museum*

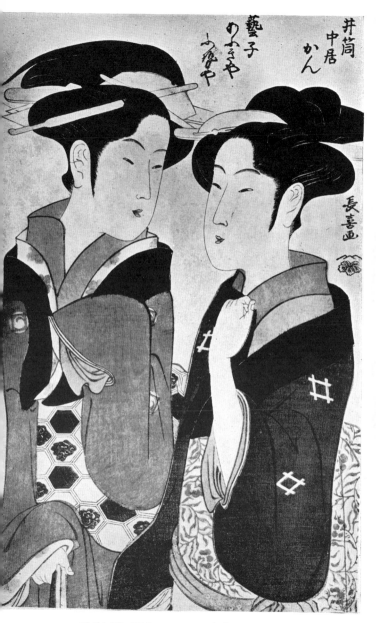

井筒
中居
かん

藝子
ふせや
ふせや

長喜画

35. Chōki: The Waitress Izutsu and the singer Fuseya
15″ × 9¾″. *Private collection*

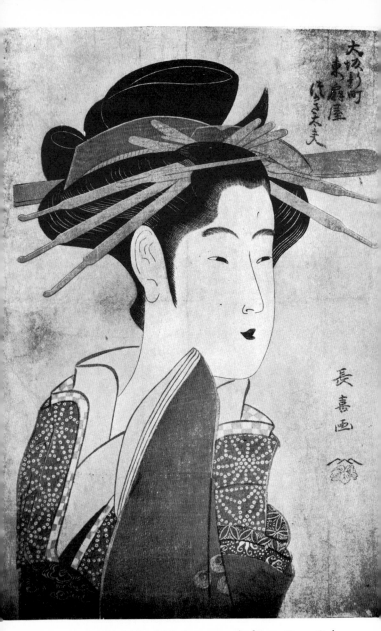

大坂さ町
東扇屋
ひさ太夫

長喜画

36. Chōki. A *Tayū* (high-class courtesan) of Tozen House, Osaka
15" × 10". *Honolulu Academy of Arts (Michener Collection)*

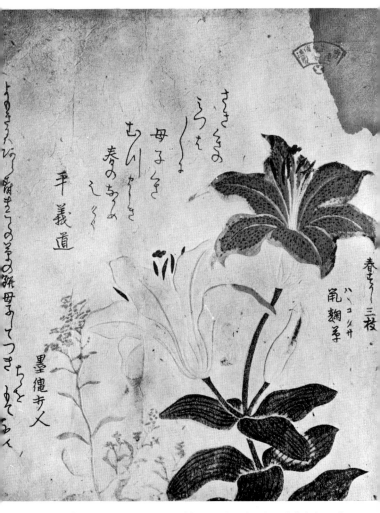

37. Kubo Shunman: *Surimono*: Tiger lilies (*yuri*) and cudweed (*hahakogusa*)
$8\frac{1}{2}'' \times 7\frac{1}{4}''$. *Victoria and Albert Museum*

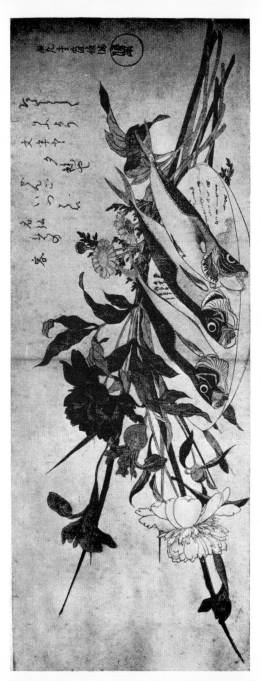

38. Kubo Shunman: Long *surimono*: Flowers and fish. 8″ × 22″. *The Chester Beatty Library*

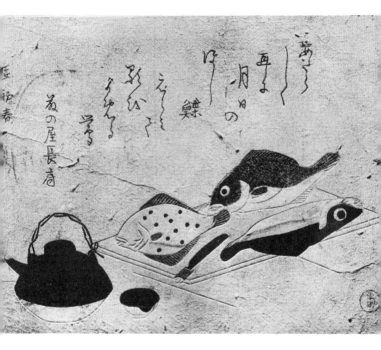

39. Kubo Shunman: *Surimono*: Fish on a board and a pottery kettle and tea-bowl
$5\frac{1}{4}'' \times 7\frac{1}{4}''$. *Author's collection*

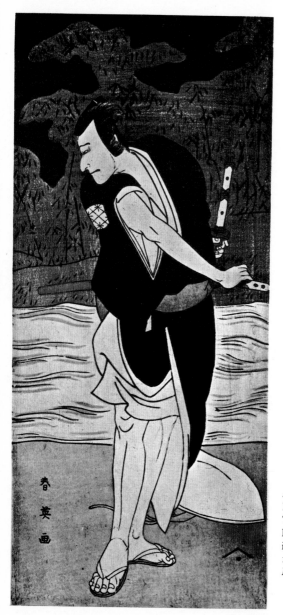

40.
Katsukawa Shunei:
The actor
Ichikawa Komazō
in character
$12\frac{1}{4}'' \times 5\frac{3}{8}''$
British Museum

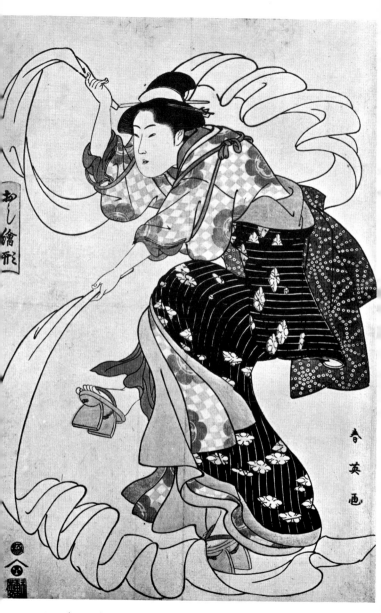

41. Katsukawa Shunei: The Bleacher's Dance. 15″×10″. *British Museum*

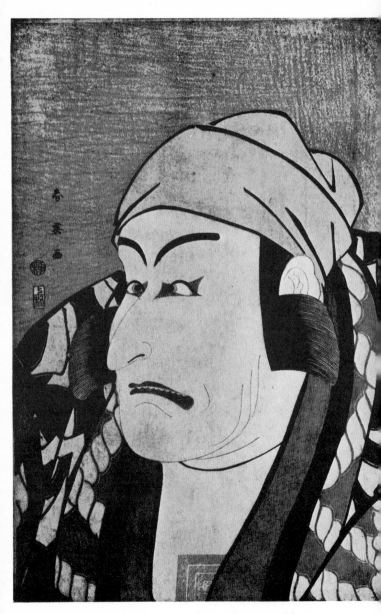

42. Katsukawa Shunei: 'Large Head'—The actor Ichikawa Danzō
15″ × 10″. *Honolulu Academy of Arts (Michener Collection)*

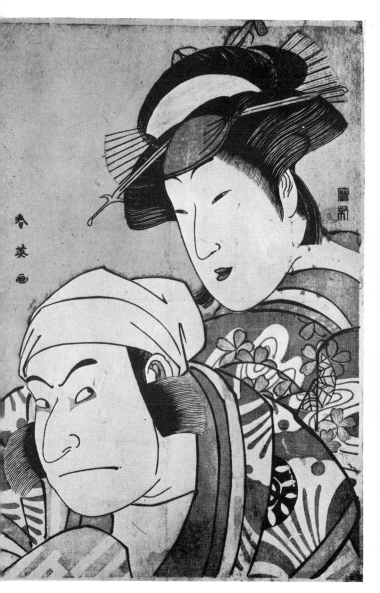

43. Katsukawa Shunei: Nakamura Noshio II as the woman
and Nakamura Denkurō II as the man in a theatrical duo
$14\frac{3}{4}'' \times 9\frac{3}{4}''$. *The Chester Beatty Library*

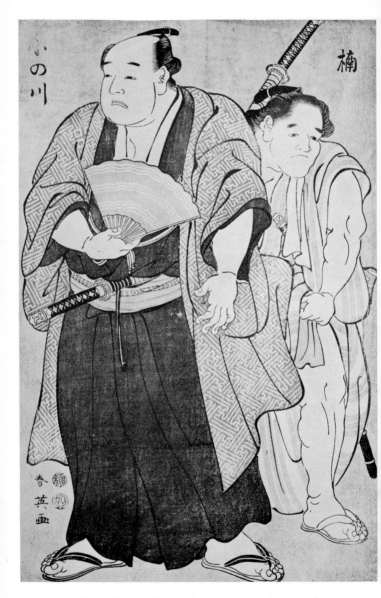

44. Katsukawa Shunei: The wrestler Onogawa and his pupil Kusonoki
14¾″ × 9⅞″. *British Museum*

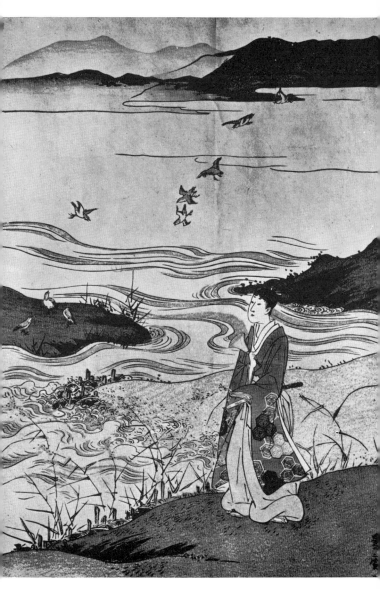

45. Utagawa Toyohiro: The *Chidori* or 'Plover' River, one of the 'Six Jewel Rivers'
15″ × 10″. *Victoria and Albert Museum*

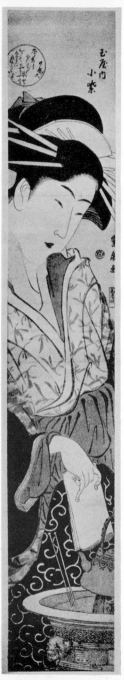

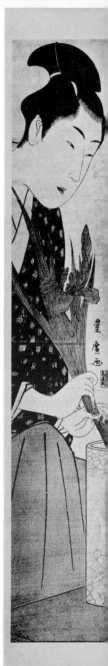

46*a*. Utagawa Toyohiro:
Komurasaki beside a
brazier. *Hashirakake*
Museum of Fine Arts, Boston

46*b*. Utagawa Toyohiro:
Young man arranging iris
Hashirakake
Museum of Fine Arts, Boston

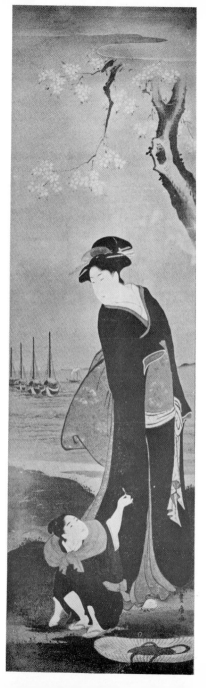

47. Utagawa Toyohiro:
Mother and boy on the beach
of a bay, the child picking
mare's-tail. Brush painting.
$36\frac{1}{2}'' \times 10''$. *Author's collection*

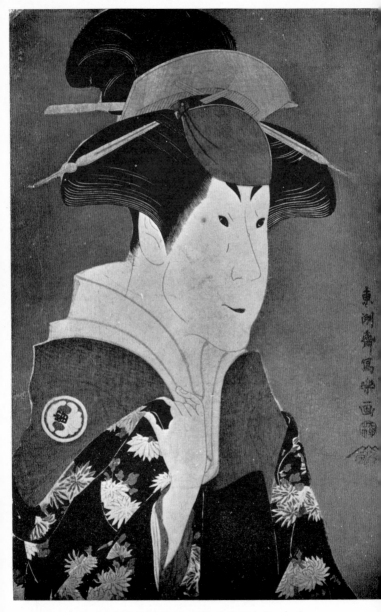

東洲齋寫樂画

48. Tōshūsai Sharaku: Segawa Tomisaburō in female character
14¼″ × 9⅜″. *British Museum*

firm woodcut line gives to the print. Furthermore, most artists, whatever the degree of originality of their designs for prints, seem to have had their lively inventiveness cramped by the more serious undertaking of painting: some may even have felt the lack of the stimulus provided by the print-publisher. Even the most successful painters, such as Eishi, Shunshō and Toyohiro, failed to produce *kakemono* to rival the best of their prints, and Utamaro, so outstandingly original in other fields, is known as a painter only by half a dozen mediocre compositions.

Yet this is not to deny that the paintings have their own appeal. Allowing the greater vitality of the prints—a vitality stimulated by the demands of a novelty-craving public, by the resourcefulness of the publishers, and by the very medium of the colour-woodcut itself—one must also concede a superb decorativeness to the finest paintings. Many, like the Toyohiro reproduced, have a powerful sweep of line and a lovely harmony of colour and often, even when the subject is a sophisticated one, a quality which can only be likened to naïveté in the actual painting, a certain childlike observation of the colourful inessentials and a painstaking representation of them.

Later artists, especially Hokusai, broke away from the style traditional, since Moronobu, to the Ukiyo-e brush-painter, and with their greater freedom produced paintings and drawings of universal appeal. Of those artists who, like Toyohiro, adhered strictly to the technique of the school, it can be said of their *kakemono* that, interesting as they are to the student and collector, they are never likely to win the world-wide appreciation and admiration accorded to the prints.

CHAPTER XIV

---○---

Utagawa Kunimasa:
A Master of the 'Large Head' Print

THE last decade of the 18th century was a period of
phenomenal productivity among Ukiyo-e artists, and a
time, too, of an extraordinarily large number of great
designers. No other decade in the history of the woodcut can
furnish an array of genius equal to that which graced the years
from 1790 to 1800. Excluding even Kiyonaga and Shunshō, who
disappear soon after the opening of the decade, and Hokusai whose
activities were largely confined to actor-prints and *surimono* at this
period, there are Utamaro; Eishi and his pupil Eishō; Shunei;
Shunkō; Shunchō; Shunman; Sharaku; Chōki; Toyokuni;
Toyohiro and Kunimasa—for all of whom this was the central
period of their careers, the time of their maturest work. Several
of these artists have been the subject of earlier chapters; others, like
Utamaro, Eishi and Toyokuni, are major figures of the school and
adequately dealt with in the ample literature of the Japanese print.
There remains Kunimasa, a much neglected artist, at any rate in
this country, and in regard to whom any discussion must involve
consideration of that enigmatic figure, Sharaku.

Born about 1773, Kunimasa was one of the first pupils to enrol
under Toyokuni and received instruction at a time when Toyo-
kuni was at the height of his powers. No artist has been so
persistently underestimated and denigrated as Toyokuni. It is
undeniable that he was responsible for an enormous number of
shoddy prints after the turn of the century, but however poor and
however numerous, they should not blind us to the really superb
works he produced earlier. Ficke's stricture, quoted above, that

his popularity was due to his being able to 'shift and veer with every change in public taste' is only a half-truth: it could not have been attained without a positive talent of his own, especially a power of commanding and often original handling of the actor-print. Kunimasa's reputation rests on an infinitely smaller output, a body of prints so limited in scope that it is easier for us to grasp the creator's personality than it is to summon up an idea of Toyokuni's, diffused through a mass of varied material, with the original and the plagiaristic inextricably confused.

In the designs relying on full-length figures, however successful on occasion, Kunimasa rarely has the grasp of dramatic composition or the faculty to surprise that Toyokuni shows in his finest theatrical prints: he is known almost exclusively by some thirty or forty 'Large Heads' of actors, and indeed, would probably have languished among the completely ignored but for the phenomenal impression made upon the West by the 'Large Heads' of Sharaku. Kunimasa's bust-portraits were produced in the years 1795-1798, and nobody can doubt his debt to Sharaku, all of whose prints had appeared in 1794. Before considering his own especial gifts, as distinct from Sharaku's, it is first of all necessary to explain the immense vogue of Sharaku among the first French collectors and the widespread adulation of his prints today.

We do not find it difficult, now, to surrender to the power of his unerring *mise-en-page*, the vitality of his line, the compulsion of his strong characterisation. The normal reaction to a Sharaku portrait is a necessity to read the face—the rest engages the attention afterwards: we are fixed by the heavily-rimmed and often squinting eyes, the startling sweep of the painted eyebrows, the grimacing mouth, and above all, by the intensity of the expression. Afterwards, we acknowledge the deliberate gesture, the meaningfulness of a hand when it no more than clutches the collar of a garment; the force of the brush-line that brings all this home, the economy and strength of the brush-strokes translated into woodcut; and finally, the colour, the colours of nature in some way heightened, dramatised, just as the gestures and facial expressions are, and set off by the mysteriously impenetrable background of dark mica (Plate 48).

It is well to remember, however, that although so impressive to us, Sharaku has not always or everywhere been admired as he is now. The American Fenollosa, one of the first art-historians to specialise in oriental art and a great protagonist of the colour-print generally, had some very harsh things to say about Sharaku the *Masters of Ukiyo-e*.[1] 'This artist,' he wrote, 'so repulsive in his odd treatment of actors, offers new evidence, if any were needed, that Kiyonaga, had he persisted in designing, would soon have stifled in a fetid atmosphere. And yet this arch-purveyor of vulgarities and degraded types has been hailed by some Western connoisseurs as a divine genius.' The book in which that diatribe appeared was published in 1896. Anderson, a little earlier, in books published in 1886 and 1895, completely ignores him, and he was apparently unknown to Strange, or thought unworthy of mention, when he wrote his 'Japanese Illustration', published in 1897. It was the French who appreciated his prints, and com-prehensive collections were for long only located in the cabinets of French collectors. There was something in the art of Sharaku that appealed forcibly to those who sought new horizons for pictorial art, beyond the 'naturalism' that had for so many centur-ies bounded the vision of painters, and a respect for which still limited the criticism of traditionalists, especially this side of the Channel. Yet, paradoxically, Sharaku produced his immense effect upon the French because his prints were in some respects nearer the European notion of realism, and because his departures from realism—his distortions, his intensification—were therefore the more powerfully felt. His 'Large Heads' are truly portraits, marked by a trenchant psychological insight—in itself a departure from normal Ukiyo-e practice—but more than that, the features and the character are brought out by the very wilful arrangement and selection that protagonists of modern art were insisting, at the end of the 19th century, was the prerogative of the artist, and which, in Sharaku, was plainly one cause of the arresting power of his prints. Shunshō's and Shunei's prints, if analysed, are, when it comes to details, as non-realistic as Sharaku's, but it is the non-realism habitual to Japanese prints, something that is part of their

[1] *The Masters of Ukiyo-e*, by E. F. Fenollosa, New York, 1896.

normal appeal to us, and due to elements of style and technique within the gift of every Ukiyo-e artist. Sharaku far more consciously went beyond the limitations of the school's style. With his analytical drawing of features and gesture, he brought his prints into the orbit of western concepts and because of that, the stark line and flat colours have a greater significance than they do in the prints of Shunshō and Shunei. The fact that the Japanese themselves only became reconciled to Sharaku's prints after they had, as a nation, become largely westernised, is a measure of support for this view. Until then, Sharaku had seemed as wild and vulgar to them as he did to Fenollosa.

Sharaku produced the whole of his more than 130 prints in the year 1794—an astonishing phenomenon for which there is absolutely no explanation. Scraps of contemporary evidence point to the fact that he was 'in advance of his time', that his prints were unpopular, probably because unflattering to the stage idols, and that he was an 'independent', aloof from allegiance to any particular sub-school. None the less, he had his admirers and copyists, and obviously impressed certain of the more regular members of the Ukiyo-e school. Chōki had a short period of infatuation, wholly detrimental to his own powers of design, and acknowledged his homage in a pillar-print of a girl shown holding a fan decorated with one of Sharaku's prints (the well-known 'Man with a pipe'). Another obscure artist, Kabukido Enkyō, did a few imitations, aping the idiosyncrasies of Sharaku, but lacking the informing spirit that co-ordinated them. Toyokuni tried his hand at the 'Large Head' print with customary success, but in a manner much his own and rarely competing with his model. Only Kunimasa returned to the vein that Sharaku had worked and left unexhausted. It is a different metal he eventually refines, and compounded with that of the Utagawa, productive of an alloy which, like most Japanese alloys, has more curious character than pure elements.

In characterisation, Kunimasa lacks the penetration of Sharaku, and stands perhaps midway between Shunei and Sharaku. Sharaku got behind the actor's mask, made us realise the meanness of the men who enacted the heroic roles, the ugly masculinity of

the *onnagata*, the players of female parts. Kunimasa is not without a certain acid in his equipment, but it is not so corrosive, does not bite so deeply, as Sharaku's vitriol. Yet his finest prints are great theatre, and eloquent of the Kabuki drama they illustrate so well. One can imagine what a superb poster the print of Ichikawa Danjurō in a *Shibaraku* scene (Plate 49) would make with its bold flaunting of the geometrical patterns, the stylisation of the hair to accentuate the pyramidal build-up. This is pictorially dramatic in a way quite different from anything that Sharaku produced, and deploys the technical resources of the woodcut in a most telling way. The concentric squares of white on a red ground, the badge or *mon* of the Ichikawa family of actors, was often introduced with immense decorative effect by actor-print artists and especially by Shunshō, but there are few prints where it has been used so successfully as in this broadsheet of Kunimasa's, where it is reduced to a huge white chevron at the right-hand corner of the print.

Plate 50 reproduces another theatrical print, this time of an actor in the role of a woman. The scholarship devoted to Sharaku has made it possible to identify the plays in which the actors he depicts took part, and in most cases even to assign to them their particular roles. Little research of this kind has so far been carried out in relation to Kunimasa, but it is doubtful if a great deal would be added to our appreciation of his prints by such documentation. The plays are invariably, to us, a farago of impossibilities, a vehicle for Kabuki as our libretto is a vehicle for operatic music, and usually with less literary merit than even the worst libretto. Consequently, lacking literary appeal, there are few plays that we get to know intimately enough for us to be able to adjudicate on the artists' interpretations of character. Imagine, if we can, an English artist's portrait-head of Edmund Kean as Macbeth: one would first have to have a thorough knowledge of the play to be able to judge whether or not the actor was adequately interpreting the playwright's conception, before we could comment on the artist's rendering of the actor's interpretation. Generally, we approach the Japanese actor prints unbiassed by any such considerations and look at them as works of

pictorial composition rather than theatrical documentation. We may lose something by reason of our ignorance of the plays, but we gain immeasurably by not having our vision conditioned by literary or histrionic considerations.

In looking at this Kunimasa print, we do not need to know the character the actor is portraying: each one of us who looks intently at it probably creates a character, and even a play, to fit the artist's portrait. The face is a most expressive one. The eyebrows are raised like excited antennae on either side of the beaked nose, and the narrow slits of eyes are almost lost in the hollows beneath the brows. But the triumph of this astringent study of a famous *onnagata* is the mean, withdrawn mouth, which underlines the disdain already implicit in the raised brows and the narrowed, calculating eyes. Shrewd, however, as we feel this face to be, it has not the power to transfix us like the best of Sharaku, perhaps because we are distracted by the incredibly elaborate coiffure and the play of the hands agitatedly pulling the *tenugui* around the shoulders. Even so, it is a superbly composed print, with a bite and piquancy entirely its own.

In the 'Yama Uba' (Plate 51) the head is slanted across the sheet in a manner surprisingly suggestive of movement, of a thrustful gesture. There is a deliberate contrast between the massive black strokes outlining the hair-fillet and the dress and the hair-fine grey-printed lines of nose and hands. This is a tremendously effective print, with a forcefulness and dynamism that is quite gripping.

There are probably thirty or forty actor-prints of this calibre by Kunimasa (Plate 52 reproduces another), but it is futile to attempt to describe others: a verbal picture can be given of some kinds of print, but not this, which relies on the expressiveness of the face and hands, and on the purely pictorial felicities that come from powerful drawing and effective placing of the head and shoulders on the page.

Few artists were so wholly devoted to the theatre as Kunimasa, and only a very few of his prints do not seem to have been prompted by theatrical productions. Two at least of these are of exceptional originality and demand mention: a three-quarter

back view of a girl seated with a *samisen* in her lap, and a girl seated by a winter-warmer known as a *kotatsu* on which a cat is ensconced. Both these are quite out of the ordinary and deserve to be better known. Kunimasa illustrated only one book, a book of Edo actors, published in 1799, in which he collaborated with Toyokuni.[1] Even on the smaller scale of the book page his portraiture is intensely dramatic, though there is little to choose between his prints and Toyokuni's, perhaps because of that curious levelling up of styles that sometimes happened when artists collaborated in illustrating a book.

There is some doubt about the date of Kunimasa's death, but he seems to have given up print-designing about 1800. His period of activity was longer than Sharaku's, but the number of prints on which his reputation rests is fewer even than those by Sharaku, and, if anything, they are rarer.

[1] *Nigao Ehon Haiyu Gaku Shitsu Tsu.*

CHAPTER XV

———— ○ ————

Hokkei:

An Accomplished Follower of Hokusai

THE feverish but often fruitful activity of *fin-de-siècle* is a phenomenon which has been remarked in the cultural history of most countries, but the succeeding exhaustion and failure of the creative impulse of *début-de-siècle* seem to have received far less notice. In Japan, for instance, at the beginning of the 19th century, there seemed for a time, after the enormous fecundity of the previous decade, a failure of the springs of inspiration, at any rate in those spheres in which Ukiyo-e had achieved its most characteristic successes—the actor-print and the beautiful-girl picture. Utamaro died in 1806 and the best prints of those artists that the publishers could call on after his death seem to lack the vital spark, whilst the worst are little short of hideous. Had Utamaro never been, no doubt we would see more in Eizan and Tsukimaro, but with his great designs before us it is difficult to tolerate the enfeebled versions of his plagiarists.

It is natural to seek reasons for the vulgarisation of actor- and courtesan-prints, and to some extent the falling standard seems attributable to a changing public. Whatever the causes, it is obvious to us that, on the one hand, the tastes and pleasures of sections of the people had coarsened since the 18th century, and, on the other, a lower social stratum was now being catered for by the publishers of colour-prints. The degeneration of the actor-print after 1800 is symptomatic of the failing standards of the class of theatre-goer and print-patron who, in the previous decade, when buying representations of actors in current plays, had obtained superb works of art by Shunei, Toyokuni, Sharaku and

Kunimasa. By 1810, Toyokuni's theatrical prints were a travesty of his fine earlier designs, the attitudes false, the features drawn to a formula of haggard ferocity, the feet and hands afflicted with arthritis, the woodcutting and printing shoddy, the colours violent and inharmonious. But they clearly had a ready sale, and what to us are their glaring faults must have appealed as virtues to the Kabuki follower of the time.

The spread of literacy, or half-literacy, and the struggle of the multitude of publishing houses to maintain their existence, resulted in a flood of literature and prints directed towards those of a low level of intellect and taste. We have seen something of the same thing here in England in our own time. The number of people able to read and able to afford to buy books and periodicals continues to rise, but the upshot has been a steady increase in the issue of cheap, sensational literature, periodicals of dubious character, horror-comics and scandal-sheets, whilst the older type of magazine, purveying literature of a more solid, elevating kind is in a decline. There were still those among the commoners who were literate and cultured to a remarkable degree, but, by the 19th century, of this class a greater proportion than formerly presumably found its interest in the work of the 'classical' masters, and the publication of considerable numbers of picture-books containing prints after such artists as Bumpō, Gesshō, Suiseki, Baitei and the like—fundamentally Chinese-inspired—and Hōitsu, who carried on the Kōrin tradition, bears witness to a popularity of works of this type so widespread that it must have affected sections of the community who earlier might have been devotees of the Ukiyo print.

The Ukiyo-e artists had, after all, always served two masters, or two publics, widely different in tastes and the level of artistic appreciation. A certain proportion of their output had always been aimed at the poorer, less educated section of the population, taking the form of *kibyōshi* 'yellow-backed storybooks', light, frivolous reading with the pictures and text mingled and cut on one block. But this and kindred types of cheap production, in the designs for which all the greatest Ukiyo-e artists served their apprenticeship, was a by-product of the artists' main activities,

and their colour-prints were invariably prepared with great care for what must have been a discerning audience. By the 19th century, the contrast between the two sections, the differing patrons, was far more sharply defined, and the prints, too, began to suffer from mass production for those who wanted cheap pictures of theatrical personalities and of the denizens of the *demi-monde* and who were satisfied with standards that would have been inconceivable earlier.

But it is a complete misconception to condemn all the prints of the 19th century because a large proportion, that most commonly in evidence, are of this debased type: there were still those artists who continued to design prints, and especially prints for books, acceptable to people with high artistic standards. Except in the field of landscape, however, the prints of these artists were rarely in the normal broadsheet form but appeared as *surimono*, or in the finely printed albums of poetry. The actor-print and the beautiful-girl picture, *bijin-e*, which had always accounted for the bulk of the published broadsheets, both went steadily downhill after 1800, but it is noticeable that Hokusai produced very few prints of those types, and the same can be said for the majority of his pupils.

It is in fact in the work of Hokusai and his principal pupils—Hokkei, Shinsai, Hokuba and Taitō—that we find the best wood-block prints of the early 19th century, and of these pupils, Hokkei is probably the designer with the most pronounced personality.

No one, of course, can deal with the Japanese print in the 19th century without an awareness of the dominating figure of Hokusai. Like Fuji itself, which can be seen from any one of Thirteen Provinces, Hokusai so far towers above his contemporaries that his presence is felt even when attention is focussed on another artist of the period. He is a phenomenon in the art of his own country, and an even greater phenomenon in the art appreciation of the West, where for so long he has been venerated for expressing the very soul of Japanese painting, despite the strenuous opposition to this deification from the Japanese themselves. He was not primarily a broadsheet designer, though his fame rests largely on his colour-prints. His major activities were

in book-illustration and in painting. Hokkei became his pupil about 1803 at a time when Hokusai's main occupation was in *surimono* designing and in illustrating novels and books of *kyōka*, especially those where the poems were the accompaniment to landscapes with figures. The titles of these books give some idea of the nature of their contents: 'Amusements of the East', really a succession of views of Edo and its environs, 1799; 'Fine Views of the Eastern Capital', 1800; and 'Both Banks of the Sumida River at a Glance', about 1805-1806.

A rare little book of *kyōka* with a preface dated 1803 (the only copy known to me has a MS. title *Shungyō-jō*, 'Album of Spring Pleasures'), has a colour print by Hokkei that shows already an obvious indebtedness to Hokusai's style, the crowd of travellers in a ferry-boat having the unmistakable physiognomy and anatomy, and also the boisterous manners, of the whimsical old artist's progeny. Before joining Hokusai, Hokkei is recorded to have had training under a Kanō artist, and later, in some of his landscape prints, there is evidence that he never entirely forgot the lessons learnt in that severe academy. It is also reported that at one time he was a fishmonger—one of his names, Uoya, means just that—but there is nothing exceptional in that: many of the Ukiyo-e artists were recruited from the ranks of shopkeepers and petty tradesmen. His close association with Hokusai is affirmed by the fact that he collaborated with his master in the production of the second and third volumes of the famous miscellany called *Manga*, these two parts appearing in 1815.

For a pupil anxious to make his way it was difficult to break away from the old master's popular style, for with all his personal eccentricities, probably even because of them, Hokusai, by the time the *Manga* volumes were well launched, had become outstandingly successful with the people of Edo. When a picture-book of Hokkei's originally called 'Ten Thousand Flowers of *Kyōka*' was republished, it was re-named *Hokkei Manga*, with the idea of tying it to Hokusai's popular series. But although *Hokkei Manga* presented a gallimaufry of sketches, rarely co-ordinated into compositions, similar to Hokusai's *Manga* volumes, no one could ever mistake it for a supplement to the master's

extraordinary work: we miss the sense of a spontaneous, irresistable urge to sketch, to translate all experience into brush-drawing, that is conveyed by Hokusai's astonishing outpouring.

Hokkei was of an altogether gentler, more meditative cast of mind, and found his true metier in the designing of *surimono*, in the interpretation of poetry and in unimpassioned landscape that resembles the easy verse of a genial observer of the countryside who is all the time remembering other poets' mighty lines, who quotes aptly, but rarely creates the quotable himself.

This was the ideal temperament for a deviser of the quaint conceits demanded in a *surimono*. In this sphere he ranks with Hokusai, Shunman, Shinsai and Toyohiro, and he continued to produce such prints long after they had, for one reason or another, ceased to do so. Hokusai, it is true, produced two memorable series of *surimono* in the year 1822, of great influence on Hokkei's 'still-life' and landscape designs, and occasionally produced one or two later, but with Hokkei they remained a major activity until his death in 1850. They fall into five main groups, classifying them by subject: still-life; *kachō*; legendary heroes and heroines; *bijin-e;* and landscapes; though there are others, often among the most exciting, which are unclassifiable. It is difficult to deal with *surimono* in general terms, but there is one feature that deserves comment in regard to Hokkei's *surimono*, and indeed to Ukiyo-e *surimono* generally from his time onwards: they have ceased to carry the personal message of the earlier prints and have developed into a genre relying on the technique and the poetic allusiveness of the original 'greetings-cards' but sold like other prints by the publishers to the general public. Something of the same kind of thing seems to have governed the production of *netsuke* at this time. Earlier these objects were made to an individual's require-ments, by artists and sculptors who turned from their normal activity to please a patron or a friend. By the 19th century, there were large numbers of professional *netsuke-shi* whose products were possibly of a higher technical standard of craftsman-ship but often lacked the individuality, the eccentricity, of the earlier pieces. Occasionally, the names of clubs are inscribed on prints, and these we may imagine were of limited circulation, but

often Hokkei's *surimono* appeared in sets of five or more, under the kind of title that linked sets of broadsheets. Thus, in the British Museum, there are two landscape *surimono* of a set of eighteen; a print of Rochishin supporting a tree from a set of 'Five Elements represented by subjects out of the *Suikoden*'; and many others could be instanced. These were presumably sold from the stalls in packets, just like other prints. Before, they had been privately commissioned, an artist often devising a *surimono* design at some-one's special behest and embodying the sponsor's ideas in it. By Hokkei's time *surimono* production was more professional, and the prints were more regular in size and general characteristics, whereas earlier they were occasional, nonconformist and the more delightful for those reasons.

But though some of Hokkei's *surimono* are perfunctory, competent but platitudinous—and the prints of courtesans and other beauties bedizened in monstrously ornate attire are the dullest—his best are wonderfully effective, both for their wit and ingenuity, and for their more purely pictorial felicities. He delighted in assemblages of strange, outlandish objects whose uses we can often only guess at, playing on the contrast of stuffs, of the texture of materials, of pitted fruit skins, polished lacquer, worn wood, shining metal. Every now and again, his leaning towards the aesthetic cult of the tea-masters becomes evident, and in one *surimono* (a calendar for 1826), there is a picture of a *tokonoma*, the household shrine and exhibition area, where hangs a stone-rubbing from a copied Chinese painting of antiquity, and a boat-shaped flower-vase with a severe twig arrangement, and where stands a 'dry-stone' arrangement of unworked rock. Such a print gives us an insight into the taste and refinement of those for whom such prints were destined.

In western hands, a *surimono* like that reproduced in Plate 53 would have perhaps ended up simply as a *trompe l'œil*, but Hokkei, using bronze and silver in the printing, mixes fantasy with reality and avoids a merely literal transcript from life. The print suggests the quiet pleasures of a winter's night. The curiously-shaped object decorated with a silver moon is a sort of *parfum-brûle* and hand-warmer known as an *anka*, and the opened book is

probably one volume of the Genji Romance (the *anka* is, in fact, decorated with a geometrical cypher standing for Chapter 41 of the romance). The book-marker is decorated with a flight of crows and the verse ties up all these diverse objects—'*Kaoru, Kaoru*, Smell! Smell! cry the crows, for it is sunrise at Nyomiya, the temple of sweet incense, in the hills of Uji'. (The British Museum Catalogue, whence this translation is taken, explains that *Kaoru*, the cawing of crows, means also fragrance.)

The other *surimono* reproduced (Plate 54) relies for its effect on the extravagantly exaggerated crescent moon in the black sky, seen beyond the end-post of a bridge decorated with propitious emblems of the New Year. There is a sort of forced simplicity about this design that we might consider specious or trite today, but only because by its very nature it begs comparison with modern derivatives in our own poster and eye-catching advertisements. We have become so used to the western prostitution of this kind of pictorial extravaganza that it is easy to miss the real originality of the Japanese designs in their day; we are so deafened on all sides by the raucous imitation trumpets that we have lost the ear for the fine note of the early instrument itself. This print was produced about 1830-1840, and it is quite salutary to think back to the same period in European art history and to try to summon up pictures or prints comparable in intent or performance.

Hokkei's landscape *surimono* are his most personal contribution to the art, but the very characteristics that constitute their principal charm render them most difficult to reproduce in monochrome. Often there is something superficially Chinese about them, amounting, as so often in the case of Hokusai, to an affectation for the antique classics based on a half-knowledge only and resulting in a diverting but impure version, slightly provincial in its anachronisms—the intrusion, for instance, of the *suyari*, cloud-bands, and the use of impenetrable gold backgrounds, the first originating in the mediaeval Japanese scrolls, the second a notable feature of Momoyama screens. These prints succeed because of the use of exquisite colour, cool, light tones discreetly

applied producing on occasion a sort of pale harmony that is quite rare in Japanese prints.

Hokkei is not generally thought of as a landscapist and his broadsheets are certainly few, but quite apart from his *surimono*, there are a number of picture-books in which he developed a type of print very much his own. His models were the quasi-topographical books of Hokusai already mentioned, but in time he achieved, as in the *surimono*, a distinctly light touch, a technique that relied on a discriminating use of unassertive colour applied decoratively and sparsely, rather than in the over-all fashion of the broadsheets of Hokusai and Hiroshige. It is a form that blends happily with the *hiragana* text in which most of the poetry books were written, a harmony between text and pictures being established that places these books among the pleasantest of the period. Typical of them is a set of three based on the favourite theme of *Setsugekka*, 'Snow, Moon and Flowers', each book having 100 poems and three prints illustrating the theme. These books were in the nature of *kubari-hon*, that is, books printed as souvenirs of special occasions and not sold to the general public. In the 'Flower' volume, it is recorded that the poems were selected from the work presented at a meeting of poets at the tea-house of Kawachiya of Willow-bridge, Ryōgoku, Edo, on the 26th day of the Fourth Month of Bunsei 11 (1828). Hokkei, it is clear, moved in a circle of poets and other persons of taste who must have viewed most of the prints published in their day with the same repugnance that we do.

Although most of Hokkei's landscapes are in book form, one series of broadsheets merits special attention. It is not in the regular *oban* format. The set of eleven prints entitled *Shokoku meisho*, 'Celebrated Views of our Native Land', are very much in the Yamato-e tradition and the wide lateral form adopted suggests a section of a *makimono*. Occasionally, there is an obtrusive, because anachronistic and archaising, introduction of bands of conventionalised cloud, but most of the prints are straightforward transcriptions of landscape, more fully worked out than those in book form, and introducing many figures engaged in pursuits of lively activity. Only a few of the set are

completely successful. In some the detail is too minute for the size of the print, and though the colour printing is exemplary, the result is a confusing medley with no central point of interest. Best known of the set is the European ship saluting at the entrance to the harbour of Nagasaki. The print reproduced (Plate 55) is another of the more successful. The slanting lines, the usual convention for depicting the heavy downpour of rain—as common in Japan as in our own country—represent a minor triumph of the woodcut art: by the simplest means we are given a sky misty with rain and a village glimpsed through shafts of rain falling like spears.

———— o ————

Keisai Eisen:
As Landscape Artist

KEISAI EISEN is an artist who typifies Ukiyo-e in the first half of the 19th century. Indiscriminately prolific, with a range from *surimono* of the utmost refinement to broadsheets of the grossest vulgarity, he pandered in a host of shoddy picture-books to the half-educated masses, and yet scored success, with some of his landscapes and *kachō* prints, among people of the most exacting standards. At this period, a number of Ukiyo-e artists begin to emerge from the shadow that obscures the lives of earlier artists. Writers like Santō Kyōden, who had been a practising Ukiyo-e artist earlier, and Shikitei Samba, who was connected with the Kabuki theatre and the artists, like Toyokuni, who portrayed it, began to turn their attention, in a casual, amateur way, to the history of the print and of the painters responsible for it. A number of rather desultory and unsatisfactory miscellanies resulted which form the basis, inadequate though it may be, for all subsequent historical accounts of the print. Eisen re-edited the original text and supplements of the main source-book, *Ukiyo-e Ruikō*, to which additions had already been made by Kyōden and Samba since it was first compiled at some date before 1800. He also wrote an entertaining semi-autobiographical *causerie* entitled 'Jottings of a Nameless Old Man', and from this and other scraps of contemporary evidence it is possible to piece together something of his erratic career. It gives us some idea of the kind of artist recruited in his day to the business of designing prints and books for the Edo commoners.

Born in 1790, Eisen came of a fairly well-to-do family. His

father was a minor artist of the Kanō line, and it was natural for Eisen to take his first art-instruction from a member of the same school, Kanō Hakkeisai (from whom he derived one of his art-names). Quite soon, however, his inclinations led him towards the Ukiyo-e circle and he took lessons from Eiji and Eizan of that school, and from Kinji Shindō, a writer and illustrator of comic plays. From about 1824 he began to illustrate books, and soon after, to design colour-prints, principally of evilly over-dressed courtesans. Displaying some skill in landscape, he was commissioned by a publisher to design a series of views of the Three Towns—Edo, Kyōto and Ōsaka—but threw up the undertaking, so the story goes, because he feared he might become too famous. From thence onward, his life alternated between bouts of fitful energy and prolonged periods of wild dissipation, and a number of instances are recorded of his having borrowed money or accepted hospitality from friends that he afterwards shamelessly discarded. Later in life, after marrying a second time, he seems to have become at least a partially reformed character, and it was during this period that his finest landscape prints were produced. He died in 1848. The general impression that remains from these old accounts, even allowing for the apochryphal nature of some, is of a libertine who led an almost incredibly Bohemian existence, who interrupted his drunken roistering to engage in bouts of furious designing, and who was always at loggerheads with officialdom and the commercial world (his 'jottings', for example, are full of pungent criticism of avaricious publishers).

Apart from a few of his illustrated books and the whole of his *surimono* which are uniformly excellent, Eisen's chief interest for me lies in his landscape prints. There are those that express an admiration for his *bijin-e*, particularly the half-length figures, but I cannot share it. The women seem the blowsy, overdressed prostitutes they unquestionably were, not as a result of a new-found realism, but simply from the overloading of the designs with irrelevant detail, from the bad colour and the indifferent printing. The *oiran* of Kiyonaga's and of Utamaro's day may have been more cultured but even had she been the most bedraggled slut,

their prints of her would still have been refined and elegant. In the 19th century, artists of great power and invention were designing prints of 'beautiful girls', but not one—Kunisada, Kuniyoshi, Eisen, Hiroshige or the rest—could compose a print of the quiet restraint, lovely colour and wonderful *mise-en-page* that are invariably found in the prints of the late 18th century.

From a variety of causes, the landscape print had become extremely popular, particularly since Hokusai's great '36 Views of Fuji' which appeared in the 'twenties. Although landscape prints were the exception before 1800 (other than in books and albums, and there mostly by non-Ukiyo-e artists), landscape was everywhere accepted as the dominant art, the vehicle for the expression of the most elevated thought and the highest forms of artistic brushwork. It was so in ancient China and had become so among those Japanese that took their ideals from the Middle Kingdom. As has been mentioned before, the Ukiyo-e print showed its independence from traditional art as much as anything by its insistence on figures, incident, everyday action instead of landscape. Why, then, did the landscape print assume the importance it did in the 19th century? Among minor reasons we may assume that sumptuary edicts of the government suppressing at various periods prints of actors and courtesans, and limiting the number of blocks utilised in printing, had some effect, though the Ukiyo-e artists invariably circumvented such legislation by one ruse or another. Possibly, the public really began to tire of the endlessly repeated pictures of courtesans. The principal cause, however, seems to have been a vastly increased interest in landscape—not the idealised landscape of the philosopher-painters, but tangible, well-known and well-documented places and landmarks, towns and villages along the much traversed highways, the Tokaidō and the Kisokaidō, Lake Omi, Mount Fuji, the Sumida and the Yodo Rivers and the bridges and fords whereby they were crossed, the pleasaunces and parks of Edo, Kyōto and Ōsaka, the hot-springs of Hakone, the waterfalls of Nikkō.

Foreign travel being interdicted by strictly enforced law, the wanderlust of a Japanese at this time, as for centuries, could only be indulged within the boundaries of his own country, and even

internal travel was not encouraged by the Bakufu. Hence, almost perforce, the curiosity that would have found an outlet— as it did among restless and inquisitive peoples of other nations— in charting unknown lands or in travelling widely in the inhabited parts of the world, was concentrated in the limited area of the Japanese islands. As a result, no nation, not even our own, be- came so addicted to topography, to guide-books, to a respect for the 'spirit of the place', to a reverence for the multitudinous associations, factual or legendary, of village, stream, mountain or other landscape feature. The antiquarian and the historian, the traveller and the pilgrim, the topographer and the geographer, all found their spheres of activity in the homeland, whereas, but for the curb on their liberty, they might have dissipated their energies over a wider field abroad. Even at home there was nothing like the freedom of passage enjoyed in England at the same period and communications were in any case purposely difficult to deter the interchange of population, so that for a knowledge of many places, not remote in distance, the Japanese had to rely on the written word and the accompanying picture. *Meisho-ki*, 'Records of famous places' were issued, usually with voluminous illustration, of almost every locality, every town, every temple, and though more often than not the pictures are of little account artistically, they satisfied the insatiable yearnings of the man-in-the-street for knowledge of the wider world around, they enabled him vicariously to make pilgrimages to places made holy by great events, to enjoy especial scenic beauties of this or that locality, to learn of the customs and the manufactures of towns as distant from him, owing to poor communications, as if they were indeed in a foreign country.

Landscape in the Ukiyo-e artists' hands was a development from these *meisho-ki* rather than the imaginative and usually unidenti- fiable landscapes painted by artists of the established schools. It was the expression of the people's aspiration to travel, which itself was the outcome of a reverence for places. Among the commoners, it is probably true to say that there was little appreciation of landscape art as such: a mountain of imaginary outline, or one without historical or literary association was

without the appeal of one linked with a famous name or incident, or notorious for its beauty. The language is full of proverbs like 'Do not use the word magnificent until you have seen Nikkō' that bear witness to an innate tendency, as strong in literature as in art, to consecrate rivers, villages, mountains even certain trees, not necessarily for the scenic beauty (though there is that too at Nikkō of course), but as the settings of great events, the objects of poetic allusion, the birth or burial place of some notable personage or the like. In the Ukiyo-e prints, literal accuracy to the lie of the land or of architectural proportions was not rigorously observed. To the arm-chair travellers for whom the prints were intended it hardly mattered, and in any case such a literal procedure would have been completely counter to the oriental approach to landscape painting, an approach even the Ukiyo-e artists were constrained, by instinct and training, to follow. They aimed to give the spirit of the place, or even more, the spirit of the literature of the place.

Hokusai's great series of prints of Fuji were ensured success as much by the subject as by the originality of the designs. These broadsheets, and the no less wonderful sets of 'Waterfalls' and 'Bridges', immediately won over the public, and it was not long before Hiroshige, Eisen and Kuniyoshi were also designing landscape prints, the first on a prolific scale, the other two in far fewer numbers. These four artists, Hokusai, Hiroshige, Kuniyoshi and Eisen, produced the bulk of the worthwhile landscape prints in the first half of the 19th century, but whereas Hokusai's and Hiroshige's prints have been consistently praised and discussed, and Kuniyoshi's, few as they are, are recognised as of unusual power, little respect has been paid to Eisen's, except, possibly, those he designed for the Kisokaidō set, and even then the limelight has fallen on him indirectly as the collaborator with Hiroshige.

The comparison of his best prints with those of his contemporaries is interesting. (He is far more uneven than Hiroshige, and his inferior prints are worthless hackwork.) There are at least three series of prints bearing his individual stamp: 'Celebrated Views in the Nikko Mountains'; 'Eight Views of Edo'; and his contribution to the 'Sixty-nine Posting-stations of the Kisokaidō'.

The Nikkō set is a series of waterfalls, for which the locality is famous, and Eisen here challenges comparison most obviously with Hokusai, whose set of 'Waterfalls' is perhaps the crowning achievement of his career as a designer of landscape-prints; and less obviously with Hiroshige and Kuniyoshi, both of whom took waterfalls as their subject on a number of occasions. Eisen is unquestionably more prosaic than the others. He did, on occasion, give evidence of quite classical tendencies, and one print in particular,[1] a *kakemono-e* of a moonlight scene with a bridge across a stream and high mountains beyond, captures the spirit of the great landscapes of the Kanō school, and is one of the most imaginatively treated landscapes in the whole range of the colour-print—one could hardly, in this case, say Ukiyo-e print; but generally, Eisen looks on the world through the eyes of the plebeian traveller, or would-be traveller, with only half an eye for the scenic splendours, and giving just as much attention to the lively activity going on around—the vending of merchandise, the actions of workmen at a variety of jobs, the squabbles of children at the roadside. In this sense, he is no more than fulfilling his role as a Ukiyo-e artist, and perhaps he is nearer the Ukiyo spirit than either Hokusai or Hiroshige, for whom the sublimity of the view often became the sole *raison d'être* of the picture. Yet in the Nikkō set, Eisen was clearly carried away by his admiration of the scenes, and though trivial incident is recorded—as it is, after all, in all but the sublimest of Hokusai's prints—a certain seriousness of intent is felt that is often lacking from his approach to landscape. The Nunobiki Waterfall near the site of the Jakkō Temple (Plate 56) is without the slightest adventitious 'human' interest, and convinces as a powerful rendering of this romantic region. It is, too, extremely effective as a colour-print. What does not come out in the reproduction is the fact that each of the peaks in the background is of a different colour—the furthest green, the central blue, the right-hand grey, and the hillside down which the water cascades is dark shadowed purple, whereby its shape is thrown up against the distant range, and the water is made to glint against its darkness. The cloud-band—this is the only one

[1] Reproduced in the Happer Catalogue, 1909.

of the series in which Eisen uses this old-fashioned expedient—can actually be thought of as a band of mist lying across the hollow, and it does help to differentiate the foreground from the middle distance. There is little apparent attempt to simplify the chaotic elements of the romantically mountainous and wooded area: this is the equivalent in the East of Kenneth Clark's 'Landscape of Fact', the diverse features unified not so much by light, as they would be in a European painting, as by the flat, simplifying washes of the woodblock technique.

The Kirifuri waterfall (Plate 57) makes an interesting comparison with Hokusai's print of the identical subject, and the gulf between the artists is emphasised. Hokusai was fascinated by the potentialities of this fall in providing the basis of a striking design, and in his ultimate version, there is more than a hint of abstraction in his surprising and daring manipulation of nature, the spidery lines of the many-armed cascade having little resemblance to the actual waterfall, but giving a magnificent pattern when translated into the bold tones of the woodcut. Eisen tackles the problem far more realistically, but his technique is not equal to his intentions. The water sways oilily down the rocky channels like floss silk, and the swirl and downward rush are well conveyed. If we still seem near to the world of fantasy, it is partly because the actual waterfall itself is fantastic, and partly because Eisen, in trying to portray moving water, has given it the heavy consistency of a viscous fluid.

In another of the series, Eisen gives his version of the *Urami-ga-taki*, the 'Back View Waterfall', so-called because at one time a mountain path took its course behind the 100-foot column of water plunging from overhanging rocks above, and the intrepid traveller who did not mind a soaking from spray could, in fact, stand behind the thunderous cascade. (A flood in 1902 carried away the overhanging rocks and a 'back view' is no longer possible.) The men in Eisen's print are exaggerated in size so that their reactions to the prospect of the crossing can be expressed in their features, and so that the concern of the onlookers at the foot of the waterfall can be made plain. Kuniyoshi and Hiroshige each made a print of this same waterfall, and of the

three Eisen's is probably the most Ukiyo-e in treatment, the human interest vying with the powerful display of scenic wonder. Hiroshige's is an altogether more poetic evocation (it occurs as No. 27 in his set of 'Views of Famous Places in the Sixty-odd Provinces'); and Kuniyoshi took this waterfall as the subject for a fantasia on European methods: figures are indicated on the mountain path, but they are of no significance, the real subject being the contrast of the cataract falling sheer in sweeping vertical lines with the fantastically twisted and scarred rocks, illumined by a light made theatrically unreal by the borrowed European chiaroscuro.

The 'Eight Views' had by Eisen's time become a useful stock motive for a set of prints, the eight subjects giving scope for a wide range of physical and atmospheric conditions—'Autumn Moon'; 'Evening Glow'; 'Evening Bell'; 'Evening Snow'; 'Night Rain'; 'Returning Geese'; 'Clear Sky' and 'Returning Boats'. Hiroshige's best known *Hakkei* is the *Omi Hakkei*, and few will dispute that in this set he rises to heights of imaginative designing rarely attained at any other time. Eisen's finest *Hakkei* is the *Edo Hakkei*, and at once we perceive his more workaday 'Floating World' interpretation of the 'Eight Views' hallowed by antiquity. The setting is Edo, the busy market place, the centre of the industrial activity, the nexus of communications, the town of a million overcrowded inhabitants. The 'Clear Sky' is over the Japan Bridge and there is a crowded foreground of struggling porters making off with their loads from the riverside warehouses, casks of *sake*, panniers of the favourite giant radishes, huge fish on yokes; and beyond, a range of mountains, serene in the clear air, and the inevitable Fuji completing the distance. *Shiba-ura no kihan*, 'Boats Returning to Shiba-ura' (Plate 58), depicts boats laden with merchandise, the bay being full of craft making for the port, and again, Fuji, this time crossed by a white streamer of cloud. This is the townsman's *Hakkei*, a commerical or mercantile 'Eight Views', but none the less valid for that.

Eisen's stature as a landscapist is usually measured by the twenty-three prints contributed by him to the Kisokaidō set, and although that does not do him full justice, there is no doubt his

masterpieces are to be found among these prints. The 'Bridge over the Inagawa at Nojiri' is a conception quite individual to him, and reminds one, in its seriousness, of the great Kanō-inspired *kakemono-e* referred to above; the 'Distant View of the Asama Mountain from Owake' is a magical depiction of a torrent of rain, falling so violently that a white mist of spray seems to spread beyond the travellers in the foreground to the base of the far-off mountains; Itabana, with a sky flushed rose over a desolate snow-scene, has a wintry poetry quite poignant in its effect; and others equally successful make it all too plain that had Eisen seen the series through to the end (the first eleven are of his design and one wonders whether Hiroshige were not called in to help bring the set to a conclusion whilst Eisen indulged in one of his wilder bouts of dissipation), he would have earned a greater reputation as a landscapist. As it is, there is a tendency to belittle him simply because he is less consistent than Hiroshige, and because even his finest prints lose by comparison with the few but sublime masterpieces which Hiroshige contributed to the set. But when all is said, no one, except Hokusai or Kuniyoshi, could have withstood the test of collaboration with Hiroshige at his greatest, and there is one unconfirmed piece of evidence that points to the fact that to his contemporaries, Eisen's prints were indistinguish-able from Hiroshige's—provided his signature was lacking. When the prints for the Kisakaidō set came to be reprinted, Eisen's name was deliberately removed from the prints he had contributed, and although Hiroshige's name was not substituted, there is little question that the public were expected to, and did in fact, assume that the whole set was drawn by the most popular landscapist of the day.

CHAPTER XVII

──────── o ────────

Utagawa Kuniyoshi:
The Master of Historical Prints.
The Hybrid Art of East and West

IN the earlier part of this book, I have stressed the part played by publishers, block-cutters and printers in the success of many colour-prints, ascribing some of the originality in theme and treatment, often credited wholly to the artist, to his partners in the enterprise. But similarly, his collaborators must also be made to shoulder part of the responsibility—the publishers a major part—for the 'decadence' of the colour-print in the 19th century. It is illogical to hold that Utamaro and Toyokuni and their pupils and followers were responsible for the downfall. The enormous demand for colour-prints from a public that now predominantly had a taste for highly coloured, sensational fare; the competition between the growing number of publishing houses; the cheapness of their stock productions and the consequent lowered standards of cutting and printing—these were the true causes of the broadsheet's decline, not a dearth of capable artists. Artists like Toyokuni were simply dragged down to the low level of the publishers.

There is no reason why we should visit the sins of the publishers on the artists. A number of really talented men have been persistently underestimated because they had the misfortune of being born into the wrong period. No one who is acquainted with their work, and that entails seeing many thousands of prints, can deny the immense capabilities of Kunisada and Kuniyoshi. That a vast number of their prints, especially Kunisada's, are

repellent to us, mainly because of spectacular or sensational subjects with colour to match, is equally undeniable, but there is a residue of splendid things in each artist's *œuvre* that makes it invidious to seem to plead for them.

We shall never know what these artists thought of the manner in which their often fine drawings were transformed into the hectic confusion of the prints. Letters of Hokusai, it is true, are recorded in which he expresses views about the relative skill of certain block-cutters, but he was a law unto himself: no *cri de cœur*, no cry of 'Woodman spare that block!' has survived of Kuniyoshi, for instance. The drawings themselves, however, where they have been preserved, allow us to assess the artist on his own merits entirely. By great good fortune, probably through the esteem in which they were held by admiring pupils, a large number of drawings by Kuniyoshi have been preserved, the greater proportion of which were at one time in the possession of the Dutch collector, Mr. Lieftinck,[1] when they were the subject of one of the masterpieces of Ukiyo-e scholarship, Mr. B. W. Robinson's 'Drawings by Utagawa Kuniyoshi'. The best of these drawings leave one in no doubt of the power and expressiveness of Kuniyoshi as a draughtsman, of his flair for capturing movement, of his bravura and attack.

Kuniyoshi has been called the 'Last Great Master of the Japanese Colour-print', and enough fine prints can be sifted from the great mass of his output—however exacting the selector—to justify that high-sounding title. He was prolific even by the standards of the period, and in addition to numerous picture-books, turned his hand to every form of the print: battle-pieces: pictures of warrior heroes, historical or legendary; theatrical prints; landscapes; *bijin-e*; fan-prints; *kachō*; comic prints; and *surimono*. In his landscapes he sometimes adopts a technique that has echoes at least of European practice, and in subjects of a professed 'foreign' origin, such as the 'Twenty-four Paragons of Filial Piety', he freely borrowed from western prints. There is, too, an inexplicable anticipation of surrealism in a few of his prints, especially the landscapes. In his humorous prints, he

[1] They are now in the Rijksmuseum voor Volkenkunst, Leiden.

comes nearer to our own conception of the comic than almost any other Japanese artist. The impersonation of notable actors by a collection of insouciant cats is not at all unlike the take-off of public figures by dressed-up monkeys in Thomas Landseer's book of etchings called 'Monkeyana'; his superb triptych of cats in 53 positions representing the 53 stations of the Tokaidō—a positive *vade mecum* of feline attitudes—reminds one of similar, if not equally brilliant, sheets of cat drawings by European artists like Steinlen; Hogarth comes to mind when we look at Kuniyoshi's 'Countenances of Various Complexions', a sheet of heads grimacing in a variety of ways at 'Dust in the Eye', 'Headache', 'Deafness' and other unpleasant afflictions; and his set of three prints 'Scribblings on the Store-house Wall', actors being caricatured as if by a wall-chalking child, (a very clever one), is irresistibly funny and quite without need of interpretation, even though it is difficult to cite a counterpart in western comic art. Clearly, it would be impossible to compress an account of an artist so versatile and prolific into one chapter (his output is conservatively put at 5,000 prints), and I intend to deal briefly only, in a general way, with the 'battle-pieces', with the landscapes and with other prints showing evidence of European influence.

Kuniyoshi was born in 1798, was apprenticed to Toyokuni, and commenced artist on his own account in 1815. His working career of 45 years thus covers what amounts to the last years of the true Ukiyo-e print. He seems to have been a typical 'Floating World' personality, genial, easy-going, fond of the bottle, versification and the company of friends, and, among other engaging eccentricities, displaying an inordinate fondness for cats, which he drew with a wonderful felicity and introduced whenever his subject could be stretched to accommodate them.

He served his apprenticeship in Toyokuni's studio at a time when that artist was in his decline, living on his great reputation and setting his signature to slapdash designs that could only be the basis for worthless prints. Kuniyoshi's theatrical prints, the least entertaining part of his output, are never wholly rid of the taint of Toyokuni. For the first ten or twelve years after 1815, the year of his first prints as an independent master, he was

forced to compete with Toyokuni and the senior pupil of the Utagawa School, Kunisada, and it seems likely that he turned from the theatrical print towards the warrior and battle-pieces as a field where the competition was less fierce, though there is little doubt that there was something in his own make-up that responded to the splendour and panoply of war as a subject for his brush. There was, in any case, a deep-seated reverence in the male Japanese for the heroes of the past, a reverence sedulously inculcated from childhood in a land where the sword was worshipped as the patent of nobility and where the national heroes were almost exclusively men famed for warlike exploits. There had always been a call for prints and picture-books of the great battles of the almost uninterrupted civil wars that had preceded the Tokugawa rule, and as if their own history was not full enough of bloody events, they translated and naturalised the epics and romances of Chinese literature that, like the Suikoden, were fullest of similar homicidal violence. But it is difficult to account for the enormously increased output of this sort of print in the first half of the 19th century, when Hokusai and his pupil Taitō, Eisen and Kuniyoshi were all frequently engaged in supplying the public in broadsheet or picture-book with illustrations to the favourite tales of strife and mortal combat that never seemed to grow stale with retelling.

The effect of sumptuary edicts in restricting the subjects open to Ukiyo-e artists has been put forward as one of the causes of the development of the warrior types of print at this period, but unless the public had a general penchant for them, such prints would never have had such a vogue. In a faithless age like our own, the repetitious iconography of the Christian and Buddhist religions becomes tedious, and in a similar way, there is a revulsion from pictures glorifying warfare among people who have ceased to be militaristic. In the past, when actions on the field of battle stirred men's hearts, almost any depiction of them was taken seriously. Nowadays, we deride the 'Charge of the Light Brigade' or the 'Death of Nelson' type of picture; and there has been a steady decline in enthusiasm in Europe for Japanese battle-pieces. But the battles Kuniyoshi so vividly created were very

real to the people for whom he designed them: the Japanese honoured the heroism of the Kusonoki family fighting against desperate odds; felt genuine horror at the apparition of the Taira ghosts rising from the sea; admired the personal feats of arms like the archery of Nasu-no-Yoichi; and gloried in Yoshitsune's generalship. Kuniyoshi appealed to them because he heightened the drama, paraded the heroism and perfidy, because, in a word, he melodramatised the real or imaginary events. And for these same reasons, most modern critics are ready to damn the prints out of hand.

To catch the spirit of Kuniyoshi's appetite for these martial themes, the fervour for deeds of knightly prowess, for 'battles long ago', for the trappings and accoutrements of a former race of giants in feats of arms, we have to go back to an earlier age of European art, to an artist like Rubens, with his gusto and impresario technique. Later artists are too sophisticated and have lost real enthusiasm for the fray, Meissonier is too dry and spiritless, Gericault too studied, even Delacroix, sombrely romantic as he is, fails to embroil us in the pell-mell confusion of the battlefield as Rubens and as Kuniyoshi do.

Kuniyoshi's most characteristic form for the battle-piece was the triptych which allowed him play for the sweeping action of figures and the panoramic background so many of the designs rely on. Unfortunately, this is the format to which a repro-duction in the dimensions of this book does least justice, the figures tending to become too diminutive to have significance. Even with this reservation, however, Plate 59 shows something of Kuniyoshi's power. The print is an illustration to the Hakkenden, a novel by Bakin, and shows Inuzuka Shinō at bay on the ridge of a temple roof, repelling the police sent to arrest him. The pulsating design is disciplined and held together by the isolated figure of Shinō from whom his attackers have temporarily been shaken off: they tumble at his feet or wait timorously at a distance, skilfully handled like the figures in a 'crowd' scene in a motion-picture and making way whilst the limelight beats down on the hero. Prints like this have a vigour and a masterly melodrama that make the uncharitable comments of critics

like Mr. Michener difficult to understand. There are many prints of this type of subject matter that merit the worst condemnations of Mr. Michener or anyone else, but what need to concern ourselves with them when there is so splendid a harvest of virile, masculine works of a kind no other artist could match?

The battle-pieces and warrior pictures are essentially Japanese in subject and treatment. Landscape, on the other hand, had always been affected by foreign models, usually Chinese in the past, and now, in the first half of the 19th century, the influence of Europe produced some curious and unexpected results, especially in the prints of Kuniyoshi.

Despite the Bakufu proscription of intercourse with the West, there was, throughout the early 19th century, a growing infiltration of western literature and prints and a stimulated curiosity concerning the 'barbarians' of the West. The period preceding the advent of Commander Perry in 1853 (from which date the channel of communication, though by no means free, was at least partially cleared), is marked by tendencies to incorporate into the texture of Japanese literature and art all the scraps of knowledge that the writers and artists were able to pick up, either from native books in which such forbidden topics were furtively introduced, or from Dutch and other prints brought into the country, or from actual contact with the Dutch traders. It is hardly matter for wonder that the Japanese appreciation of all matters European at this time should strike us as immature or naïve. The European sources themselves were by no means representative of the culture of the West, and the *Rangakusha*, the students of western affairs, had little proper instruction, even in the Dutch language, their principal means of acquiring information. Much of the thought and practice of the time show a sort of groping towards the truth, divination rather than knowledge, and sometimes there were ludicrous misunderstandings and misinterpretations. There was never, at this time, more than a half-assimilation of western techniques in painting, a binding, rather than a grafting, of the alien chiaroscuro and perspective on to the native root of calligraphic line. It is not surprising that

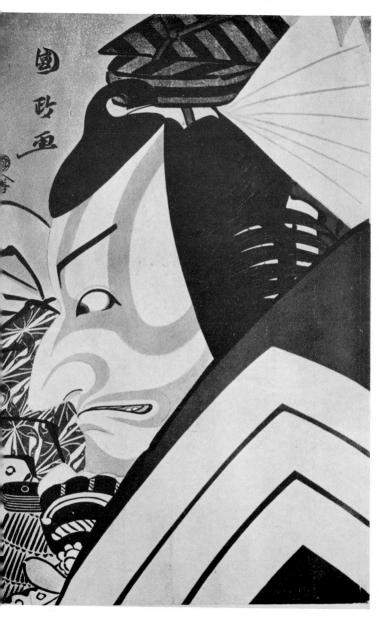

49. Utagawa Kunimasa: Ichikawa Danjurō in the *Shibaraku*
15¼″ × 10⅛″. *British Museum*

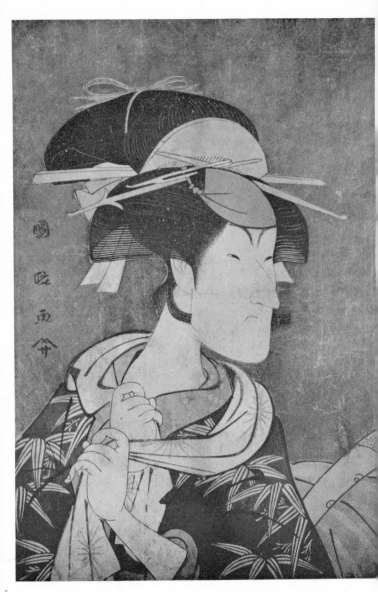

50. Utagawa Kunimasa: The actor Tomisaburō in a feminine role
$15\frac{1}{4}'' \times 10\frac{1}{4}''$. *Rijksprentenkabinet, Amsterdam*

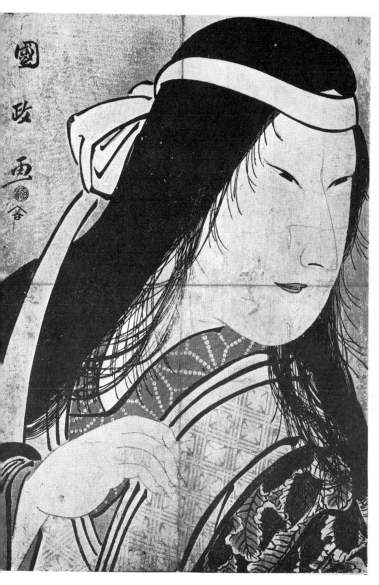

51. Utagawa Kunimasa: An actor as Yama-uba
13⅝" × 9½". *British Museum*

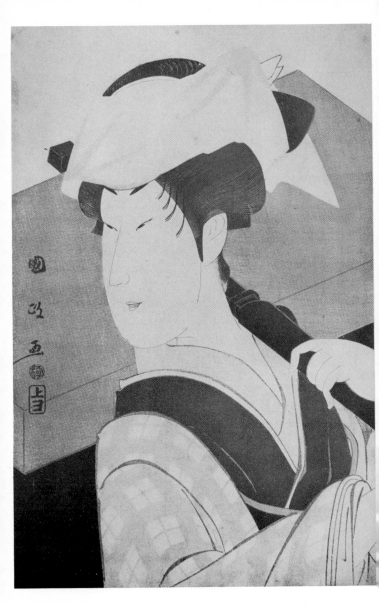

52. Utagawa Kunimasa: The actor Nakamura Noshio as the courtesan Shōshō with travelling-box over her shoulder in a play performed in 1797 $14\frac{3}{4}'' \times 10''$. *Honolulu Academy of Arts (Michener Collection)*

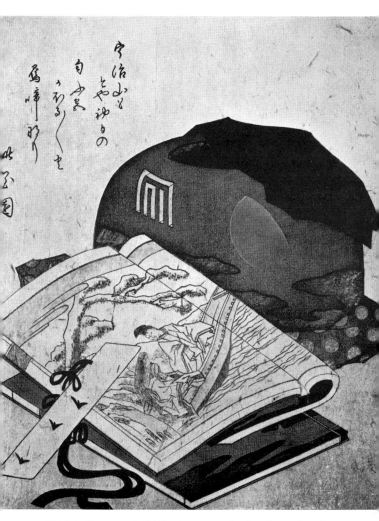

53. Hokkei: *Surimono*. Still life with an open book and a perfume-burner
$7\frac{3}{4}'' \times 6\frac{5}{8}''$. *British Museum*

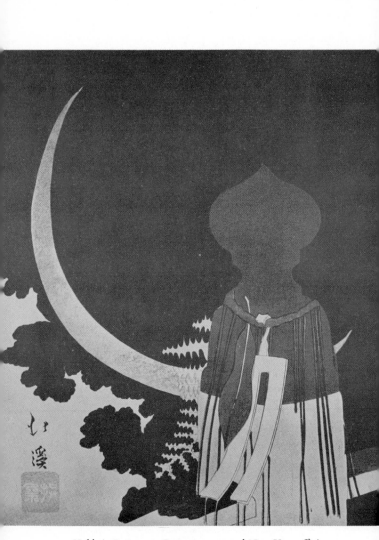

54. Hokkei: *Surimono*. Crescent moon and New Year offerings
on the newel of a bridge. 8″ × 8″. *British Museum*

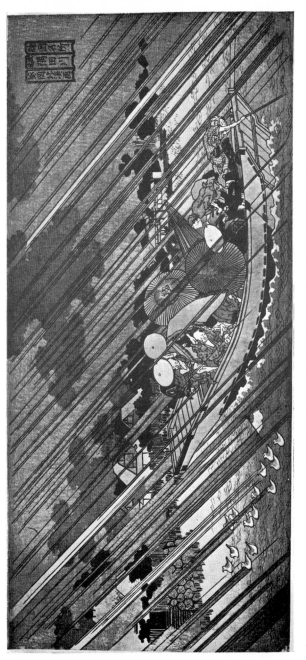

55. Hokkei: A ferry on the Sumida River, from the series 'Celebrated Views of Our Native Land'. $7\frac{7}{8}'' \times 15\frac{1}{4}''$. *British Museum*

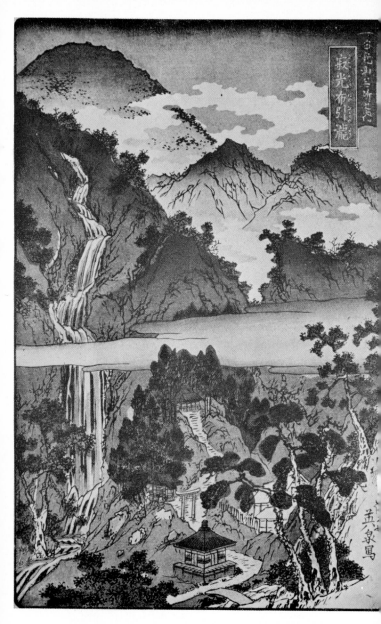

56. Keisai Eisen: The Nunobiki Waterfall from the series 'Celebrated Views in the Nikkō Mountains'. 15″×10″. *Victoria and Albert Museum*

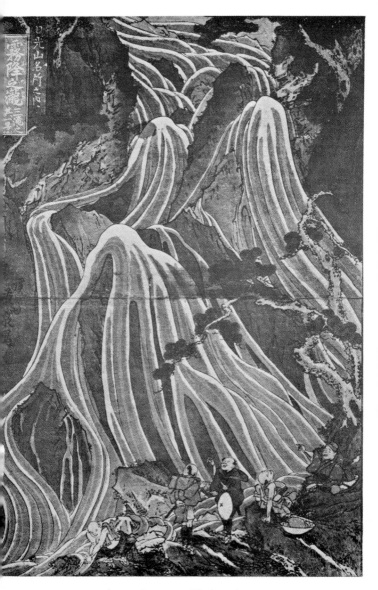

57. Keisai Eisen: The Kirifuri Waterfall from the same series as No. 56
15″×10″. *Victoria and Albert Museum*

58. Keisai Eisen: Boats returning to Shiba-ura,
from the 'Eight Views of Edo'
10″ × 15″. *British Museum*

59. Utagawa Kuniyoshi: The high roof of Hōryū: Inuzuka Shinō defending himself against the police led by Inukai Kempachi. Triptych, each sheet 14¾″×10″. *B. W. Robinson Collection*

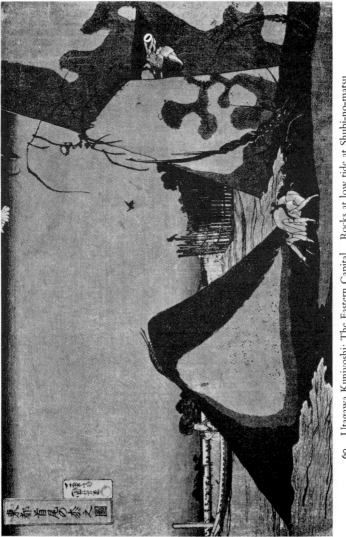

60. Utagawa Kuniyoshi: The Eastern Capital. Rocks at low tide at Shubi-no-matsu
$9\frac{5}{8}'' \times 14\frac{3}{8}''$. *B. W. Robinson Collection*

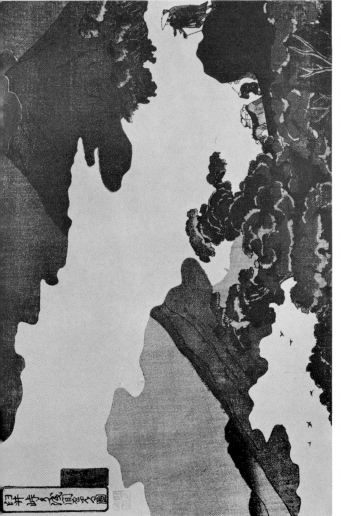

61. Utagawa Kuniyoshi: Mount Asama seen from Usuitoge Pass 15″ × 10″. *B. W. Robinson Collection*

62. Utagawa Kuniyoshi: Binshiken from the '24 Chinese Examples of Filial Piety'. 9½″×6⅞″. *B. W. Robinson Collection*

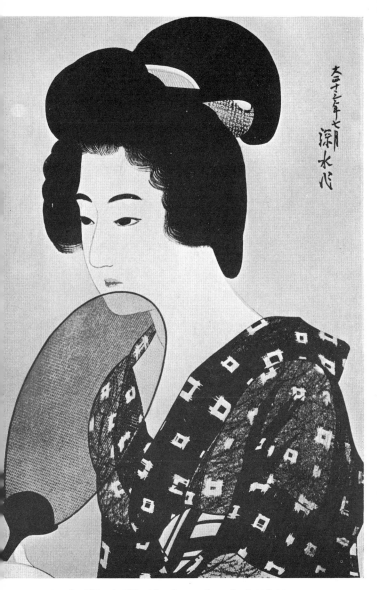

63. Itō Shinsui: Girl with a fan. 15″ × 10″. *British Museum*

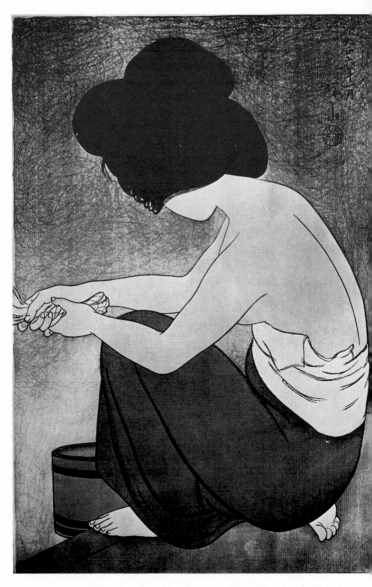

64. Itō Shinsui: Girl washing linen. $15\frac{1}{2}'' \times 10\frac{1}{8}''$. *British Museum*

this unlikely alliance should have led to some of the most curious and bizarre products in the history of art.

Similarly strange results came from the attempt on the part of Europeans to assimilate oriental art in the 18th century. Here again, a lack of knowledge and understanding of the fundamental differences between eastern and western practice led to the most fantastic products, typical Chinoiserie being the outcome of western imagination working on a very imperfect idea of the vast exotic world of China, Chinese art and architecture. Chinoiserie remained very largely in the domain of the decorator and no one was likely, or competent, to criticise the absurdities and solecisms perpetrated by the designers. In any case, the figures, buildings, furniture and staffage generally, were intended to be Chinese. To have a relative idea of what the Japanese attempted to do we have to visualise western artists of the 18th century depicting scenes of Ranelagh and Vauxhall in the Chinese manner, using the painting technique and conventions of the oriental artist. Our knowledge of Chinese painting at that time was about as rudimentary as that possessed by the Japanese of European. In neither the Chinoiserie nor the Japanese western-influenced art was there a case of real fertilisation as there was later when the Impressionists came in contact with the Japanese print.

The obvious influence of Europe, especially in the 'perspective' pictures called *Uki-e*, has been mentioned in earlier chapters, but no artists prior to Kuniyoshi had experimented so purposefully as he in an attempt to fuse the styles of East and West, or exploited so successfully the possibilities of this amalgam as a means of bizarrerie, a transformation of everyday Japan into a hybrid land of unreality. Hokusai and his pupils Hokujū and Shinsai had anticipated Kuniyoshi's employment of high light and shadow and exaggerated perspective, but certain of Kuniyoshi's landscapes, to be mentioned shortly, represent a more deliberate policy than the experiments of earlier artists.

There were, it should be mentioned, other expressions than the Ukiyo-e of the influence of the West in paintings and prints. One of the most interesting is that which arose from the close contact of the Japanese with the Dutch at the trading port of Nagasaki.

Nagasaki-e, that is, prints made at that port, represent the popular Japanese view of foreigners, their ships and everything else brought by them to Japan. The peculiarities of Nagasaki-e arise from the fact that they were drawn by artisans of an unpolished draughtsmanship who, in transcribing things European (or Chinese) contrived to hide to a large extent their own native style of drawing: in fact, more often than not they had no proper grounding in art at all. *Yokohama-e*, prints produced after the opening up of Japan to foreigners, represent something different again, since although they are pictures of foreign communities and their ships, the artists were often members of the Ukiyo-e school—Sadahide, a pupil of Kunisada, is one of the great exponents of this type of print—and the unsophisticated style of the Nagasaki-e was replaced by a kind of baroque Ukiyo-e with effects learned from western art, now more easily accessible to Japanese artists.

Kuniyoshi's earliest landscapes, as for example a Tokaidō series on twelve sheets with several stations in each of the wide panoramic views, are without marked European traits, and have the lively human interest of the typical Ukiyo-e landscapes like those of Hiroshige and Eisen. Shortly after this set, however, a series of Views of Edo appeared (*Tōto Meisho*), a set of ten remarkable prints in which there is a noticeably western handling of the sky, of trees, of perspective generally, and furthermore, a concern with atmospheric phenomena, like the rainbow that appears in one, or the halo around the moon in another—the latter, especially, lighting the print with an unearthly glow and producing such an air of unreality that the figures might be the players in a pantomime enacted before an exotic backdrop. Certain of this set have been frequently reproduced—the 'Seaweed-gathers at Omori' is probably Kuniyoshi's best-known landscape and has invariably received highest praise, though I prefer a number of others before it; the 'Pottery Kilns at Imado' for one, with its oddly impalpable suggestion of the macabre. The amorphous shapes of the kilns are the more disturbing in this typical Japanese setting for being given solidity by western shadows. Inexplicably, they bring a brooding disquiet to a scene of quite harmless everyday activity.

A second set of Edo views, of which five only are known, and produced, like the other set, about 1835, contains that memorable 'Shower on the river-bank at Ommayagashi', which is perhaps the most convincing rain-storm in the Japanese print, achieved, like the Hokkei (Plate 55), by clever block-printing technique; and the view of Mitsutama, in which the sulphurous smoke from a fire lit by men caulking a boat in the foreground drifts in front of a view of the distant bank of the river, where a bridge, towers and warehouses are sharply outlined as they would be in an etching by Rembrandt.

It might have been possible at one time to have told exactly what European prints and paintings were available to Kuniyoshi and his contemporaries, but the research would necessarily have fallen to the Japanese themselves, and until recent years, the Ukiyo-e artists were hardly the object of the serious scholarship such an investigation would have called for. The frequent use of a large tree in the foreground of some of Kuniyoshi's landscapes led Bidwell[1] to suggest Turner as the source of inspiration, but the expedient was a common one in western landscape painting and there is no print of Kuniyoshi's that satisfactorily confirms this engaging theory.

The most exceptional of this set is that entitled 'The Rocks at low tide at Shubi-no-matsu' (Plate 60). This owes its astonishing effect only partially to the imported chiaroscuro: the strange conception is Kuniyoshi's own. As the tide recedes, it reveals forbidding rocks, black in places with underwater slime, and below them a wrack of rotten ropes and other things too shapeless to name. It is as if it were a stretch of the sea-bed never uncovered before, and there is the smell of pollution and decay. The very crabs that lurk in the rocks are sinister, and the monstrous shrimp that clings to the slope of the rock, like the dragon in Turner's 'Polyphemus', crawls with stealthy, menacing intent. What makes the foreground scene the more inexplicable is the placid unconcern of the figure, probably a seaweed gatherer, seated in a boat beyond the rocks. He, and the far-off trees, belong to our normal, everyday world: the rest is the appalling

[1] 'Artibus Asiae', IV, 194.

foreshore of a nightmare. In this unparalleled combination of everyday realism and realistic fantasy, Kuniyoshi produced a surrealistic picture long before that word was invented. Something of this same unaccountably unsettling atmosphere pervades another acknowledged masterpiece, the famous 'Night Attack' from the last act of the Chūshingura.

The 'Twenty-four Paragons of Filial Piety' was a favourite theme with the Japanese painters of all schools, and was often treated in serious or parodied form by the Ukiyo-e artists. In his oblong series with this title, Kuniyoshi frankly borrows and copies from European prints, not only for the landscapes but for the figures as well. This is not really the case of an influence: it is a wholesale adaptation of foreign models. Perhaps the extremest instance is that of 'Sōsan returning home to his aged mother', in which the architecture and landscape setting must have been lifted bodily from an Italian print. The small upright 'Twenty-four Paragons' is even more extraordinary. Plate 62 shows a typical example. Binshiken, one of the Paragons, was cursed with a stepmother who had two sons of her own. She starved him and treated him cruelly to the point when he was so weak he could not stand, but when his father at last discovered his plight and threatened to divorce his wife, Binshiken interceded for her and her two sons, and the stepmother, duly chastened, reformed her ways. Kuniyoshi here depicts the stepmother and her two plump children. She is leaning in the graceless attitude and the artful draperies of a Venus by Poelenburgh on what might be a seat of some sort, or even a spinet. It is covered by a cloth and not perhaps fully understood by the Japanese artist. Behind stands an incongruous peacock. This has all the appearance of being a near-literal transcription of a European picture or print, by a Dutch artist in the pseudo-classic style, van Mieris, van de Werff or some such inferior painter. The oddly Baroque flavour of Kuniyoshi's *europoiserie* arises as much as anything from the bad models he copied. In both the oblong and the upright series of the 'Twenty-four Paragons', occur Japanese versions of the figures in rajah-like garments with which the Dutch fondly clothed their Biblical personages, and so these versions are

doubly anachronistic. And all the time, there is the suspicion of masquerade in these transcriptions: the faces, the line, and above all, the woodcut technique, are unmistakably Japanese, despite the make-up, the curly wigs, the turbans, and the alien light and shade.

Prints like this may have little artistic merit, but they are curiosities of great interest. Soon after Kuniyoshi's death in 1861, the channels of communication between Japan and the rest of the world were opened, and the artists of the country were able freely to study western paintings and prints. The result was a far more systematic westernisation of their art than had been possible before, and the virtual end of the Ukiyo-e print.

CHAPTER XVIII

———————○———————

Itō Shinsui:
The Attempt to Revive the Print
(1915-1930)

M OST accounts of the Ukiyo-e print end long before the
20th century begins, but the aftermath of the two
centuries of unceasingly original productivity is at
least worth considering if for no other purpose than that of bring-
ing home the true virtues of the print in its heyday, and the
reasons for the late prints ceasing to have meaning for us as works
of art.

The period following the Restoration in 1868, when, the old
restraints removed, the Japanese were swept up in an unbounded
and unreasoning enthusiasm for the arts and sciences of the western
world, was a time of confusion in the country, both as to the way
of life and in the practice of the arts. The complexity of the
cross-currents, of the old die-hard nationalism and the modern
competitiveness seeking to vie suddenly with the West in every
field of activity, showed itself in the restlessness of the people and
the unchecked drift of their art. The debased Ukiyo-e of the
legion of pupils of Kuniyoshi and Kunisada spent itself in wilder
and cruder heroics, to the majority of which our only response is a
shudder, or in over-sentimentalised versions of domestic scenes
and pictures of lovely girls, many of which were drawn by artists
who had, for the first time, an eye to the tourist trade. The
completely false idea of Japan, current almost up to the events of the
last war, was created as much as anything from these mawkish
pictures of *musume* in pretty frocks, feeding goldfish under profuse

cherry-blossom or maples of impossible hue, or standing, wistfully slant-eyed, in the picturesque snow which, in palpably white flakes, falls on the coquettishly tilted umbrella. Like the execrable egg-shell china of Kyōto, fondly cherished by sailors' grand-daughters as the supreme achievement in ceramics of the clever little people of Old Japan, some of the colour-prints of this period have been accepted as representative of the pictorial art of the country.

Native-style painting *was* kept alive by a few artists whilst the treacherous invader was generally courted and acclaimed, but it was a weakened and debilitated art even before 1868, and had little to offer except patriotism in opposition to the blandishments of the novel art of the West, now for the first time freely accessible to everyone. The protagonists of the traditional classical styles insisted on those features of their art that differentiated it from the western, but in emphasising on the one hand the calligraphic brush-line and on the other the 'splash-ink' formlessness, they merely asserted a banal nationalism without presenting any new or vital artistic idea. The popular artist Kyōsai, with his boisterous virility, managed to preserve something of his integrity and to design prints that we still find powerful, but even in his case you feel that too much of his energy was wasted in competing with and holding his own against the pervasive western style.

In Kuniyoshi we witness the curious effects of the infiltration, by devious routes, of elements of westernism, and how, in an artist of his remarkable ability, prints of a positive originality resulted from a fortuitous *mélange*. In Kobayashi Kiyochika (1847-1905), who embraced the European doctrine from the out-set and took instruction in painting from an Englishman, we see the next stage in the destruction of a national style of colour-print. He is not completely naturalised, his design still often reveals the Japanese hand, and the very colour-woodcut medium, imposing some restraint on the designer, is still clearly that of the unmatch-able Japanese craftsmen. But realism in the western sense of a photographic representation of nature was something new to the Japanese, as novel as a steam train or electricity. They wanted to show they could do realistic pictures as well as the foreigners and

bent all their energies to this misguided end. The most trivial and obvious expedients were employed to exhibit this trick of lifelike representation, and snow scenes and night scenes, with stars pricking through a blue-black sky and river lights casting rippling rainbow reflections, were repeated *ad nauseam* by Kiyochika, Ogura Ryūson and others who developed this sort of print.

So, by a sort of tragic irony, just at a time when western artists were breaking with the tradition of representationalism that had dogged them for centuries, and drawing strength from the example of Japan, the Japanese were tricked by the specious cleverness of western realism into exchanging their own valid artistic ideals for a mere facility to mimic nature and to compete with the camera.

The main subjects of the old Ukiyo-e masters continued to engage the new post-Restoration generations of artists, but now the prints of actors and courtesans are jejune and uninspiring, and the old robust tang has gone. The Ukiyo spirit has died. Ukiyo-e art was the product of a certain society, a certain temper of a lusty hedonistic people seeking an outlet from the hardships of a repressive régime, an escape from the dullness of their workaday, stay-at-home lives. By the 20th century there was a new world, a new outlook, and the art-forms that that earlier spirit had given rise to were bound to be obsolete.

Kabuki retained its non-realistic character until the Restoration, but contact with the West led to moves towards realism in the theatre as in painting and with equally pernicious effects on the native genius. A population familiar eventually with the western stage and the representational film began to look on Kabuki as a museum theatre, an expression of the past, to be attended for its historical and aesthetic contribution to the stage, but not primarily for entertainment, much as we ourselves tolerantly endure mediaeval mystery plays. Recent Kabuki prints, as, for example, those of Sekino Junichirō, are a different thing entirely from the old Ukiyo-e theatrical prints, as they do not arise from that immediate contact with a theatre of the vital dynamic force in the people's lives that inspired Kiyonobu and Kiyomasu, Shunshō and

Toyokuni, Sharaku and Kunimasa. Junichirō's well-known portrait of the modern Kabuki actor Kichiemon is a symbol almost of the change. The head is worked out in full western light-and-shade technique, and behind—in truth we may cry 'Shades of Sharaku!'—is the faint indication of one of Sharaku's portrait busts. Perhaps Junichirō meant his portrait to be symbolic of the long-continuing Kabuki tradition: but it is also symbolic of what Japanese artists lost in the transposition of the bias of their art from East to West.

Human nature being what it is, it is perhaps not surprising that the *bijin-e*, the 'beautiful-girl picture' should have withstood all the revolution in art styles with the smallest differences in presentation. Yet it is in a comparison of later with the earlier versions of just this form of print, the bust, half-length or full-length figure of a single girl, the subject of many of the very greatest Ukiyo-e prints, that we discover the most obvious reasons for the hold over us of the pre-1800 prints, and the almost complete lack of appeal of the modern.

Hachiguchi Gōyō (1886-1921) and Itō Shinsui (born 1896) are two talented artists who represent the attempt, and the failure, to revive the *bijin-e* in the present century. Gōyō died very young and his prints probably owe something of their prominence to their scarcity—only 14 different subjects are known. That they were based on the Ukiyo-e print can hardly be doubted. The figure of a girl that forms the subject of practically all his designs is robed in *kimono* of patterns that often recall those worn by the models of Kiyonaga and Utamaro; and many of his prints, in direct imitation of Utamaro and Chōki, are printed on a mica background. Gōyō was drawing on a wide knowledge of Ukiyo-e (he was joint editor of an important book on the colour-print in Japan, published in 1917-1918), and he could not have been unaware, because he was surrounded by them, of western-style paintings of women. He was accordingly encumbered with a learning, a historical sense and an eclecticism neither Utamaro nor Chōki laboured under. His prints, striking as they are from the very brilliance of the woodblock translations of his drawings, are vitiated by the archaism implicit in an attempt to design Ukiyo-e

bijin-e for an audience that was fundamentally different from the people for whom Utamaro and Chōki and the rest had designed their masterpieces; and also, by the departures in style from the principles on which the earlier prints are based.

In Shinsui's *bijin-e*, perhaps more than in Gōyō's, we can assess these stylistic factors that have almost inevitably arisen to cast doubt on the aesthetic validity of the modern print. Utamaro and Chōki, and others of that period, relied on the outline and the flat pattern of colour. Shinsui (Plates 63 and 64) gives depth and plasticity. He employs, even unconsciously, the western mode of drawing 'in the round', whereby the figures are given a solidity quite foreign to the early artists' style. And given this solidity, this simulation of a third dimension, we look for naturalness in the face and figure. But the features of his girls, still half conventionalised, seem empty, and we sense a lack of integration between the unelaborated face and the actuality conveyed by the solid shoulders on which the head is set. Shinsui tried to combine the best of both worlds, and in doing so, lost both: the supremely satisfying two-dimensional pattern of the early masters, with its excitingly critical equipoise between descriptiveness and purely abstract form; and the impression of actuality, the projection out of the picture space of the form and even the personality of the sitter that the realism of the western painter could on occasion achieve.

Perhaps, too, Shinsui is too near to us in time and space. However much we may deny it, seeking always for absolute values in art, unaffected by external considerations, the fact remains that part of the appeal of any art is the consciousness of its origin in peoples of remote ages and distant countries, with whom we have no other ties than their memorials in art. Admiration for the Japanese print has grown deeper for the knowledge we have slowly acquired of the 'Floating World', and as the expression of a people and a way of life, the print has come to have an added significance over and above—but inextricably compounded with—our appraisal of its purely pictorial characteristics. Shinsui is of our own day and his work, carrying none of those almost mystic associations with an otherwise unreachable past, seems at best an abortive resurrection, or at worst a sham.

Select Bibliography

The following is a representative selection mainly of books in European languages. Japanese books, apart from a few that comprise collections of reproductions with a minimum of text, have been omitted.

BACKGROUND

BOXER, C. R.: *Jan Compagnie in Japan, 1600–1850.* An Essay on the cultural, artistic and scientific influence exercised by the Hollanders in Japan from the 17th to the 19th centuries. The Hague, 1936 and 1950.

BROWN, LOUISE NORTON: *Block Printing and Book Illustration in Japan.* London, 1924.

DE BECKER, JOSEPH ERNEST: *The Nightless City, or, The History of the Yoshiwara Yukwaku.* Yokohama, 1899.

ERNST, EARLE: *The Kabuki Theatre.* London, 1956.

HONJŌ, EIJIRŌ: *Economic Theory of the History of Japan in the Tokugawa Period.* Tokyo, 1943.

LANE, RICHARD: *The Beginnings of the Modern Japanese Novel: Kana-zōshi, 1600–1682.* Harvard Journal of Asiatic Studies, Vol. 20, December, 1957.

LANE, RICHARD: *Saikaku and the Japanese Novel of Realism.* Japan Quarterly, April–June, 1957.

LANE, Richard: *Saikaku's Contemporaries and Followers. The Ukiyo-zōshi, 1680–1780.* Monumenta Nipponica. Vol. XIV, Nos. 3–4, 1958–1959.

MORRISON, ARTHUR: *The Painters of Japan.* London, 1911.

MURDOCH, J. A.: *A History of Japan,* Vol. III. The Tokugawa Epoch, 1652–1868. London, 1926.

PAINE, ROBERT TREAT and SOPER, ALEXANDER: *The Art and Architecture of Japan,* The Pelican History of Art. London, 1955.

SANSOM, GEORGE B.: *Japan: A Short Cultural History.* London, 1931 and 1946.

SANSOM, GEORGE B.: *The Western World and Japan, A Study in the Interaction of European and Asiatic Culture.* New York, 1950.

TODA, KENJI: *Descriptive Catalogue of Japanese and Chinese Illustrated Books in the Ryerson Library of the Art Institute of Chicago.* Chicago, 1931.

VOLKER, T.: *Ukiyo-e Quartet. Publisher, Designer, Engraver and Printer.* Leiden, 1949.

GENERAL LITERATURE ON THE PRINT

BINYON, LAURENCE and SEXTON, J. J. O'BRIEN: *Japanese Colour Prints.* London, 1923.

BOLLER, WILLY: *Masterpieces of the Japanese Colour Woodcut.* Boston, n.d. and London, 1957.

FICKE, ARTHUR DAVIDSON: *Chats on Japanese Prints*. London, 1915.

GOOKIN, F. W.: *Japanese Colour Prints and their Designers*. New York, 1913.

FUJIKAKE, SHIZUYA: *Japanese Wood Block Prints*. Tokyo, Japan Travel Bureau, 1953.

HILLIER, J.: *Japanese Masters of the Colour-Print*. London, 1954.

MICHENER, JAMES A.: *The Floating World*. New York, 1954.

NOGUCHI, YONE: *The Ukiyoye Primitives*. Tokyo, 1933.

RUMPF, FRITZ: *Meister des Japanischen Farbenholzschnittes*. Berlin, 1924.

SHIBUI, KIYOSHI: *Éstampes Érotiques Primitives du Japon*. Tokyo, 1926.

STEWART, BASIL: *Subjects Portrayed in Japanese Colour Prints*. London, 1922.

Ukiyo-e Taika Shusei. Tokyo, 1931-1932.

INDIVIDUAL MASTERS

HARUNOBU

KURTH, JULIUS: *Suzuki Harunobu*. Munich, 1922.

YOSHIDA, TERUJI: *Harunobu Zenshū*. Tōkyō, 1942.

HIROSHIGE

NOGUCHI, YONE: *Hiroshige*. New York, 1921.

STRANGE, EDWARD F.: *The Colour-Prints of Hiroshige*. London, n.d.

HOKUSAI

GONCOURT, EDMUND DE: *Hokusai*. Paris, 1896.

HILLIER, J.: *Hokusai. Paintings, Drawings and Woodcuts*. London, 1955.

PERZYNSKI, FREIDRICH: *Hokusai*. Bielefeld and Leipzig, 1904.

REVONS, H.: *Étude sur Hok'sai*. Paris, 1896.

KIYONAGA

HIRANO, CHIE: *Kiyonaga. A Study of His Life and Works*. Boston, 1939.

SHARAKU

HENDERSON, HAROLD G. and LEDOUX, LOUIS V.: *The Surviving Works of Sharaku*. New York, 1939.

RUMPF, FRITZ: *Sharaku*. Berlin, 1932.

SHUNSHO

SUCCO, FRIEDRICH: *Katsukawa Shunshō*. Dresden, 1922.

TOYOKUNI

SUCCO, FRIEDRICH: *Utagawa Toyokuni und seine Zeit*. Munich, 1913-1914.

UTAMARO

GONCOURT, EDMUND DE: *Outamaro. Le Peintre des Maisons Vertes*. Paris, 1891.

HILLIER J.: *Utamaro*. In the press.

KURTH, JULIUS: *Utamaro*. Leipzig, 1907.

YOSHIDA, TERUJI: *Utamaro Zenshū*. Tōkyō, 1941.

CATALOGUES
Public Collections

British Museum, London:

BINYON, LAURENCE: *A Catalogue of Japanese and Chinese Woodcuts in the British Museum*. London, 1916.

Victoria and Albert Museum, London:
RUFFY, A. W.: *Japanese Colour-Prints*. London, 1952.
Ueno, Japan:
Ukiyo-e Zenshū. Tōkyō, 1958.

National Museum, Stockholm:
PER BJURSTRÖM: *Japanska Träsnitt. Japanese Colour Prints in the National Museum*. 1958.

The Art Institute of Chicago:
GUNSAULUS, HELEN C.: *The Clarence Buckingham Collection of Japanese Prints. The Primitives*. Portland, Maine, 1955.

Metropolitan Museum of Art, New York:
PRIEST, ALAN: *Japanese Prints from the Henry L. Phillips Collection*. New York, 1947.

<center>Private Collections</center>

KAWAURA: *Album of Old Japanese Prints of the Ukiyo-e School. Reproduced from the collection of Kenichi Kawaura*. Tōkyō, 1919.
LEDOUX, LOUIS V.: *Japanese Prints in the Ledoux Collection*. Vol. I, The Primitives; Vol. II, Harunobu and Shunshō; Vol. III, Bunchō to Utamaro; Vol. IV, Sharaku to Toyokuni; Vol. V, Hokusai and Hiroshige. New York, 1942-1951.
MATSUKATA: *Catalogue of the Ukiyo-ye Prints in the Collection of Mr. Kojiro Matsukata*. Osaka, 1925.
MOSLE: GOOKIN, F. W.: *Descriptive Catalogue of the Japanese Colour-Prints in the Collection of Alexander G. Mosle*. Leipzig, 1927.
SCHEIWE: HEMPEL, DR. ROSE: Sammlung Theodor Scheiwe. Munster, 1957.

<center>Exhibitions</center>

London:
MORRISON, ARTHUR: *Exhibition of Japanese Prints. The Fine Art Society*. London, 1909 and 1910.

New York:
FENOLLOSA, E. F.: *The Masters of Ukiyo-ye*. New York, 1896.
LEDOUX, LOUIS V.: *Exhibition of Japanese Figure-Prints from Moronobu to Toyokuni*. The Grolier Club. New York, 1923.

Paris:
KOECHLIN, R., Editor. Vignier and Inada, Cataloguers: Musée des Arts Decoratifs, Paris, 1909-1914. Vol. I, *Éstampes Japonaises Primitives;* Vol. II, *Harunobu, Koriūsai, Shunshō;* Vol. III, *Kiyonaga, Bunchō, Sharaku;* Vol. IV, *Utamaro;* Vol. V, *Yeishi, Chōki, Hokusai;* Vol. VI, *Toyokuni, Hiroshige*.

Rotterdam:
C. OUWEHAND: *Surimono*. Museum Boymans, 1953.

Tōkyō:
WATANABE, S.: *Hiroshige. Catalogue of Memorial Exhibition*. Tōkyō, 1918.
INOUE WAYU: *Utamaro Memorial Exhibition*. Tōkyō, 1926.

Auction Sales

Amsterdam:
Lieftinck, 1935.

Berlin:
Straus-Negbaur, 1928; Solf, 1936.

London:
Happer, 1909; Barclay, Blondeau, Gookin, van Heymel, Ritchie, 1910; 'An
Importer of Japanese Products', 1911; Tuke, Miller, Satow, Foxwell,
Orange and Thorneycroft, Swettenham, 1912; 'A Gentleman Residing in
Paris', 1913; Danckwerts, 1914; Kington Baker, Hilditch, 1916; Wilson,
1918; Crewdson, 1919; Getting, 1920; Thatcher Clarke, 1921; Sexton,
1923; Crzellitzer, 1925; Hall, Harmsworth, 1938.

New York:
Bunkyo Matsuki, 1907-8; Blanchard, Metzgar, 1916; Hirakawa, Genthe, 1917;
May, 1918; Hunter, Metzgar, 1919; Hoyt, 1920; Ficke, Spaulding, 'French
Connoisseur', Shraubstadter, van Caneghen, 'A Distinguished French
Connoisseur' (Jacquin), 1921; Rouart, The Art Museum, Bremen, Hamil-
ton Easter Field, 1922; A Collection from Berlin, 1923; 'New York
Collector', 1924; Ficke, Kawaura, 1925; Mori, 1926; Wright, 1927; Fuller,
Garland, 1945; Church, 1946; Phillips, 1947; Morse, 1957.

Paris:
Hayashi, 1902; Gillot, Barboutau, 1904; 'Un Amateur de L'Étranger', 1909;
Ikeda, 1910; Morita, 1912; Bermond, 1913; Manzi, 1920; Barnes, 1921;
Haviland, 1922-1924; Gonse, 1922-1924; Charvarse, Saloman, 1922; Isaac,
1925; Javal, Corbin, 1926; Migeon, 1931; Portier, 1933; Chausson, 1926.

Short Glossary of Japanese Words

BAKUFU: 'Tent or Curtain Government', referring originally to the H.Q. of an army in the field, whence it came to be applied to the Government of the Shōgun, or Military Dictator.

CHAYA: Tea-house.

CHŌNIN: The townsmen.

DAIMYŌ: A feudal lord.

EDO: The Eastern Capital, now Tōkyō.

E-GOYOMI: Pictorial calendars.

EHON: Picture-book.

ENGAWA: A verandah or balcony.

FUDE or HITSU: Brush for writing or painting; a painter's brushwork.

FURISODE: Long-sleeved *kimono* worn by young unmarried women.

FŪRYŪ: Fashionable, *à la mode*.

FUSUMA: Sliding partitions for dividing Japanese rooms.

FUTON: Quilted coverlets for bedding or warmth.

GEISHA: Trained female entertainer, especially in music and dancing.

GŌ: Art-name: *nom de pinceau*.

GA: Picture, drawing; drawn by.

GAMYŌ: Art personal name (as distinct from *Geisei*, q.v.).

GAFU: Book of drawings.

GEISEI: Art surname.

GETA: Clog-like footwear.

GIGA: Drawn for amusement.

HAKKEI: Eight Views.

HAKAMA: Wide trousers, worn by both sexes.

HANAMICHI: 'The Flower Walk', a raised passage extending from stage to auditorium in the Kabuki theatre, used as an extension to the stage.

HANSHI: The commonest and cheapest Japanese paper.

HAORI: A short coat worn over the *kimono*.

HIBACHI: A charcoal brazier.

HOKKYŌ: An inferior Buddhist rank, also conferred on writers and artists.

Hon: A book.

Hōsho: A thick paper of superior quality used for better-class prints after the introduction of full-colour printing.

Jōruri: Epic or narrative sung or chanted to *samisen* accompaniment, originally for the puppet stage, later for Kabuki; also the written and illustrated versions.

Kabuki: The popular drama.

Kakemono: A hanging painting.

Kakemono-e: A print often hung as a *kakemono*.

Kamuro: A young girl attendant on an *oiran* and destined herself to become a courtesan.

Kana-zōshi: Booklets printed in the simplified *kana* script.

Kaomise: Literally, to 'show one's face'. The performances to introduce actors to audiences at the commencement of the troupe's engagement for the current season.

Kibyōshi: Cheap story booklets, 'yellow-backs'.

Kimono: Generally, anything worn; specifically, the long dress worn by both men and women.

Kiwame: 'Approved'; stamped, after 1790, by censors on prints that passed their scrutiny.

Komusō: Originally the name of a Zen Buddhist sect, the priests wearing a straw 'beehive' hat and begging for alms by playing the *shakuhachi*. Political and other outlaws often joined the sect.

Koto: A thirteen-stringed musical instrument.

Kyōka: Humorous verses of 31 syllables.

Masa: A thin but tough paper in general use for colour-prints.

Meisho-ki: Guide-books, usually profusely illustrated.

Minogami: A stronger type of *hanshi*, thin enough to be used for drawings for the block-cutter.

Monogatari: Narrative, romance.

Musume: A young woman.

Nengō: The name of a period or era, e.g. Genroku, 1688-1703.

Nihonbashi: The 'Japan Bridge' the starting point of the Tokaidō in central Edo.

No: The classical drama.

Obi: Sash or girdle.

Oiran: Courtesan of superior type, especially in the Edo Yoshiwara.

Ryōgoku: A famous bridge over the Sumida River in Edo.

Sake: Spirits distilled from rice.

Samisen: A three-stringed guitar-like instrument.

SAMURAI: A knight of the military caste.

SEIRŌ: The 'Green Houses', i.e. premises licensed for prostitution.

SHAKUHACHI: A bamboo pipe.

SHIBARAKU: 'Tarry a Moment!', a traditional theatrical interlude.

SHIN-YOSHIWARA: The licensed area of Edo, originally in the Nihon-bashi area, was moved in 1657 to the northern outskirts of the town and thus became known as the Shin or 'New' Yoshiwara.

SHINZŌ: An apprentice courtesan, attendant on established *oiran*.

SHŌJI: A sliding door or window, consisting of a wooden frame covered with tough paper.

SHUNGA: Erotic drawings and prints.

SUMI: Black ink.

SUMO: Japanese wrestling.

SURIMONO: Prints of an especial type for greetings and commemorative occasions; see Chapter XI.

TABI: Socks with a separate division only for the big toe.

TAYŪ: First-class courtesan.

TORII: The entrance of a Shintō Temple or Shrine.

UCHIKAKE: A long, lined garment worn loosely over a *kimono* by women.

UKIYO-E: 'Floating World' Pictures.

UKIYO-ZŌSHI: 'Floating World' booklets, realistic novelettes.

WAKASHU: A young man under eighteen; also an effeminate and dissolute youth, a catamite.

WARAGI: Straw sandals tied around the ankles.

YARITE: The woman superintendent of the 'Green Houses'.

YŪJO: A courtesan.

YUKATA: A cotton kimono, a bathrobe.

Sizes of prints

The sizes of prints depended on the stock sheet sizes in which paper was made, a factor that varied at different periods. Until *hōsho* paper came into use after the introduction of the full colour-print, *masa* had been used; after 1842, the restrictions introduced by the Bakufu to curb luxury led to *masa* being used again, except perhaps for *surimono*. *Ōban*, the commonest format encountered, was one-half a medium-sized *hōsho* sheet; *hoso-e* was one-third of a sheet of *masa*. The early *kakemono-e* were printed on *masa* and this necessitated the pasting of two sheets together to give the required length. The late

hashirakake were printed on extra long sheets of *masa*. The following sizes are approximate only:

BAI-ŌBAN	13 inches	× 18 inches
OBAN	$15\frac{3}{4}$	× $10\frac{1}{2}$
CHŪBAN	11	× 8
AIBAN	13	× 9
HOSO-E	12/13	× $5\frac{1}{2}$/6
KOBAN	$5\frac{1}{2}$	× $4\frac{1}{2}$
TANZAKU	14	× 4
HASHIRAKAKE	26/29	× $4\frac{1}{2}$/5
KAKEMONO-E	23	× 12

Terms used in connection with colour-printing

ATENASHI-BOKASHI: 'Indefinite shading', uneven application of colour achieved by floating pigment on to a dampened block.

BAREN: A circular pad used for rubbing the surface of the paper over a woodblock in order to take an 'impression'.

BENI-GIRAI: 'Pink avoided'; prints in a restricted range of colours. See Chapter IX.

BENI-ZURI-E: 'Pink printed pictures', actually used to denote prints in two colours, usually pink and green, though sometimes yellow or blue were substituted for the green.

BIJIN-E: 'Beautiful girl' pictures.

DŌSA: A size for treating paper to prevent colours running.

FUKI-BOKASHI: 'Wiped shading', even gradation of colour from dark to light by wiping the colour from the block with a cloth.

HAKKAKE: 'Brushing over'; overprinting to deepen or to gradate colour.

HAN: A woodblock for printing.

ICHIMAI-E: A separately-issued print; a broadsheet.

ISHI-ZURI-E: 'Stone-printed prints', actually white-line prints taken from woodblocks. See Chapter VIII for a description.

KACHŌ-E: Pictures of birds and flowers.

KAPPA-ZURI-E: Stencilled pictures, not true colour-prints.

KARA-ZURI: Blind printing, embossing, *gauffrage*.

KATSURA NO TSUYAZURI: Overprinting of black on black to give a shiny surface to the hair.

KENTO: Guide-marks on the woodblocks to ensure accurate register.

KIMEKOMI: Blind-printing, the impressed lines outlining and giving form to figures rather than to designs or patterns.

KIRARA-E: Mica prints.

KIZURI-E: Yellow-ground prints.

NISHIKI-E: 'Brocade pictures'; polychrome prints from Harunobu onwards.

SUMI-E: Prints in black ink only.

TAN-E: Prints hand-coloured with *tan*, red-lead pigment.

TATE-E: Vertical print.

TEMBOKASHI: 'Sky shading', making the lower part of the sky lighter than the upper, a common device in 19th-century landscape prints.

TSUYAZURI: 'Shiny printing'; a sort of blind printing whereby the *face* of the paper was burnished over the pattern to be printed.

UCHIWA-E: Fan-prints.

UKI-E: Perspective pictures.

URUSHI-E: Lacquer prints.

YOKO-E: Horizontal prints.

Index